THE WORKS OF J.M.W. TURNER AT THE NATIONAL GALLERY OF IRELAND

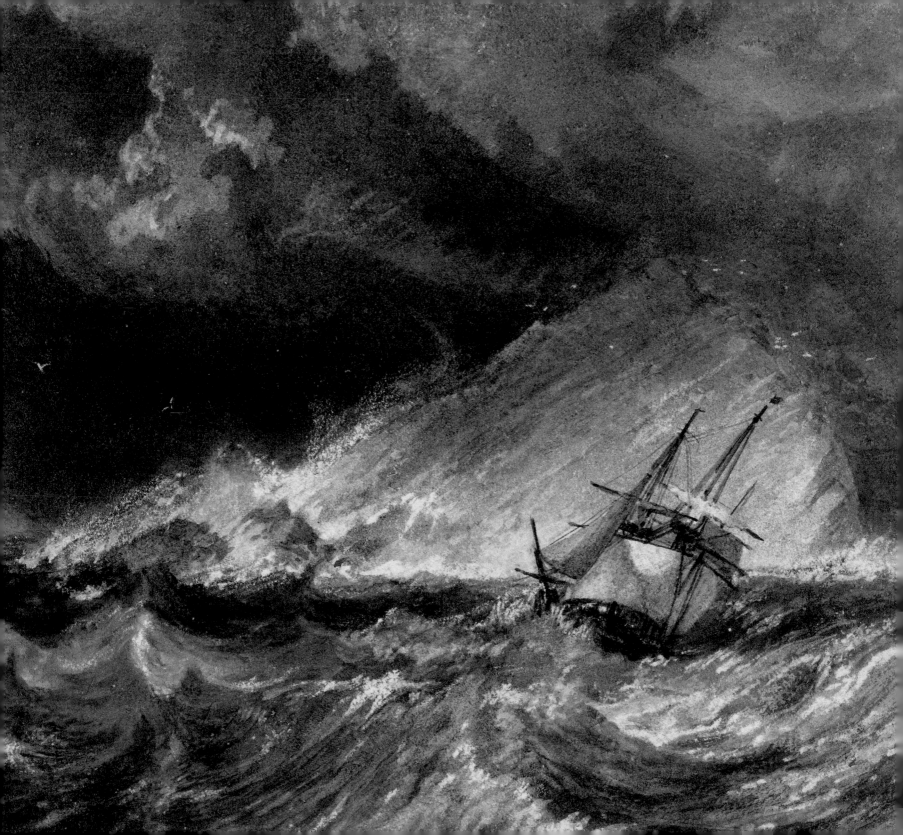

# THE WORKS OF J.M.W. TURNER
# AT THE NATIONAL GALLERY OF IRELAND

ANNE HODGE AND NIAMH MAC NALLY

Copyright © 2022 National Gallery of Ireland and the authors
ISBN 978-1-904288-47-3

Catalogue designed by Jason Ellams
Printed by Castuera

Gallery images: Photos, National Gallery of Ireland
Photographer: Roy Hewson

Cover: *The Doge's Palace and Piazzetta*, c.1840 (detail) NGI.2423
Frontispiece: *A Ship against the Mewstone at the entrance to Plymouth Sound*, c.1814 (detail) NGI.2423
Page 8: *Clovelly Bay, North Devon*, c.1822 (detail) NGI.2414
Page 22: *Ostend Harbour*, c.1840 (detail) NGI.2425
Page 144: *Sunset over Petworth Park Sussex*, c.1828 (detail) NGI.2430

# Contents

6     **Director's Foreword**

7     **Sponsor's Foreword**

9     **The History of the Turner Collection at the National Gallery of Ireland**
ANNE HODGE

23     **Turner: Traveller Extraordinaire**
NIAMH MAC NALLY

36     **Turner's Travels in Britain and Europe**

37     **J.M.W Turner: Catalogue of Works**

126     **Turner's Watercolour Materials**
RANSON DAVEY

141     **Acknowledgements**

142     **Select bibliography**

## Director's Foreword

This handsomely designed publication presents a comprehensive overview of the 31 watercolours, by J.M.W. Turner, bequeathed to the National Gallery of Ireland by the distinguished collector, Henry Vaughan (1809-1899). These exceptional works, by the most celebrated British artist of the early nineteenth century, are presented to the public each January, the month when daylight is weakest. This unusual restriction, imposed by the donor, was a perceptive acknowledgement of the fragility of works on paper. If exhibited for long periods in strong light, their colours will fade over time. Because of Vaughan's foresight, the National Gallery of Ireland's Turner watercolours have retained their freshness and immediacy, while their short period on annual exhibition ensures a high level of public interest each year.

Vaughan's primary concern was to build an exemplary collection of works by this most admired of Romantic artists, who was the key artist in his collection of British art. Alongside his bequest to the National Gallery of Ireland, Vaughan left significant groups of Turners to the National Galleries of Scotland, the National Gallery in London (these works are now part of the Turner Bequest at the Tate), and a smaller group to the Victoria and Albert Museum (the V&A).

The works in Dublin are of unsurpassed distinction and represent a wide range of subjects and places. They demonstrate Turner's breath-taking mastery of the watercolour medium. This publication presents insights, comparisons and research about Turner's technique and artistry forty years after the Gallery's last major publication on the Vaughan Bequest. With this volume, we are fortunate to be able to present an illuminating perspective on Turner's remarkable achievements, for each new generation of visitors to the Gallery. We are delighted that Grant Thornton support the annual Turner exhibition at the Gallery.

**Sean Rainbird,** *Director, National Gallery of Ireland*

## Sponsor's Foreword

Turner was an innovator. Among his many achievements, he elevated the status of watercolour painting, producing remarkable works on paper that rival the power of oil painting. In the Gallery's collection of 31 watercolours donated by Henry Vaughan, Turner confirms that landscape painting can embody the highest aspirations of art, going beyond the expected. He captures the raw power of nature across land and sea, dark and light, in calm and stormy conditions.

At Grant Thornton Ireland, we bring you the local knowledge, national expertise and global presence to help you and your business succeed – wherever you're located. We deliver solutions to all business challenges and are a global network of over 60,000 people, with member firms in 130+ countries having a common goal — to help you realise your ambitions and go beyond the expected. This is why our network combines global scale and capability with local insights and understanding. So, whether you're growing in one market or many, looking to operate more effectively, managing risk and regulation, or realising stakeholder value, we have the assurance, tax and advisory capabilities you need with the quality you expect. Our people invest the time to truly understand your business, giving real insight and a fresh perspective to help you go beyond.

Grant Thornton are immensely proud support the National Gallery of Ireland's annual celebration of Turner, one of the world's most-loved artists.

Colin Feely, *Partner, Grant Thornton*

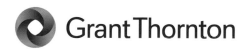

Turner Exhibitions Partner

# THE HISTORY OF THE TURNER COLLECTION AT THE NATIONAL GALLERY OF IRELAND

ANNE HODGE

'... the greatest artistic genius of the British School and the most poetic and imaginative landscape painter the world has seen.'[1]

This is how Henry Doyle (Director of the National Gallery of Ireland 1869-92) described J.M.W. Turner in the biographical entry that precedes a list of five oil paintings by Turner which hung in the Gallery in 1890. Doyle had borrowed five impressive oils (fig. 1), all part of the Turner Bequest, on long term loan from the National Gallery in London.[2] The National Gallery of Ireland Board Minutes of 31 July 1884 reported that the five paintings, having been 'cleaned and restored by Mr John Tracy', had been hung in the Gallery. These paintings remained in Dublin until 1948 when their return was requested by the Tate Gallery.[3] It has largely been forgotten that for the first half of the twentieth century it was possible to view both oils and watercolours by Turner in the National Gallery of Ireland. Today, just one oil by Turner is in a public art collection on the island of Ireland. *The Dawn of Christianity (Flight into Egypt)*, 1844, (fig. 2) once owned by the great Turner collector B.G. Windus (1790-1867),

was presented to the Ulster Museum in 1911 by Lady Currie, wife of a shipping magnate Sir Donald Currie (1825-1909).[4]

The Gallery's collection of works by Turner comprises 36 watercolours and drawings which span his entire career and a complete set of the *Liber Studiorum* print series. Thirty-one of the watercolours were bequeathed by a wealthy English art collector, Henry Vaughan in 1899. Turner's reputation has, if anything, increased since Henry Doyle wrote his laudatory remarks in 1890. His oils and watercolours are loved and admired by artists, critics and the public alike. Turner is one of the household names of the art world and exhibitions of his work never fail to draw large crowds. This catalogue, which draws heavily on research undertaken over the last 25 years by curators at Tate and independent scholars, explores each of the works in the National Gallery of Ireland's collection in detail. Many revised dates and new titles are published here for the first time.

**1.** National Gallery of Ireland Summary Catalogue, 1890, p.134
**2.** In 1883, the National Gallery Loan Act was passed to allow paintings to be lent to public galleries across the British Isles. The five paintings borrowed by the National Gallery of Ireland were: *The Opening of the Walhalla*, 1843; *Lake Avernus: the Fates and the Golden Bough*, 1834; *Richmond Bridge on the Thames*, 1808; *The Departure of Regulus*, 1837 and *Madonna della Salute, Venice*, 1844.
**3.** See National Gallery of Ireland Archives Box 22 Administration (1948-49) for correspondence between the Gallery and Tate on this matter. The bulk of the Turner Bequest had been transferred from the National Gallery, London to the Tate Gallery in 1929.
**4.** The painting formed part of an National Gallery of Ireland exhibition: *Imagining the Divine: the Holy Family in Art*, 26 November 2012–31 March 2013.

Fig. 1: J.M.W. Turner, *The Opening of the Wallhalla*, 1843
Photo © Tate

## J.M.W. Turner

Joseph Mallord William Turner (1775-1851) was born in London. His father William was a barber while his mother Mary Marshall came from a family of butchers. The Turners lived in Maiden Lane, near Covent Garden. Turner's only sibling, a younger sister, Mary Ann, died in 1783. His interest in drawing emerged at an early age and he appears to have been encouraged at home – it is said that his father pinned his son's sketches up in his shop for customers to admire. Turner is thought to have studied drawing under the architectural draftsman Thomas Malton (1748-1804) whose brother James famously published a series of popular aquatint views of Dublin in the 1790s. In December 1789, aged fourteen, Turner was admitted to the Royal Academy's School. The following year he exhibited his first work at the Academy's annual show, a watercolour entitled *The Archbishop's Palace, Lambeth*, (W 10). Turner was fascinated by nature and the landscape around him and from an early point in his career made sketching tours. Throughout the 1790s he toured Britain, visiting Wales, the Lake District and Scotland. In 1793 he was commissioned by *The Copper-Plate Magazine* to provide watercolour views of Kent to be reproduced as black and white illustrations.

In the mid 1790s, Turner attended Dr Thomas Monro's 'Academy'. Turner and other young artists like Thomas Girtin spent their evenings at the doctor's home making copies from drawings in his collection. They were paid three shillings and sixpence for each evening's work. By 1797 Turner had already made his mark as one of the best topographical draftsmen of the day. He was ambitious and keen to progress in life. The Royal Academician Joseph Farington (1747-1821) was interested in the young artist and in his diary entry for 24 October 1798 he writes that Turner spoke to him frankly about:

*his present situation. He said by continuing to reside at his Fathers, he benefitted him and his mother, but he thought he might derive advantages from placing himself in a more respectable situation. He said he had more commissions at present than he could execute and got more money than he expended.*[5]

The following year, 1799, Turner moved into a house on fashionable Harley Street. His mother, who suffered from an affliction of the mind, was by then in Bethlem Hospital where she died in 1804.

Turner's reputation and stature among his peers rose swiftly and in 1802 he was elected a member of the Royal Academy. In 1804, following major building work, he opened his first gallery at his home in Harley Street. This allowed him to show prospective patrons his work in well-lit surroundings. He was a canny man of business and cultivated wealthy patrons who bought his pictures and encouraged him to sketch and paint in their grand country estates. In 1807, the first prints in his *Liber Studiorum* series were published. The purpose of this major print project was to raise the profile of landscape art and to disseminate his work to a larger audience. That same year, Turner was elected Professor of Perspective at the Royal Academy.

From 1817, Turner made almost yearly visits to mainland Europe.[6] He continued to travel until 1845, when ill-health forced him to curtail his peregrinations. In old age he became reclusive, although he continued to exhibit at the Royal Academy until 1850, the year before he died. Around Christmas 1849, he wrote to

5. Farington, vol.3, p.1075
6. See Niamh MacNally's essay, p.23 for more information on Turner's tours.

Fig. 3: J.M.W. Turner, *Clontarf Castle, Co. Dublin*, c.1817. Courtesy of Sotheby's Picture Library

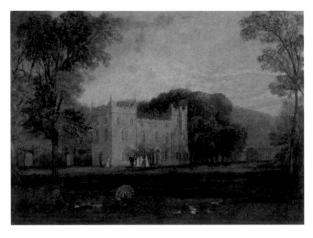

Fig. 4: John Kirkwood after Charles Grey. *Portrait of Thomas Moore*, 1842. NGI.2014.65

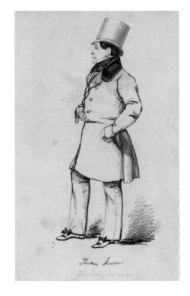

Hawkesworth, son of his old friend and patron Walter Fawkes (1769-1825) complaining: ' ... my health is on the wain [sic]. I cannot bear the same fatigue, or have the same bearing against it as I formerly had – but time and tide stop not'.[7] He died on the morning of 19 December 1851, at 119 Cheyne Walk, Chelsea, where he had lived for some years with a widow, Mrs Sophia Booth.

He left the contents of his studio, a huge collection of sketchbooks, watercolours and oils, to the British nation. In his will, Turner stated that two assessors should check the works, in order that 'only such of the Pictures, Drawings and Sketches as shall in their opinion have been painted, drawn or sketched by the Testator's Hand without any Distinction of finished or unfinished ...' would be included in the works given to the National Gallery.[8] The Turner Bequest, which comprises almost 20,000 items, mainly works on paper, was transferred from the National Gallery, London to the Tate Gallery in the early years of the twentieth century. Following severe flooding in the winter of 1928/9, they were moved to the British Museum and did not return to Tate until 1987.[9]

## Turner and Ireland

Despite the frequency and variety of his tours Turner never set foot in Ireland, which was only a short journey by sea from the North Wales coast. A watercolour by Turner of Clontarf Castle, (fig. 3) located on the coast north of Dublin does exist however.[10] It once formed part of the collection at Farnley Hall near Leeds. In 1816, Walter Fawkes, the owner of Farnley Hall, married Maria Sophia Vernon, daughter of John Vernon of Clontarf Castle. It is possible that Turner painted the watercolour from a sketch by another hand, as a reminder for the new Mrs Fawkes of her childhood home.

A definite Irish connection is Turner's friendship with the Irish poet Thomas Moore (1779-1852). Turner first met Moore, author of the hugely popular *Irish Melodies* in 1819 in Rome. In his memoirs, Moore wrote of meeting Turner in March 1834, when he asked him to make some drawings of Bowood near his home in Wiltshire. Turner

7. Gage, 1980, p.223
8. Finberg, 1909, p.v
9. In 1987 a new, purpose-built series of galleries (The Clore Gallery) were opened at Tate Britain to house the Turner Bequest.
10. This watercolour is in a private collection. Sotheby's Irish Sale, May 13, 2005, lot 16.

Fig. 5: Cumberland Terrace, London, York and Son, c.1870-1900.
© Historic England

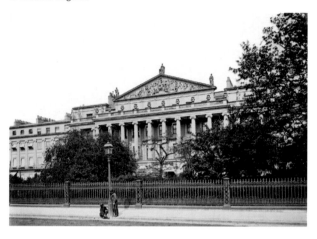

retorted: 'But Ireland, Mr. Moore, Ireland! There's the region connected with your name. Why not illustrate the whole life? I have often longed to go to that country; but I am, I confess, afraid to venture myself there. Under the wing of Thomas Moore, however, I should be safe.'[11] Despite this enthusiasm Turner never visited Ireland. He did however design four vignette illustrations for Moore's *The Epicurean, a Tale; and Alciphron, a Poem*. Moore had begun writing these epic works shortly after leaving Italy but they were not published until 1827. Turner provided illustrations for the 1839 edition.

## Henry Vaughan

Henry Vaughan (1809-99) was the eldest surviving son of the successful Southwark hat manufacturer George Vaughan and his wife Elizabeth Andrews.[12] When George Vaughan died in 1828, Henry inherited a great fortune which allowed him to pursue his interest in art. He travelled in Europe and began collecting art. His interests were wide-ranging and he acquired old master drawings, medieval stained glass, illuminated manuscripts and coins. Most significant however was his interest in drawings and paintings by nineteenth century British artists including Turner, Constable, Thomas Stothard, Thomas Lawrence and John Flaxman. Of Quaker background, Vaughan was a great philanthropist who never wished his charitable works to be acknowledged publicly. In 1848, he gave £5000 anonymously to found the Andrews Scholarship at University College London in honour of his mother. From 1834, Vaughan lived at 28 Cumberland Terrace, part of a grand neo-classical terrace designed by John Nash (fig. 5). He was a knowledgeable and enthusiastic art patron and a member of the renowned London art

club the Athenaeum. In 1866, with the art historian and critic John Ruskin (1819-1900) among others, he became a founder member of The Burlington Fine Arts Club. Like Ruskin, Vaughan is listed as a member of the Royal Architectural Museum in its 1876 handbook.[13]

Vaughan was a generous lender to exhibitions including the major *Exhibition of Art Treasures of the United Kingdom* held in Manchester in 1857. He was particularly interested in Turner's works on paper and amassed an important collection of prints and watercolours over his lifetime. He was a 'second generation' collector, that is he did not acquire works directly from the artist but from dealers and at auction. A letter from Thomas Lupton (who had worked as an engraver for Turner for many years) to Vaughan dated 30 January 1865 reveals how Vaughan acquired items for his collection. 'I send you these hasty scribbles of Shipping I spoke of made by Turner forty years ago to describe the different kinds of shipping' (fig. 7).[14] In 1872 Vaughan co-curated an exhibition of Turner's *Liber Studiorum* prints at the Burlington Fine Arts

**11.** Thomas Moore, *Memoirs, Journal and Correspondence* (editor Lord John Russell) 8 vols; vol. vii., p.77
**12.** See Baker, 2006, pp. 9-25 for the most detailed biography of Vaughan available.
**13.** Thanks to Pia Haertinger, Augsburg, Germany who referred to this connection in a letter to Adrian LeHarivel, Curator of British Art, 16 December 1992. The Royal Architectural Museum, whose main purpose was didactic, had a rich collection of casts of architectural ornament and drawings. In 1904 the Architectural Association took over its running and later the collections were dispersed, primarily to the V&A Museum.
**14.** Letter is attached to a drawing (B 1975.4.1761) in the Yale Center for British Art, New Haven. See also the catalogue entry for NGI.2401.

Fig. 7: J.M.W. Turner, *Sketch of Two Ships on a Catalogue Page*, c.1823.
Yale Center for British Art, Paul Mellon Collection B1975.4.1761.
Public Domain

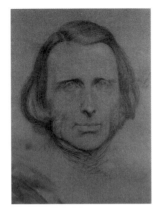

Fig. 6: Henry Doyle, *Portrait of John Ruskin*, c.1880. NGI.2383

suggested that five or six collections of drawings 'each completely illustrative of Turner's modes of study and succession of practice, might easily be prepared for the Academies of Edinburgh, Dublin and the principal English manufacturing towns.' He believed these select groups of Turner drawings would be of 'great advantage to students in the Provinces'.[17] In 1861 Ruskin presented a set of 25 of his own Turner watercolours, in a custom built wooden cabinet, to the Fitzwilliam Museum Cambridge, for the use of students (fig. 8).

Fig. 8: William and Edward Snell, Drawing Cabinet, 1861.
© The Fitzwilliam Museum, Cambridge

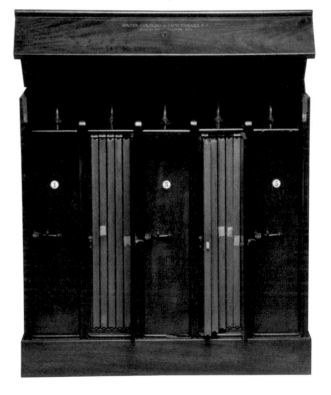

Club. The exhibition was accompanied by a scholarly catalogue co-written by Vaughan and J.E. Taylor (1850-1905), a fellow Turner enthusiast.

In caring for his collection, Vaughan was much influenced by the practice and writings of John Ruskin, Turner's great champion (fig. 6). Ruskin warned of the damage caused to watercolours by over exposure to light. Referring to the 1857 *Art Treasures* exhibition, where artworks were housed from May to October in a cast-iron and glass structure similar to the Crystal Palace, he railed that Turner's watercolours had been: 'virtually destroyed in that single summer, their rose-colours entirely destroyed and half their blues, leaving nothing safe but the brown'.[15] Although some of Vaughan's Turner drawings were framed and hung in his London home, most were stored in portfolios.[16] In his report on the Turner Bequest (1858), Ruskin

15. Cook and Wedderburn, 1903-12, pp.343-44
16. Baker, 2006, p.10
17. Ian Warrell lists all the works lent to Dublin as part of Ruskin's first three loan collections. See *Turner Studies*, vol.11, no.1, pp.36-49.

THE WORKS OF J.M.W. TURNER

Ruskin was aware of Vaughan as a collector of Turner's works. He wrote to his secretary Howell from Interlaken in Switzerland in May 1866: 'All you have done is right except sending Mr Henry Vaughan about his business. He is a great Turner man. Please write to him that he would be welcome to see everything of mine, but I would rather show them to him myself.'[18]

## The Vaughan Bequest

Although Henry Vaughan was generous with his wealth in life, it was in death that his true generosity became apparent.[19] Vaughan died unmarried on 26 November 1899, leaving most of his monetary wealth to medical charities and hospitals. He divided his superb art collection among public museums. The British Museum received 555 items including 57 old master drawings and over 100 *Liber Studiorum* proofs and related drawings. His collection of medieval stained glass and carvings, plus six Turner watercolours and oil studies by Constable, went to the Science and Art Museum (now the V&A). University College London received his Constable mezzotints, the remainder of his *Liber Studiorum* prints and a number of etchings by Rembrandt. In addition, they received a colourful watercolour by Turner of Lake Lucerne. Vaughan divided the bulk of his collection of Turner watercolours between the National Gallery London (23), the National Gallery of Scotland (38) and the National Gallery of Ireland (31).

Dublin's 31 drawings arrived in September 1900 in a custom-made wooden cabinet (fig. 9). Dating from the early 1790s to the 1840s and in excellent condition, they were accompanied by a valuation list drawn up by

Sotheby's in March 1900 at Vaughan's solicitors' behest (fig. 10).[20] The cleverly designed oak cabinet (which has no maker's label) contains 31 frames which slide in and out on wooden runners. Each frame once had a little leather handle on the side, but only one survives intact. There is a pull down stand on the left side of the cabinet where a framed watercolour can be placed for easy viewing. A small number of frames retain the remnants of labels inscribed with Vaughan's name and address. This indicates that Vaughan lent some of these framed works to exhibitions. Frame number six has a barely legible inscription in ink on the back 'Cox D Haystack and Haycock Vaughan' which seems to suggest that this cabinet once held works by other artists.[21]

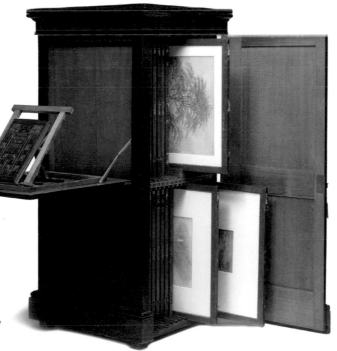

Fig. 9: Vaughan Bequest Cabinet. National Gallery of Ireland

18. Ruskin, 1903-12 vol. 37, p.688
19. Vaughan gave Constable's famous oil painting *The Haywain*, 1821, to the National Gallery, London anonymously in 1886 and five important drawings by Michelangelo to the British Museum in 1887.
20. National Gallery of Ireland Archives: Dossier file NGI.2401, sheet 3.
21. Until recently (2011) the drawings remained in the cabinet in the Prints and Drawings Study Room. They have been removed for conservation reasons.

Fig. 10: Valuation list of Vaughan Bequest watercolours, 1900
National Gallery of Ireland Library and Archives, dossier file NGI.2401

*List of drawings by J.M.W. Turner R.A. Bequeathed to the National Gallery, Ireland, by the late Henry Vaughan*

| | | |
|---|---|---|
| 1. | Vessels at sea – Blacklead Pencil – Signed with initials "JMWT." | £10 |
| 2. | Near Netley – Water colour – | £40 |
| 3. | Campagna. " | £60 |
| 4. | Dover – very early – washed drawing. | £40 |
| 5. | Waterfall – water colour | £25 |
| 6. | Shakespeares Cliff – very early – water colour | £50 |
| 7. | Dover Harbour – " water colour | £50 |
| 8. | Canterbury (Gate of). water colour – | £150 |
| 9. | Study of Beech Trees. | £60 |
| 10. | Edinburgh, from near the Calton Hill – " | £150 |
| 11. | Hastings – very fine – water colour – | £300 |
| 12. | Coast scene – a sketch – water colour | £10 |
| 13. | The Mewstone – very fine – water colour | £250 |
| 14. | Clovelly " " | £300 |
| 15. | Folkestone – fine – water colour – | £100 |
| 16. | Italian Valley – very fine sketch – water colour. | £100 |
| 17. | Venice – San Giorgio – water colour – sketch. | £20 |
| 18. | Passau – very fine – water colour – | £200 |
| 19. | Stelvio. very fine – " | £250 |
| 20. | Bellinzona – sketch. " very good | £150 |
| 21. | Tête Noire – sketch – " a very good. | £100 |
| 22. | Lucerne – " " | £20 |
| 23. | Venice – Doges Palace – very fine – water colour. | £500 |
| 24. | Assos. very fine – " | £100 |
| 25. | Yarmouth " " | £150 |
| 26. | Venice – The Guidecca – " | £150 |

22. Ruskin stated that the 25 Turner watercolours he gave the Fitzwilliam in 1861 should be kept in the closed cabinet except when being viewed by students. National Gallery of Ireland Archives: Dossier file NGI.2401, sheet 4, letter to Walter Armstrong from M.R. James, Director of the Fitzwilliam Museum (23 January 1900) who comments that there were no 'rules' per se laid down by Ruskin.
23. Correspondence in National Gallery of Ireland Archives: Dossier file NGI.2401. Vaughan's will stated that if the Gallery did not wish to accept his bequest the works should be offered to the V&A. See page 90 for an image of this watercolour in the V&A's collection *A Valley in Switzerland*, c.1842, accession number: 981-1900.

The conditions attached to Vaughan's bequest show how much he was influenced by Ruskin and how keen he was that the works be enjoyed and studied by all. His will states that the 31 numbered watercolours were to be given to the National Gallery of Ireland on condition that they would be: 'exhibited to the public and be copied subject to the same rules and regulations as the drawings by Turner RA are subjected to at the Fitzwilliam Museum Cambridge and in addition that the drawings be exhibited to the public all at one time free of charge during the month of January in every year [...] at all other times [they are] to be kept in the cabinet provided'[22].

A resolution passed by the Governors and Guardians of the National Gallery of Ireland on 25 January 1900 stated that the Gallery 'gratefully accepted' the bequest and the collection of watercolours went on display for the first time in January 1901. It is strange that Walter Armstrong (National Gallery of Ireland Director, 1892-1914), who accepted this wonderful bequest on behalf of the Gallery, refused an additional Turner watercolour from Vaughan's collection. A delicate sketch of a Swiss valley which was marked 'to go with 16' was discovered by Vaughan's solicitors in August 1900. It had been overlooked, but the solicitors believed Vaughan intended it to go to Dublin and offered it to Armstrong. Having viewed it, he decided it was not worth taking and, as per the instructions in Vaughan's will, it went to the V&A.[23]

## Other gifts and bequests

Over its 150 year history, the National Gallery of Ireland has received gifts or bequests of works by Turner from five other benefactors apart from Vaughan. In 1872 William Smith (1808-76), a retired London print dealer and art collector, gave over 50 works to the Gallery (fig. 11). Director Henry Doyle had asked private collectors to lend works to a loan exhibition of watercolours and drawings and Smith responded by making a permanent gift of his loan. The minutes of the Gallery Board Meeting of Thursday 11 December 1872 record that Mr William Smith had presented 'a series of 52 drawings illustrating the formation and progress of the British School of watercolour painting' and that he had announced his intention of 'completing the series down to the present time by further gifts from time to time'. His gift included three works by Turner but two, a view of St Alban's Abbey and a large sheet depicting Caernarvon Castle have since been re-attributed.[24] Smith was a wealthy man who had retired from the family print-selling business in 1848. He had made his fortune through acting as an intermediary between the British Museum and private collectors and helped in the early development of the British Museum's prints and drawings collection. He died suddenly on 6 September 1876. His will stated that he wished the Science and Art Museum to select whatever works they wanted from his collection while the National Gallery of Ireland could make their selection from the remaining works. The best quality works were undoubtedly chosen by the London museum. They acquired some superb works by Turner including an important large-scale early view of Tintern Abbey (V&A 1683-1871).

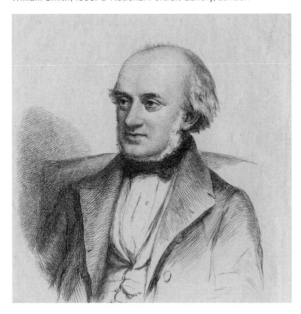

Fig. 11: William Carpenter, after Margaret Carpenter, *Portrait of William Smith*, 1858. © National Portrait Gallery, London

In early 1903, two years after the Vaughan Bequest watercolours went on display, a learned clergyman, Stopford Augustus Brooke (1832-1916) gave his set of *Liber Studiorum* prints to the National Gallery of Ireland. Brooke had published two books on Turner's *Liber Studiorum* print series in 1885 and 1889 and knew Armstrong having assisted him when the latter was preparing his 1902 book on Turner. Stopford Brooke was brought up in Kingstown (now Dún Laoghaire), a well-to-do suburb south of Dublin, where his father was curate of the Mariners' Church. His love for the art of J.M.W. Turner can be traced to his first visit to London in 1857, aged 24. Following a visit to the National Gallery he wrote excitedly to his brother William: 'Saw the Turners! This man Turner haunts me. What cloud effects! What seas! What rocks and trees! It is the very core of Nature's heart.'[25]

24. NGI.2283 *St Alban's Abbey* (now believed to be a copy of an original Turner watercolour in the V&A), NGI.2284 *Harlech Castle* (see catalogue entry page 48) and NGI.2285 *Caernarvon Castle* (now doubtfully attributed to George Petrie).
25. Jacks, L.P. *The Life and Letters of Stopford Brooke*, New York, 1917, p.81

Fig. 12: George Charles Beresford, *Portrait of Stopford Augustus Brooke*, 1905. © National Portrait Gallery, London

Fig. 13: F.W. Burton, *Portrait of Annie Callwell*, c.1845 (detail). NGI.6030

In later life his London house, No. 1 Manchester Square, was filled with art. He was a gregarious and sociable man who enjoyed showing visitors his collection (fig. 12). He refers to his gift to the National Gallery of Ireland in a letter to his mother on her ninety-first birthday.

*I have just sent off the last batch of the Liber Studiorum to Ireland. My poor walls look very denuded and unhappy. I hope they will look well in Dublin and that they will interest the Irish. It will give me great pleasure to see them all some-day and renew my friendship with them. And I like that far better than leaving them in my will and never seeing them in their new place.*[26]

The prints are of excellent quality, mainly first states, with sharp, richly etched lines. The versos of most of the sheets are inscribed with brief notes. For example the frontispiece is inscribed 'first state very rare'. On 3 March 1903, *The Irish Times* reported on the opening of the new Milltown wing at the National Gallery of Ireland, praising the 'transformation' of the galleries. It commented that the pictures were now hung 'on the line' rather than 'skied' and noted that a whole gallery had been reserved for works by Turner, with oils on one wall and the 71 newly acquired *Liber Studiorum* prints hung on the other walls.

In 1904, the Gallery received another work by Turner, this time a delicate watercolour sketch of *Wellmich on the Rhine*, 1841 (NGI.3776). It was part of a group of 37 watercolours by British and Irish artists bequeathed by an elderly Dublin lady, Miss Annie Callwell, who lived at 25 Herbert Place on the south side of the city. The 1901 census records that Miss Callwell, aged 71, lived alone with a cook and house-maid in a large thirteen-roomed

26. Ibid, p.22

house with stables and a coach house. Her father Robert (d.1871) had been a partner in a firm of general merchants, Callwell and Horner, located at 10 Bachelors Walk. He was also a director of the Bank of Ireland and a member of the Royal Dublin Society (RDS) and the Royal Irish Academy (RIA). He collected art and in the 1840s commissioned Frederic William Burton (1816-1900) to paint a portrait of his young daughter Annie (fig. 13). The Callwell bequest included five landscapes by George Petrie (a fellow RIA member), fourteen by F.W. Burton, including the famous *Aran Fisherman's Drowned Child*, 1841, and works by the English watercolourists David Cox, Thomas Miles Richardson Junior and James Duffield Harding. The artworks are fairly typical of those favoured by educated middle-class collectors. They were bequeathed subject to the condition that: 'none of the pictures be at any time removed out of the city of Dublin'.[27]

In 1953 it was announced in the press that Mr Roland L'Estrange Bryce had died leaving Garinish Island with its house and gardens to the Irish State (fig. 14). The island had been bought in 1910 by Roland's father John Annan Bryce (1843-1923), a wealthy merchant and politician from Belfast. One hundred men were employed over a three year period to lay out the Italianate gardens designed by Harold Peto. Bryce Senior was a dedicated art collector. On his death the bulk of his collection, which included Italian paintings, English furniture and Persian rugs, was dispersed in a huge sale of over 2000 lots. A small number of artworks were retained in the house on Garinish Island including watercolours by Turner.

Roland Bryce's will stated that the contents of the house should be kept intact 'subject to the right of the Taoiseach to transfer, if he so desires, the three watercolours by J.M.W. Turner to some public picture gallery in Ireland'. Despite the fact that three watercolours are mentioned in the will, when an inventory of the house was undertaken by staff of the Office of Public Works (OPW, the body responsible for heritage sites) in March 1954, only two watercolours by Turner were found. A memorandum (in the OPW files) that accompanies the inventory states: 'There was a question of three "Turner" water colours but I could only find one definitely in the Study, and another water colour in Mr McKenzie's Room which Mrs Tudor-Craig [Roland Bryce's sister] stated was a second "Turner". She stated that there were only two and that the third must have been an error'. The issue of the missing third Turner was not re-visited or referred to in any further correspondence. Another OPW memorandum, dated August 1954, refers to a discussion with Thomas McGreevey (National Gallery of Ireland Director,

Fig. 14: Harold Peto, *The Casita*, 'The Garden Teahouse', Garinish Island, 1911. © Photographic Archive, National Monuments Service, Government of Ireland

**27.** National Gallery of Ireland Archives Minute Book, vol. 1896-1905, pp.209-210, 24 March 1904

Fig. 15: Clementine, Lady Beit, 1995. Photo © National Gallery of Ireland. Photographer: Roy Hewson

**28.** OPW Heritage Properties (Box File) Bryce House 8, Collected Reports and Information Garinish Island.
**29.** National Library of Ireland, Sir Hugh Lane Additional Papers, MS 27775.
**30.** National Gallery of Ireland Archives, Directors' files, Beit dedication file 2001 (restrictions apply), letter dated 21 October.

1950-63) about the Turner watercolours: 'From my description he said that the Gallery had lots of similar sketches and that he did not think they would be interested. I gathered that very few are thought worth putting on exhibition.'[28] This exchange highlights the lack of knowledge and interest in the Turner pictures at the time and tallies with the fact that, from around 1907 until the late 1940s, the annual exhibition of Turner watercolours was not referred to at all in the press.

Bryce House was damp and unsuitable for housing works on paper. However the Turner watercolours remained hanging on the walls and are not mentioned again in the OPW files until the early 1970s. In 1971 Dr. Michael Wynne, (Curator of Irish Art and Assistant Director of the National Gallery of Ireland 1965-97) visited the house and recommended that the Turner watercolours be moved to the Gallery as they were suffering damage from damp and over-exposure to light. They were moved to the National Gallery of Ireland in July 1972 and formally transferred in August of that year. Both watercolours, a view of the Austrian town of Bregenz (NGI.7511) and a drawing of the Rialto Bridge, Venice (NGI.7512) are quite faded and bear evidence of mould damage.

Almost 50 years after Roland Bryce bequeathed his Turner watercolours to the Irish nation, Clementine, Lady Beit (fig. 15) gave a vignette by Turner entitled *The Castellated Rhine*, c.1832, to the Gallery. This most recent acquisition happily filled a gap in the collection. Until the acquisition of this work, the Gallery did not hold an example of the vignettes which Turner produced to illustrate the poetry and prose of Byron and other writers in the 1830s. Clementine Mitford (1915-2005) was born into the British aristocracy. Her grandfather

John Mitford was the first Lord Redesdale, while the celebrated Mitford sisters were her first-cousins. In 1939 she married Sir Alfred Beit (1903-94), a Conservative MP, son of Sir Otto Beit (1865-1930), a wealthy art collector of German origin. A series of letters (1910-19) in the National Library of Ireland, shows that Sir Hugh Lane (1875-1915) advised Otto Beit in his collecting.[29] Alfred inherited this great art collection on his father's death in 1930.

In 1945 Alfred and Clementine Beit moved to South Africa. In 1952, unhappy with the apartheid regime, they bought Russborough House, a grand neo-classical mansion in County Wicklow. They developed a strong relationship with the National Gallery of Ireland and loaned many pictures to the collection. In 1987 they donated seventeen priceless paintings including works by Goya, Vermeer and Metsu to the Gallery. In October 2001 a wing of the Gallery was re-named the Beit Wing in recognition of their generosity. In a letter to Raymond Keaveney (National Gallery of Ireland Director, 1988-2012), thanking him for the honour, Clementine Beit wrote:

*I only wish that Alfred could have been there, but I am sure he is aware of it. Having had the good fortune to have been surrounded by beautiful pictures and objects, he had been brought up by his father to study them, care for them and above all to share them.*

Lady Beit died in 2005, just short of her ninetieth birthday.[30]

### Public reception and display
There was a flurry of excitement in the Dublin newspapers in January 1900 when it became clear that a London art-collector and philanthropist had left

31 watercolours by Turner to the National Gallery of Ireland. On 4 January 1900, the *Daily Express* called it 'a bequest of great value.' Giving its monetary value as £3,000, the article asserted that 'its artistic value in a country in which first-rate works of art are comparatively rare is beyond estimation'. *The Irish Times* described the bequest as a handsome gift and noted: 'we are so unaccustomed to being remembered in such matters, and to receive so few public presents of such magnitude, that we can scarcely realise our claim to recognition in the disposal of the national benefaction'.[31] There is a sense that Ireland was viewed as a backwater in artistic terms. Newspapers outside Dublin did not regard the bequest as newsworthy and there is no mention of Turner or the Vaughan Bequest in any of the leading provincial papers of the time.[32]

When the watercolours went on display for the first time in January 1901, there was another brief flurry of media interest. The mainly short articles which appeared in the Dublin papers all repeated the same information. They pointed out the particular conditions of Vaughan's bequest, the pristine condition of the works and the fact that the collection was representative of the works produced over the whole of Turner's career. These articles also noted that when not on display, they were stored in 'a dark cabinet specially constructed for their reception'.[33]

The watercolours were hung on screens in the main gallery of the Upper Dargan Wing (the Grand Gallery), by chains attached to the brass rings that form an integral part of each frame. The Turner watercolours replaced a retrospective exhibition of works by the recently deceased Sir F.W. Burton, and, like that exhibition, attracted many visitors.[34] *The Irish Times*

reported on how the works were displayed. They appear to have been hung in reverse chronological order, with the early drawings 'hung on the screen furthest from the entrance' while the later more colourful works were given precedence: the view of the Doge's Palace, Venice occupied 'the central place on the first screen'.[35]

There was little interest in the annual display in subsequent years. Between 1907 and 1942, the exhibition was not covered by the press. On 26 January 1943, a brief article in *The Irish Times* mentioned the 'tradition' of the annual Turner exhibition. It noted that they were on view in the Irish Room and encouraged art lovers to visit, especially given that 'a couple of hundred of the major masterpieces are away for the period of the Emergency.'[36] On 6 January, 1969 the regular fine arts column in *The Irish Times* noted: 'this January they have been well hung in the new wing of the National Gallery, three flights up ...' which seems to indicate that they had been somewhat neglected in previous years.[37]

The publication of Barbara Dawson's comprehensive catalogue of the Turner watercolours in 1988 appears to have re-ignited media attention. Today the annual Turner exhibition is greeted on the first day of January with something of a fanfare, with many illustrated articles appearing in daily newspapers and weekend supplements. The collection is now displayed in the purpose-built Print Gallery, which opened in 1996. The fact that the National Gallery of Ireland continues to adhere to the conditions laid down by Henry Vaughan over 100 years ago, insisting that the collection is only shown during the month of January, consolidates the appeal of the collection, and lends a sense of drama and mystery to the annual exhibition of Turner's great watercolours.

**31.** *The Irish Times*, 6 January 1900.
**32.** Sincere thanks to Małgorzata Dynak, Gallery Intern, who spent many hours trawling through microfilm copies of newspapers in the National Library including: *Irish Independent, Dublin Daily Express, Freeman's Journal, Evening Mail, Evening Herald, The Cork Examiner, Belfast Telegraph, Kilkenny Moderator, Kerry News, Limerick Chronicle, Sligo Independent, Waterford News* and *New Ross Standard*.
**33.** *Irish Times*, 2 January 1901.
**34.** National Gallery of Ireland Minute Book (1896- ) 21 February 1901, pp.123-124. There is no mention of the annual Turner display in the National Gallery of Ireland Board Minutes for 1902, 1903, 1904 or 1905.
**35.** *Irish Times*, 2 January 1901.
**36.** World War II was referred to as 'the Emergency' in Ireland.
**37.** There are no old photographs of the Vaughan Bequest watercolours in the National Gallery of Ireland's Archives. The earliest surviving photographs date to the 1990s.

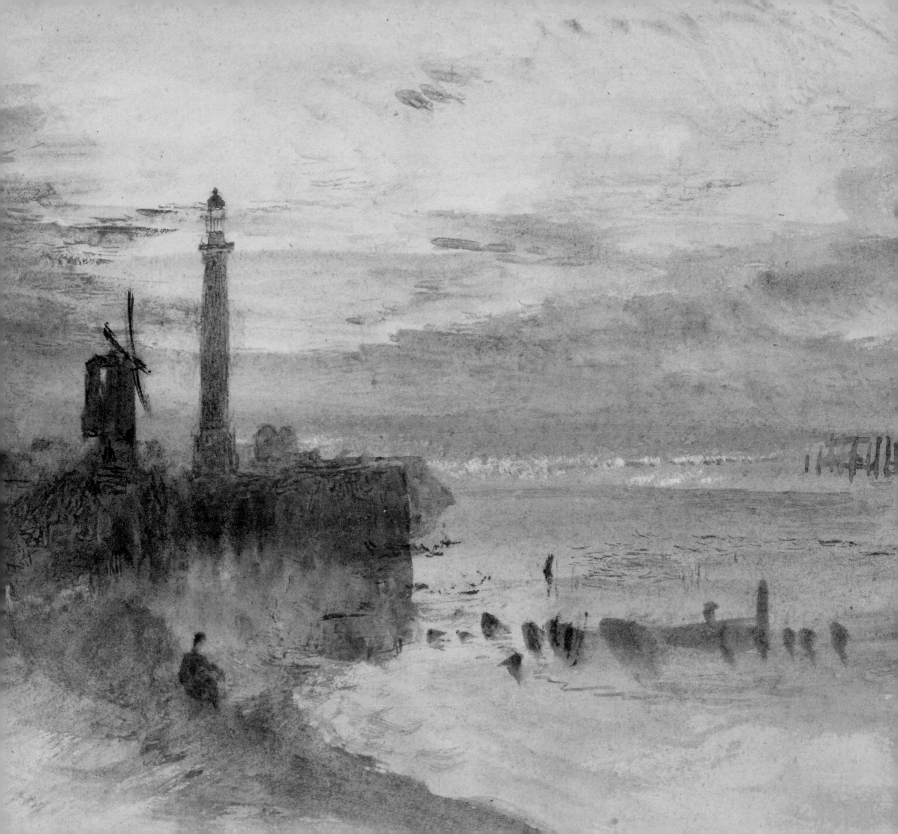

# TURNER:
# TRAVELLER EXTRAORDINAIRE

NIAMH MAC NALLY

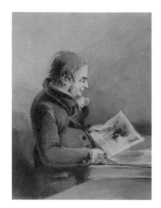

Fig. 16: J.T. Smith (1766-1835) *Portrait of JMW Turner in the Print Room in the British Museum,* 1830-32. © The Trustees of the British Museum

Travel was an essential part of Turner's life (fig. 16). It supplied vital material for his topographical work and stimulated his imagination. With few exceptions, the majority of Turner's paintings and watercolours depict places he observed directly. His belief that first-hand experience was vital to his profession as a landscape painter drove him to become an adventurous and energetic traveller. Turner was by no means a mere topographer who recorded identifiable views for tourists. In addition to depicting the natural features of a place, he explored its inherent social and cultural aspects. He revered the beauty of nature but also sought to capture in his paintings and drawings the widespread dynamic developments and innovations brought about by the Industrial Revolution.

Throughout his life, travel provided Turner with a constant recharging of mind and spirit. From his early years in the 1790s through to his gradual decline in the late 1840s, Turner considered the onset of summer and the closing of the Royal Academy exhibition as his sign to depart on sketching tours. He would return to London by early October and from then until the following April he would work tirelessly in his studio, utilising the wealth of data in his innumerable sketchbooks to produce ambitious oils and watercolours for exhibition and on commission. He rarely altered this annual routine.

Due to the outbreak of war between Britain and France in 1793, Turner's earliest tours were restricted to Britain. He explored his native land enthusiastically in the 1790s, when tours of picturesque scenery were in vogue, visiting many parts of England, Scotland and Wales. The early watercolours in the Gallery's collection illustrate only a fraction of his extensive tours throughout

Britain. They include views of Harlech Castle in Wales, Canterbury in Kent and Norbury Park in Surrey. The collection also includes some detailed early line and wash drawings of Dover Harbour, which reveal Turner's deep interest in shipping. The works resulting from the artist's first Scottish tour of 1801 indicate his move away from topographical exactitude and precision toward greater expression in colour, and a more personal, Romantic approach to landscape (fig. 17). Through his use of richer, denser pigments he moved beyond the traditional notion of watercolours as 'tinted drawings'.

As Turner established his foothold in the art world and as his fame grew so too did the demand of publishers for his work. For the duration of the Napoleonic Wars, Turner focused on his homeland of Britain and produced watercolours for series like W.B. Cooke's *Picturesque Views on the Southern Coast of England* (1814-26), and Charles Heath's *Picturesque Views in England and Wales* (1827-38). These print series considerably increased the

Fig. 17: *Edinburgh from below Arthur's Seat*, 1801, NGI.2410

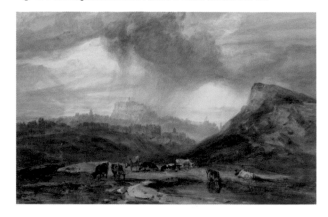

public audience for his art and earned him a sizeable income. The dramatic seascape *A Ship against the Mew Stone, at the entrance to Plymouth Sound*, c.1814, and the jewel-like watercolour *Clovelly Bay, North Devon*, c.1822, are two highly detailed small scale designs provided by Turner for the series *Picturesque Views on the Southern Coast of England*. In these lyrical yet closely observed scenes, Turner explores the interrelationship of land and sea to great effect. The Gallery is fortunate that Vaughan bequeathed these richly coloured drawings to the collection. Turner continued to travel extensively in Britain all his life, for both work and pleasure, creating coastal views like the tumultuous storm scene *A Shipwreck off Hastings*, c.1825, and the tranquil *Fishing Boats on Folkestone Beach, Kent*, c.1826-27 (fig. 18). In this 'picturesque' view of Folkestone on the Kent coast Turner makes reference to the industry of the area and its inhabitants, with local people shown gathering fish and mending nets along the shoreline.

Turner shrewdly cultivated a series of loyal patrons across Britain, some of whom later became his friends. His patrons included noblemen and wealthy landowners such as Lord Egremont (1751-1837) in Sussex, Sir John Fleming Leicester (1762-1827) in Cheshire, Walter Fawkes (1769-1825) in Yorkshire, and H.A.J. Munro of Novar (1797 1864) in the Scottish Highlands. It was the usual practice for artists to sojourn in the houses of gentlemen, making drawings for commissioned views. Turner often took up residence in their grand houses and occasionally was even given his own studio space. The numerous sparkling studies on blue paper that Turner made at Lord Egremont's house and estate, Petworth Park, are testament to his sense of ease in these surroundings. Vaughan bequeathed one fine colour study to the Gallery that shows Petworth's expansive parkland at sunset (fig. 19).

Fig. 18: *Fishing Boats on Folkestone Beach, Kent*, c.1826-27, NGI.2415

Fig. 19: *Sunset over Petworth Park, Sussex*, c.1828, NGI.2430

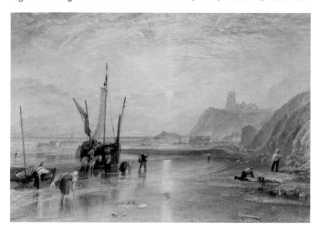

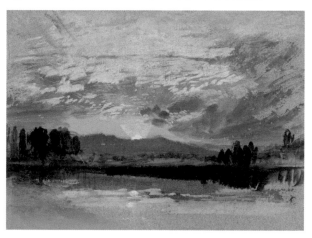

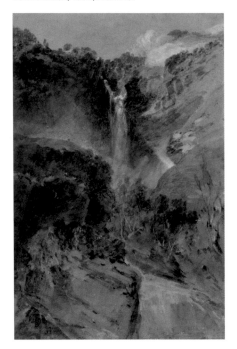

Fig. 20: *The Great Fall of the Reichenbach*, 1802, NGI.2431

## Early Continental Tours

Aged twenty-seven and newly elected as a member of the Royal Academy, Turner, along with scores of other British artists and writers, took advantage of the brief Peace of Amiens in 1802 to make a tour of the Continent that considerably enriched his art. Turner's itinerary in 1802 has been covered in detail by David Hill[1], and can be followed in published maps. Turner's trip across the Channel in 1802 was funded by a consortium of noble patrons. He was in Paris twice that year, around the 18-26 of July and again for approximately three weeks from late September into October, on his return from the alpine tour that had been his main priority. During this longer stay he voraciously studied and sketched in the Louvre, which was abundant with paintings and other treasures seized by Napoleon on his military campaigns. Unlike many of his fellow artists, who limited themselves to the sights and galleries of Paris, Turner seized the opportunity on this trip to travel as far south as Aosta, in the Italian Alps, while the political situation allowed.[2] The Alps offered Turner a logical extension to his interest in the mountains of his homeland. Switzerland's high mountains could arouse awe and terror in the viewer. The notion of the sublime landscape was perfectly summed up for Turner in Edmund Burke's (1729-97) influential essay *A Philosophical Enquiry into the Origin of our Ideas of the Sublime and the Beautiful* (1757). Turner first became acquainted with Switzerland through the watercolours of John Robert Cozens (1752-97), which he copied while studying at Dr Monro's 'Academy' between 1794 and 1796.

Turner's first European tour of 1802 lasted almost three months and yielded some 500 drawings in nine sketchbooks. Farington recounted Turner's first impressions of Switzerland in his diary entry for October 1802:

*The trees in Switzerland are bad for a painter, – fragments and precipices very romantic, and strikingly grand. The Country on the whole surpasses Wales; and Scotland too. He underwent much fatigue from walking, and often experienced bad living & lodgings. The weather was very fine. He saw very fine Thunder Storms among the Mountains.*[3]

The compositional study *The Great Fall of the Reichenbach*, 1802, (fig. 20) on a grey prepared paper, originally formed part of Turner's 'St Gotthard and Mont blanc' sketchbook (TB LXXV). It is a preliminary work for

**1.** Hill, 1992
**2.** Hamilton, 2009, p.22
**3.** Farington, vol.V, p.1890

a finished watercolour in the Cecil Higgins Collection, Bedford. Turner skilfully captured the dizzying height of the waterfall and the deep chasm into which it cascades. He developed a myriad of unconventional techniques, not only to capture the impact of a dramatic scene, but also to elevate watercolour to the status of oil painting. He blended the pigment with his fingers and scratched out highlights with his long thumbnail, cultivated for the purpose.

Turner tended to exaggerate aspects of the Swiss landscape for his own ends. Ruskin defended Turner's approach in *Modern Painters* (1843), writing: 'the aim of the great inventive landscape painter must be to give the far higher and deeper truth of mental vision, rather than that of the physical facts.'[4] With the resumption of hostilities in 1803, Turner's movements abroad were once again restricted and he did not cross the Channel again until 1817, two years after Napoleon's defeat at Waterloo.

Of all Turner's destinations, Italy was not only the most distant but the most significant in artistic terms. The popularity of Lord Byron's fourth canto of *Childe Harold's Pilgrimage* published in 1818, which contained passages on Italy certainly fostered Turner's interest in the country. He had provided eighteen watercolours for Hakewill's *Picturesque Tour of Italy*, engraved and published in 1819-20, based on the architect's topographical drawings. This collaboration may have encouraged Turner to visit Italy himself.

Turner's first journey to Rome in 1819 was the longest of his entire career, lasting a full six months.[5] His route to the ancient city took him through France and into Italy via the Mont Cenis Pass. If Switzerland was the embodiment of the sublime landscape, Italy was

the country in which Turner discovered the roots of the classical landscape tradition, epitomized by the paintings of Claude Lorrain (c.1604-82). Throughout his career Turner strove to emulate and even surpass the work of Claude Lorrain. He eagerly scribbled 'the first bit of Claude' in his 'Ancona to Rome' sketchbook of 1819 (TB CLXXVII; D40928).[6] The impact of the bright Italian light on Turner's work was expressed through his heightened use of golden tones. He delighted in depicting large crowd scenes, such as festivals and thronged market-places.

In 1819, Turner reached Venice on Wednesday the first of September, and stayed until the eighth or ninth of that month. The city was part of the Austrian Empire and in economic decline, with many of its splendid buildings in decay. It was not a regular stop off for British artists touring Italy, who instead focused on the celebrated antiquities and monuments of Rome and its surroundings.[7] On leaving Venice, Turner spent another fifteen or so weeks in Italy, mainly in Rome, before travelling back to London in 1820. The watercolour

4. Ruskin, 1903-12, vol.6, p.35
5. For a detailed account of Turner's Italian visits see: Dr. Cecilia Powell, *Turner in the South: Rome, Naples, Florence*, 1987 and James Hamilton's *Turner and Italy*, 2009.
6. Wilton, 1982, p.25
7. Joll, Butlin and Herrmann, 2001, p.359

*The Grand Canal from below the Rialto Bridge*, 1820, (fig. 21) features an unusual viewpoint underneath the Rialto Bridge. Turner sketched the Rialto from a multitude of different angles and viewpoints, evident in the close-up double page view of the bridge in the 'Milan to Venice' sketchbook of 1819 (TB CLXXV 79 & 78 a; D40890), from the Turner Bequest in Tate Britain.

### Preparation for Travel

Turner prepared diligently for his Continental travels and often followed the routes and itineraries recommended in the practical guidebooks of the day, such as John Murray's *Handbooks for Travellers* or Mariana Starke's *Information and Directions for Travellers on the Continent*.[8] Travelling economically and lightly, he carried both small hard-back sketchbooks for brief memoranda and larger soft-covered sketchbooks that could easily be rolled and pocketed. For convenience, he even made a small portable paint-box by sticking cakes of colour into the leather covers of an almanac (fig. 22). Yet for all these diligent preparations, he was regarded as somewhat haphazard, mislaying knapsacks while on the move. In 1829, Clara Wells (1787-1883), the eldest daughter of watercolourist William Frederick Wells (1762-1836), one of Turner's closest friends, described him as 'the most careless personage of my acquaintance', who habitually lost, 'more than half his own baggage in every tour he makes.'[9]

Turner is not known to have kept a diary of his travels and unfortunately the sketchbooks and drawings themselves are rarely dated. These drawings document his tours and provide a sense of his remarkable curiosity for new places and panoramas. Turner did not need to embark on new tours in order to fulfil a topographical commission, but would regularly consult his wealth of sketches, often made years, or even decades earlier. In comparison with the habits of other artists of the period the frequency with which Turner visited Europe was exceptional. By 1845, when his travels were curtailed by old age, he had completed a staggering twenty major European tours or shorter trips. His destinations included Switzerland, Germany, Italy, France and Holland, in addition to Belgium, Luxembourg, Denmark and Austria. He was essentially interested in the European countries traditionally associated with the Grand Tour and showed little interest in exploring countries like Spain, the Holy Land and Asia Minor.

Fig. 22: Turner's travelling watercolour case (private collection). Photo © Tate

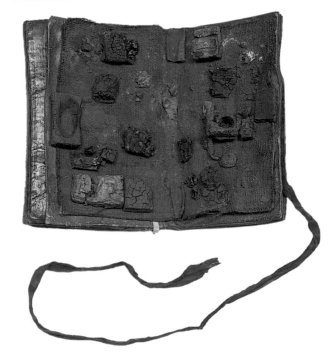

8. Powell in Selborne, 2008, p.24
9. Gage, 1980, p.132, fn.9

In 1799, having failed to agree terms, Turner declined Lord Elgin's invitation to accompany him as a topographical draughtsman on an expedition to Athens. This was a lost opportunity for Turner as he never visited Greece.

### Sketching and Sketchbooks

Many of Turner's sketchbooks are identified by the names of the principal places he visited on a specific tour, jotted on either the outside or the inside of the front covers, for example 'Milan to Venice'.[10] In preparation for tours he often copied practical notes from guidebooks into his sketchbooks regarding distances, equipment and recommended views. He noted down words or phrases in French, German, and Italian to aid his progress, but he never mastered anything more than the rudiments of conversation in a foreign language.[11] His sketchbooks also contain random bits of information: remedies for digestive complaints, addresses and contacts, financial calculations, as well as lines of poetry.[12] He often bought sketchbooks abroad although the majority of the watercolours in the Gallery's collection are done on Whatman paper, a high quality English wove paper preferred by Turner for its smooth surface.

As a habitual sketcher, Turner's sketchbooks became an invaluable tool, enabling him to record his journeys on-the-spot.[13] They provide a fascinating glimpse into the initial creative spark that occurred while he worked in the field. Back in his London studio, the sketchbooks, acting as the repository of his experiences, were the means by which he could recall his travels, allowing him to summon up a specific location, viewpoint or weather effect easily. Turner's private sketches and studies were for him both preparatory exercises and mementos of treasured views. It is unlikely that he would have visualized them on public display or for sale.

The bulk of the material contained in Turner's sketchbooks, of which almost 300 survive, comprises pencil drawings. This was his preferred means of establishing a view, as it was the quickest method of working in the open air. The journalist Cyrus Redding, who witnessed Turner making pencil sketches in Devon in 1813, described his technique as 'a kind of shorthand … slender graphic memoranda… writing rather than drawing….'[14] Through such cursory jottings he captured the essence of his subject that was later adapted and worked up in his studio. Ruskin observed Turner's avoidance of colour sketching:

*before the deliberate processes necessary to secure the true colours could be got through, the effect would have changed twenty times over. He therefore almost always wrote the colours down in words and laid in the effect at home.*[15]

Over the years, Turner honed his powers of observation and developed the ability to rapidly transcribe the general forms of the landscape while on the move. Around 1843, William Lake Price (1810-91), on board a steamer on Lake Como, spotted Turner scribbling in a minuscule sketchbook, swiftly recording the shoreline and mountain's ever-changing features as they passed. When travelling, Turner employed a hard-back, pocket-sized sketchbook, filling it with rapid, schematic pencil sketches, working either across both pages or subdividing each page into separate areas for a sequence of different thumbnail images. When based in a certain place for an extended period Turner tended

**10.** Joll, Butlin and Herrmann, 2001, p.298
**11.** Wilton, 1982, p.14
**12.** Powell in Selborne, 2008, p.29
**13.** See Nicola Moorby's essay 'An Italian Treasury: Turner's sketchbooks' in: Hamilton, 2009, pp.111-117
**14.** Joll, Butlin, & Herrmann, 2001, p.205
**15.** Ibid.

Fig. 23: *A First-Rate Taking in Stores*, 1818
Trustees, Cecil Higgins Art Gallery, Bedford, England

to use larger sketchbooks, which allowed him greater scope to explore natural phenomena and inspired a renewed interest in colour.

Turner was highly prolific. He was not only an obsessive sketcher with a powerful memory, but a fast and industrious worker. He feverishly worked on batches of watercolours in his London studio, dunking them in water and applying colour while the paper was wet. While visiting Farnley Hall near Leeds, Turner had 'cords spread across the room as in that of a washer woman, and paper tinted with pink and blue and yellow hanging on them to dry'.[16] Also at Farnley, Turner was observed by Francis Hawkesworth Fawkes (1797-1871), his patron's son, in the process of creating the famous watercolour *A First-Rate Taking in Stores* in 1818 (fig. 23):

> *he began by pouring wet paint till it was saturated, he tore, he scratched, he scrubbed at it in a kind of frenzy and the whole thing was chaos – but gradually and as if by magic the lovely ship, with all its exquisite minutiae, came into being and by luncheon time the drawing was taken down in triumph.*[17]

These accounts indicate the sense of urgency, purpose, drive and confidence with which Turner approached not only his art, but his travels and life in general. He was an artist prepared to try out any method or any newly-invented material, and if the result pleased him he would return to it again and again.

**The Trials of Travel in Turner's Day**
Turner revelled in the risks and challenges presented by travel, undertaking many arduous journeys throughout his life. He endured, depicted, and even relished the often foul weather he encountered *en route*. He described some of the inconveniences associated with travel in letters, declaring: 'Weather miserably wet; I shall be web-footed like a drake' (Yorkshire, 1816).[18] As a traveller Turner displayed great stamina, often scaling treacherous Alpine paths in order to capture a view. Even as an elderly man, his insatiable appetite for travel, often in difficult terrain, was not easily quenched.

Fig. 24: *Snowstorm, Mont Cenis*, 1820
Birmingham Museum and Art Gallery, Public Domain

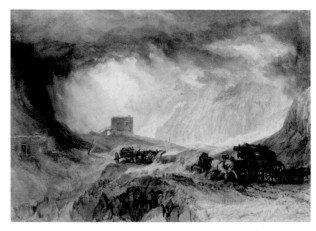

**16.** Wilton, 1979, p.104
**17.** Ibid.
**18.** Gage, 1980, p.67

THE WORKS OF J.M.W. TURNER

In his paintings and drawings he recorded some of the hazardous incidents and dangers that travellers were exposed to. The watercolour *Snowstorm, Mont Cenis*, 1820, (fig. 24) records the perilous coaching accident he experienced on the return journey from his first Italian expedition. Turner's experiences of severe weather conditions on the sea and in the mountains, lend a personal resonance to the theme of man's struggle against the elements, explored in many of his artworks. He went to great lengths to achieve a sense of 'being there', and as an intrepid sailor he claimed to have been strapped to the mast of a ship during a storm at sea, depicted in *Snow-Storm – Steam-Boat off a Harbour's Mouth* (RA, 1842). This story fits with Cecilia Powell's description of the artist, who, she notes 'outwardly resembled a weather-beaten sea-captain.'[19] Turner made hasty sketches of varying weather combinations and phenomena as they occurred, but when it came to depicting a place in a painting he selected whatever meteorological effect he thought appropriate to his subject. In a sketchbook of 1808, he noted one of the greatest difficulties in painting, 'to produce wavy air, as some call the wind... to give that wind he must give the cause as well as the effect.'[20] The weather he was exposed to on his travels lingered in his memory, and was vividly recalled in both his art and prose years later.

Turner experienced at first-hand, a revolution in transport and patterns of travel, with the arrival of the railway and steamships and the building of new roads and canals. He utilized every mode of available transport and evoked the new-found speed of the nineteenth century in paintings like *The Fighting Temeraire, tugged to her Last Berth to be broken up,* 1839 (NG524), (fig. 25) and *Rain, Steam and Speed – The Great Western Railway,* 1844 (NG538), both in the National Gallery, London. While the former marks the transition from sail to steam power, the latter celebrates Brunel's Maidenhead railway bridge, finished in 1839. Turner, the consummate traveller, harnessed this accelerated pace of travel and used steamboats to travel along the rivers of the Continent, including the Loire in 1826 and the Seine in 1829.

## Turner's later tours

Turner was known to guard his privacy and was never dependent on companionship while travelling. However, during the late summer of 1836, he journeyed through France and Italy to Turin on a sketching trip with his friend and patron Munro of Novar, who shared his devotion to art and travel. They stopped in numerous places en route before travelling through the mountainous Val d'Aosta. Turner's first biographer, the journalist Walter Thornbury (1828-76), recorded Munro's memories of the trip:

Fig. 25: *The Fighting Temeraire*
© The National Gallery London, Turner Bequest, 1856

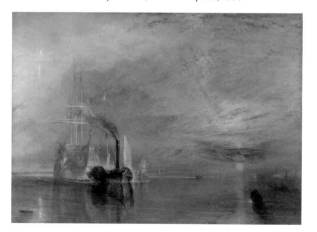

**19.** See Cecilia's Powell's in-depth essay on Turner's travels entitled 'Poetry in Motion' in: Selborne, 2008, pp.13-30
**20.** Joll, Butlin and Herrmann, 2001, p.309

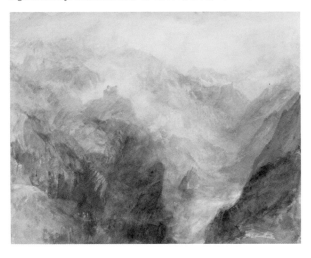

*His first inquiry in the morning when they started
to sketch was always, 'Have you got the sponge?'
It was with the sponge that Turner obtained many of
his misty and aerial effects. Turner never rhapsodised
about scenery, but at some distance from his
companion – generally much higher applied himself
to work in a silent, concentrated frame of mind.
The superior elevation he required for the purpose of
obtaining greater distance and more of a bird's-eye
view. The sketches were rapid, and with the aid of his
tremendous memory were completed subsequently at
leisure, at the inn...his touch was so sure and decisive,
and his materials were of the rudest – brushes worn
away to single hairs, and now thrice as valuable as
they were when new. If you bore with his way,
Mr Munro said, it was easy to get on very pleasantly
with him.*[21]

The Val d'Aosta region challenged Turner to develop
new processes for the expression of immense scale
and expansive atmosphere. Seen from a dizzying height,
the mountain peaks in the watercolour *Montjovet
from below St Vincent, looking down the Val d'Aosta
towards Berriaz,* 1836, (fig. 26) seem to dissolve into
a veiled mist of rich colour.

Turner travelled through the small Duchy of
Luxembourg, located between the valleys of the
Meuse and the Mosel, in 1824 and 1839. His second
tour resulted in a very intensive study of the city.
The juxtaposition of man-made bastions with deep
ravines and gorges inspired him to create over twenty
coloured drawings on blue paper on his return
home. In the Dublin watercolour *Le Pont du Château,
Luxembourg,* 1839, Turner achieves an awe-inspiring

view of the city's monumental features on a minute
scale, through a skilful combination of rich colour and
atmospheric effects.

Venice, the magical island city of the Adriatic,
was a major source of inspiration for Turner during
the last three decades of his life.[22] Although he paid
only three fairly short visits to Venice, in 1819, 1833 and
1840, it captured his imagination in a profound way.
He found more material there for his lifelong study of light
and colour than anywhere else. He was acutely aware
that Venice was highly sought after as a subject among
collectors. Turner's last Venetian trip of 1840 proved to
be extraordinarily productive, even though he stayed just
fourteen days. Starting at Rotterdam, he travelled up the
Rhine, passing through Heidelberg and Bregenz, on the
eastern shore of Lake Constance (the Bodensee), then
onward to Innsbruck and the Alps, where he crossed at
the Brenner Pass. He then made the arduous journey
through the Dolomites to Belluno before finally reaching
Venice on 20 August.[23] In the expressive watercolour,

**21.** Hamilton, 2009, p.122
**22.** See Warrell, 2003, pp.14-29,
for an in-depth account of Turner's
three visits to the city.
**23.** See Warrell, 2003, p.31, for a
detailed map of Turner's travels to
and from Venice in 1819, 1833 and
1840.

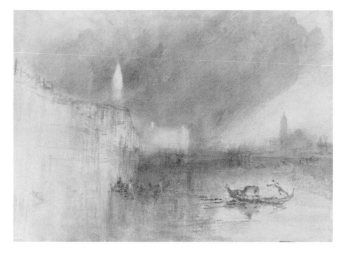

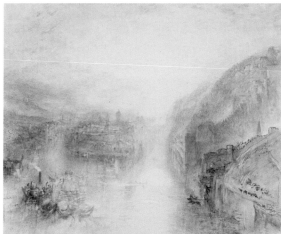

*The Doge's Palace and Piazzetta, Venice*, c.1840, Turner weaves an intricate pattern of rich colour to evoke a glowing radiance which envelopes solid form, making the city appear as insubstantial as light.

All of Turner's Venetian sojourns occurred around the same time of year, hence, as James Hamilton points out:

> the only Venice he ever saw was late summer Venice with its long days, its storms, mists, and its particular light. Snowbound or flooded winter Venice, or sparkling, light blue, spring Venice, were outside his experience.[24]

In the Dublin watercolour *Storm at the Mouth of the Grand Canal, Venice*, c.1840, (fig. 27) Turner captures the atmospheric phenomena and light effects particular to a late afternoon squall. In an economical but effective manner, merging broad washes of blue and mauve, he creates the impression of a dense rain-cloud moving over the city, drenching it in parts. Using a pen dipped in watercolour, he delineates the canal buildings with a few vertical strokes, a characteristic feature of his late style. During his visit of 1840, Turner also produced a number of nocturnal scenes and works depicting lightning storms. These works resonate with a sense of mystery and theatricality, while others are tinged with a sense of poignancy.

Returning from Venice, Turner took a steamship across the Gulf of Trieste, which saved him the burden of crossing the Alps by road. He continued north to Vienna and then up the Danube past Passau to Regensburg (then known as Ratisbon). Passau, the 'pearl of the Danube' is spectacularly located at the confluence of the Danube, Inn and Ilz rivers. Inspired by its unique location, Turner painted it from a variety of different perspectives. In the luminous watercolour of Passau (fig. 28), the prominent steam ferry, in the left foreground, displays Turner's enthusiasm for the technological advances of the day.

24. Hamilton, 2009, p.95

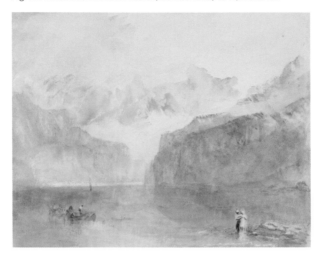

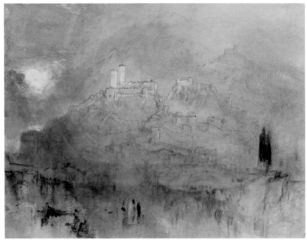

Switzerland and the Alps became increasingly important destinations for Turner as he grew older. The onset of old age prohibited him from making the longer journey to Italy after 1840, but he continued to return to central Switzerland while his health allowed. The drama inherent in Turner's early Swiss works gives way to scenes of peace and tranquillity in his late watercolours of the 1840s. Topographical detail is abandoned in favour of atmosphere. The evanescent, misty evocations of one of Turner's favourite haunts Lake Lucerne are typical of his late style (fig. 29).

In the early 1840s, Turner devised a new method for selling his watercolours. At the beginning of 1842, he set out to make a group of finished watercolours based on colour sketches he had produced during his tour of Switzerland in the autumn of the previous year.[25] His agent Thomas Griffith (1795–1868), armed with these sketches or 'sample' studies, was set the task of seeking commissions from a small, select group of prospective patrons, who would order larger, finished watercolours

to be worked up from their chosen sketches.[26] He produced ten finished watercolours, which were purchased by loyal collectors like Ruskin, Munro of Novar and Elhanan Bicknell (1788-1861), the whaling entrepreneur, while the tenth subject, 'Constance', was made for Thomas Griffith as payment for his role as Turner's agent.[27] In the years that followed, Turner intended to produce further sets of Swiss watercolours according to a similar procedure. The recently discovered inscription, 'Bellinzona/No.5', on the verso of the Dublin drawing of Bellinzona, (fig. 30) provides further proof that this is one of the colour sketches produced by Turner in 1842-43, and shown to potential clients. By the 1840s, Turner's artworks, which had become increasingly abstract, were widely misunderstood and derided by critics for their lack of finish. Conversely Ruskin championed Turner's work, and viewed his late Swiss watercolours as the epitome of his artistic achievement.

**25.** See Warrell, 1995, pp.10-20, for an in-depth account of Turner's Swiss tours.
**26.** See Warrell, 1995, pp.149-155, for the definitive modern account and detailed listing of the origins of the late watercolours.
**27.** Warrell, 1995, p.13

Fig. 31: *Bregenz, above the Bodensee, Austria*, c.1840, NGI.7511

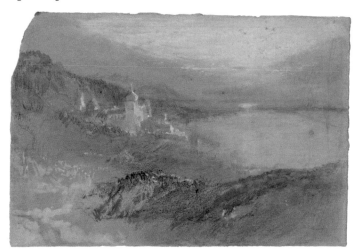

## Master of Light and Atmosphere

Today Turner's works are perceived as exemplary, in terms of their virtuoso technical effects, expressive qualities and wide-ranging subject matter. Turner continually exposed himself to different natural phenomena, and this in turn led to his unmatched ability to depict light and atmosphere. The dynamic sense of movement inherent in his landscapes is due, in no small part, to his personal experiences as a traveller. His enthusiasm for the scientific advances and technological achievements of the day is also visible in many of his artworks.

The National Gallery of Ireland's exquisite collection of 36 Turner watercolours offers an insight into the artist's extensive and far reaching travels. The works show how his approach and style became increasingly experimental and spontaneous with the passage of time. The detailed topographical drawings of his early years are replaced by evocative watercolours made up of diaphanous layers of wash. By the end of his life,

Turner was freely and effortlessly combining chalks, pencil, watercolour and gouache in a single study. The view of Bregenz, (fig. 31) displays Turner's innovative use of media and mark-making. As Turner's career progressed, the actual locations he depicted, became somewhat secondary to the revolutionary techniques and atmospheric effects he deployed.

Turner's eagerness to succeed as an artist was given expression through his determined focus, dedication and professionalism. His travels were inextricably linked to his livelihood, providing him with a continued source of income by way of commissions and requests. Even as an infirm, elderly man his lifelong passion for travel did not wane. Mr W. Bartlett, a doctor who attended Turner towards the end of his life at his house in Chelsea, recounted: 'he offered should he recover to take me on the continent and shew me all the places he had visited.'[28]

28. Finberg, 1961, p.437

# Turner's Travels in Britain and Europe

Some of the places which appear in the National Gallery
of Ireland collection and other significant locations

**Atlantic Ocean**

London•
**Dover**•
**Ostend**•
Calais•
•**Brussels**
•**Cologne**
•**Coblenz**
**Luxembourg**
•Paris
*Rhine*
*Loire*
*Seine*
Regensburg
*Danube*
•**Passau**
•Schaffhausen
•Zurich
Innsbruck
•**Lucerne**
Lausanne•
•St Gotthard
Geneva•
Lyon•
•Mont Blanc
*Rhône*
**Aosta**•
**Venice**•
•**Rome**

**Mediterranean Sea**

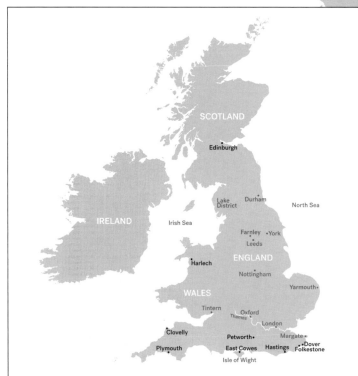

SCOTLAND

•Edinburgh

Durham•
Lake District
North Sea

IRELAND

Irish Sea

Farnley •York
Leeds

•Harlech
ENGLAND
Nottingham

Yarmouth•

WALES

Tintern
Oxford
*Thames*
London

•Clovelly
Petworth•
Margate•
•Dover
Plymouth•
East Cowes•
Hastings•
Folkestone•
Isle of Wight

*Maps are not to scale*

# J.M.W. TURNER:
# CATALOGUE OF WORKS

The 'W' numbers used in the text refer to Andrew Wilton's identification numbers in his comprehensive catalogue, *J.M.W. Turner, his Art and Life*, New York, 1979. Wilton was the first Curator of the Clore Gallery for the Turner Collection at Tate Britain, London, and is the author of many books on the artist, including the standard catalogue of the watercolours. Unless specified otherwise, all references to Dublin refer to the National Gallery of Ireland.

Catalogue entries by Anne Hodge, *Curator of Prints and Drawings* (AH) and Niamh MacNally, *Curator of the Prints and Drawings Study Room* (NMN)

# The West Gate, Canterbury, Kent, c.1794

INSCRIBED (lower left):
Turner; and (lower right, faintly): Turner
Graphite and watercolour with white highlights on ivory wove paper, 27.9 x 20.2cm
PROVENANCE: Henry Vaughan Bequest, 1900
NGI.2408

The latter decades of the eighteenth century saw a growing interest in the natural and built heritage of Britain. This interest was related to the fact that travel beyond Britain's shores to France was impossible due to the ongoing war between the two countries. Collectors were interested in gathering images of their own land. The market for drawings and prints of historical abbeys, castles, mountains and picturesque valleys was growing and skilled topographical artists were in great demand. The young Turner soon became financially independent, thanks to the income he earned from prints made after his topographical watercolours. In 1793, he was commissioned to produce a drawing of Rochester in Kent for the newly established *Copper-Plate Magazine*. In total, Turner produced fifteen topographical drawings for the short-lived magazine which folded in 1798. Other notable artists who contributed to the publication included Paul Sandby (1730/1-1809), Thomas Malton (1748-1804), Thomas Hearne (1744-1817) and Turner's exact contemporary Thomas Girtin (1775-1802).

Following his 1793 tour of Kent, Turner made quite a number of highly finished watercolours of notable buildings in Canterbury. He would have worked up these drawings back in his studio weeks or even months later from pencil sketches made 'on the spot'. In this view (W 56) the great towers of the West Gate dominate but there are many small details which add human interest and humour. The lean-to built against the city wall features a laconic man slouched against the door frame. The whetstone standing by the bank may indicate his trade as a knife-sharpener. The carriage driving across the bridge, a characteristic feature of the work of Thomas Malton, whose drawing classes Turner attended, gives a sense of realism and liveliness

to the scene. Another 1794 view of Tonbridge Castle, Kent also features a small carriage driving over a bridge (Fitzwilliam Museum, PD 1588).

Turner's treatment of the river is typical of how he rendered reflections and slow-moving water at this date. *Old Welsh Bridge, Shrewsbury*, 1794 (Whitworth Gallery, D.1892.90; W 82), (fig. 32) is similar in terms of technique and signature. Turner used horizontal lines of watercolour wash along with vertical wavy lines and scraping out to deftly create a realistic impression of ripples and reflections on the surface of the river. This sheet is signed 'Turner' with a distinctive Greek 'ε', which may have been his way of distinguishing himself from his contemporaries. The sheet is in fact signed in two places, lower left, under the large rock to the left of the fence, and lower right. The second signature is much abraded, barely visible to the naked eye. Henry Vaughan exhibited this watercolour at the Royal Academy in 1887 and it was valued at £150 in 1900.[1]    AH

Fig. 32: J.M.W. Turner, *Old Welsh Bridge, Shrewsbury*, 1794 Whitworth Art Gallery, The University of Manchester. Photo © Whitworth Art Gallery / Bridgeman Images

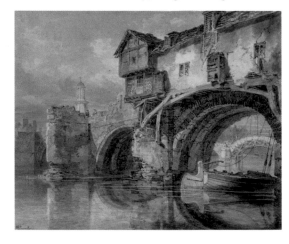

1. This is the value included in the listing which accompanied the watercolours when they arrived at the National Gallery of Ireland in 1900. It was drawn up by Sotheby's at Vaughan's solicitors' request.

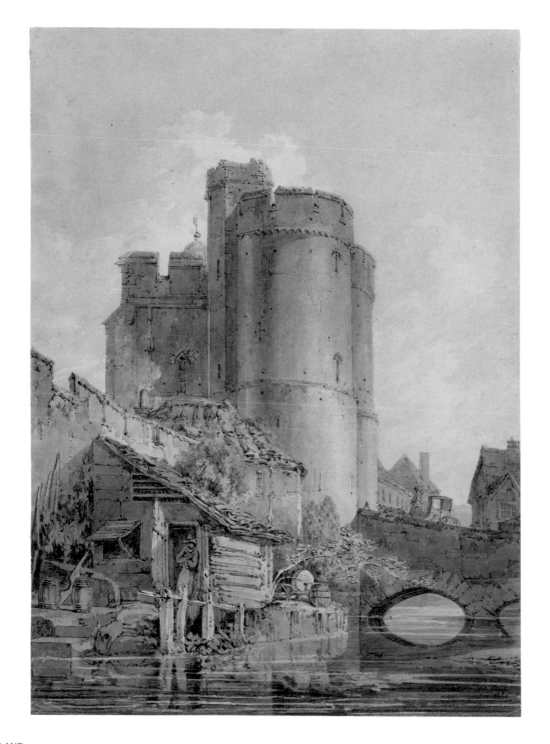

# The Waterfront of Old Dover Harbour, 1794/97

Graphite with blue and grey washes on off-white wove paper, 22.5 x 28.4cm
WATERMARK: J WHATMAN
PROVENANCE: Henry Vaughan Bequest, 1900
NGI.2407

Dover offered Turner the opportunity to observe the minutiae of maritime life at first hand. He first visited the town in 1792. Ten years later in 1802, he boarded a ferry from Dover bound for Calais on the first of his many Continental trips.

The attribution of these so-called 'Monro School' drawings, characterized by fine broken graphite lines and a limited palette of blue and grey washes, has been the subject of much debate. In his article *The 'Monro School' Question: Some Answers*, Andrew Wilton stated that the 'smaller Dover drawings,[...] which figure in many public collections and frequently appear on the market, are difficult to assess on account of the seemingly endless permutations of artists and copyists involved in their production.'[1] Wilton argued that some of these Dover views were jointly drawn by Girtin and Turner and that others may have been drawn by John Henderson (1764-1843) or Edward Dayes (1763-1804). Still other sheets appeared to him to have been both drawn and coloured by Girtin. The only sheets Wilton attributed with confidence to Turner were a group of outline drawings in the Turner Bequest (TB XVI). In his entry for 12 November 1798, inveterate diarist Joseph Farington (1747-1821) noted:

*Turner and Girtin told us they had been employed by Dr Monro 3 years to draw at his house. They went at six and staid till Ten. Girtin drew in outlines and Turner washed in the effects. They were chiefly employed in copying the outlines of unfinished drawings of Cozens &c. of which copies they made finished drawings.*[2]

Dr Thomas Monro (1759-1833) was a physician who specialised in disorders of the mind. He was also a notable art collector with a particular interest in drawings. On Friday 14 April, 1797, Farington dined with Monro. He reported: 'Dr Monro's house is full of drawings. In the dining parlour 90 drawings framed and glazed are hung up, and in the Drawing Room 120 – they consist of drawings of Hearne, Barrett, Smith, Laporte, Turner, Wheatley and Girtin.'[3] From the early 1790s Monro invited young artists like Girtin and Turner to copy from drawings in his collection. They were paid for their work and the set-up was sometimes referred to as 'Monro's Academy'.

Pieter van der Merwe of the National Maritime Museum, Greenwich, notes that the vessel in the background of this drawing appears to be: 'a gaff-rigged Dutch boyer or something very similar. The side netting on stanchions is unusual and may suggest she is a passenger vessel, rigged for safety.' He goes on to suggest that the very long pennant may indicate that the boat is plying for trade, since it is far longer than those flown for normal wind-vane use.[4] Cormac Lowth of the National Maritime Museum, Dublin, suggested this vessel is a small Dutch boat of a type known as a 'Tjalk', mostly used for carrying cargo, although also used for fishing.[5] Lowth also noted that the vessel on the left, being overhauled, could be a small frigate or corvette due to the gun-port located near the stern. 'Monro School' drawings, like this tranquil monochrome sheet, clearly illustrate Turner's keen interest in all aspects of shipping and sea-faring. NMN

1. Wilton, *Turner Studies*, Winter 1984, vol.4, no.2, p.21
2. Farington, vol.3, p.822
3. Ibid, p.1090
4. Email correspondence, 6 May 2011
5. Email correspondence, 17 May 2012

# Old Dover Harbour, Kent, 1794/97

INSCRIBED (upper edge, centre) in graphite: *The Shakspear Cliff*
Graphite with blue and grey washes on off-white wove paper, 23.2 x 34.4cm
PROVENANCE: Henry Vaughan Bequest, 1900
NGI.2404

Turner's use of colour washes in blue and grey evoke the delicate nuances of atmospheric light in this coastal scene. Pieter van der Merwe has pointed out the uncanny similarity between this sheet and another image of Dover Harbour in a private collection.[1] That drawing came to light in 2000 (not in Wilton).[2]

Van der Merwe has also noted that the boats depicted in the foreground of the Dublin drawing are probably, given the shape of the hull, Brighton hogboats or 'hoggies', so-called despite the fact that they were to be found all along the south coast. There are two, possibly three, small boats on the distant beach that may be 'Deal luggers'. These boats, usually used for fishing, sometimes functioned as pilot boats. Given their small size they could dash out quickly to compete for trade.[3] The mast of the foreground boat is shown lowered into a 'crutch', which gave a vessel greater stability. This was generally associated with the use of drift nets in the herring industry, along with other forms of static fishing, such as 'stow netting'.[4] The seamen's jackets, hung out scarecrow-fashion on the mizzen masts of the boats to dry, are a typical Turnerian motif.[5] *Dover, Harbour and Shipping*, c.1792-93,[6] (Fitzwilliam Museum, Cambridge, PD. 18-1953), displays sails or clothing hanging out to dry across a mast that has been lowered into a crutch (fig. 33). In that image the sailor on the deck appears to be pulling on a rope to hoist a jacket up on the mast.    NMN

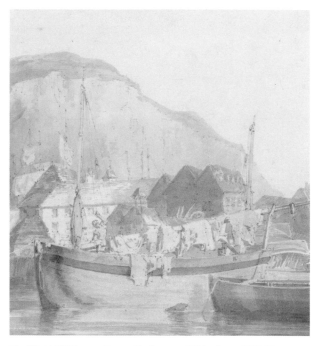

Fig. 33: J.M.W. Turner, *Dover, Harbour and Shipping*, c.1792-93 © The Fitzwilliam Museum, Cambridge

**1.** Pieter van der Merwe, 'Unexpected Encounters at Dover', in *Turner Society News*, no. 110, Dec. 2008, p.18.
**2.** Sold to a private collector at Sotheby's in June 2008 as *Boats in the Harbour at Dover*, c.1793.
**3.** Email correspondence, 6 May 2011
**4.** Cormac Lowth of the National Maritime Museum, Dublin, in e-mail correspondence, 15 May 2012
**5.** Lowth has suggested that Turner has represented fishermen's oilskin smocks, made from canvas sailcloth and coated with linseed oil.
**6.** This watercolour can be connected with a group of drawings and watercolours of Dover scenes attributed to Turner in the British Museum, bequeathed by the artist John Henderson's son in 1878.

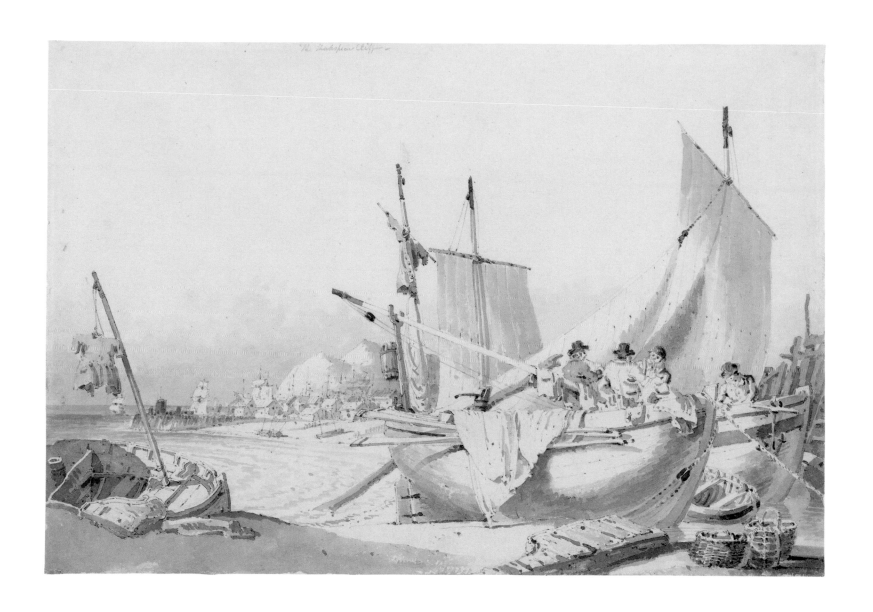

## Shakespeare's Cliff, Dover, 1794/97

Graphite with blue and grey washes on off-white wove paper, 20.6 x 27cm
PROVENANCE: Henry Vaughan Bequest, 1900
NGI.2406

The famous White Cliffs of Dover stretch out east and west from the town. The cliff face, up to 350 feet high in parts, owes its arresting appearance to its composition of white chalk accentuated by streaks of black flint. Throughout history these cliffs, located at the narrowest part of the English Channel, have acted as a symbolic defence barrier. The crossing at Dover was once the primary route to mainland Europe. Situated west of Dover, Shakespeare's Cliff is so-called due to its traditional association with a famous passage in *King Lear*. In Act IV, Scene I, Gloucester, having asked Edgar, 'Dost thou know Dover?' says, 'There is a cliff, whose high and bending head looks fearfully in the confined deep: Bring me to the very brim of it...'

This sheet features a broken and dotted line which picks out the uneven surface of the cliff face. This line is a characteristic feature of Turner's early topographical drawings. Another watercolour in blue and grey wash

*A Boat on the Shore near Shakespeare's Cliff, Dover,* 1795-96 (TB CCCLXXVIII 4) is jointly attributed to Turner and Girtin (fig. 34). In contrast to the Dublin drawing, Shakespeare's Cliff is here set further back and shown at more of an angle. A safely-grounded boat, possibly a gaff rigged 'pilot cutter', is shown in the foreground with its sails lowered, ready for de-rigging.[1]

Although there is a sense of calm in the Dublin drawing, evoked by the gentle lapping waves, there is also a sense of foreboding, as dark clouds gather on the low horizon. The motif re-appears in another topographical watercolour *Dover from Shakespeare's Cliff,* c.1825 (private collection, USA; W 483), produced by Turner for the series *Picturesque Views on the Southern Coast of England* published between 1814 and 1826.                                          NMN

Fig. 34: J.M.W. Turner, Thomas Girtin, *A Boat on the Shore near Shakespeare's Cliff, Dover,* 1795-96. D36619. Photo © Tate

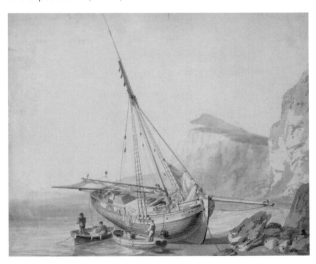

**1.** Cutters were a type of boat common to many parts of the English coast, particularly the English Channel, during the latter part of the eighteenth century onwards. They were used for a variety of purposes, including as pilot boats, revenue patrol boats, mail carriers, and as beam trawlers. In a naval context they would have been used as dispatch boats, due to their fast speed and good sea-keeping abilities.

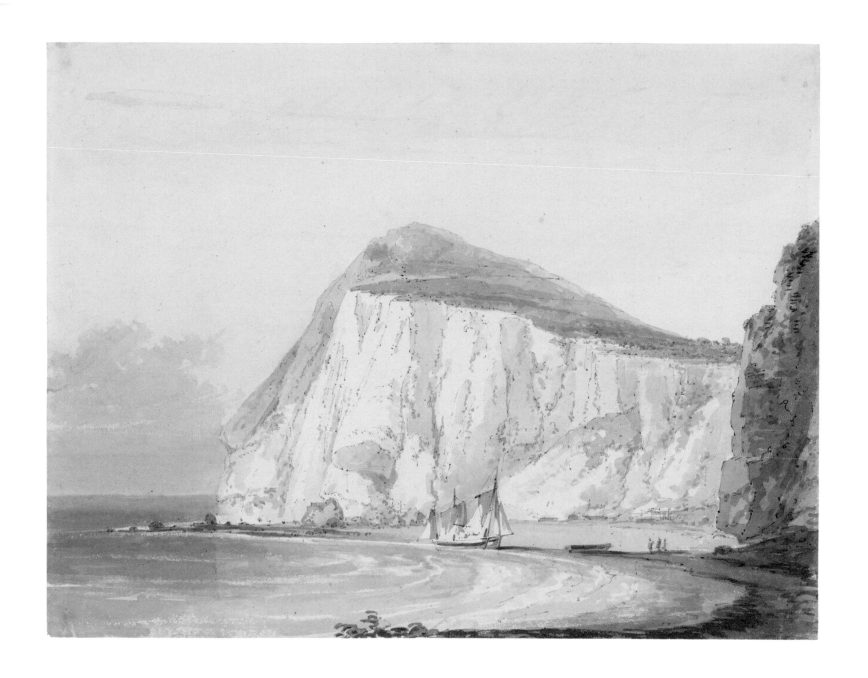

# Sluice Gate, Netley Abbey, Hampshire, 1794/97

INSCRIBED (on verso) in
graphite: Near Netley Abby
Graphite with blue and grey
washes on off-white wove
paper, 13.6 x 20.6cm
WATERMARK: WHATMAN
PROVENANCE: Henry Vaughan
Bequest, 1900
NGI.2402

In this simple image, Turner focuses his attention
on the semi-abstract form of a rustic sluice gate.
The wooden structure itself and the lights and darks
of the surrounding trees are accurately drawn.
The inclusion of a woman with a bucket walking
away from the stream indicates the importance of
this watercourse to the local people.

Despite being an everyday piece of engineering,
the sluice gate takes centre stage. Dr Gustav Waagen,
an influential German art-historian wrote of Turner in his
1854 survey of British art: 'he treats the most common
little subjects, such as a group of trees, a meadow, a
shaded stream, with such art as to impart to them the
most picturesque charm.'[1] Another similarly charming
watercolour, which shows Turner's delight in seemingly
insignificant landscape features is *Craig-y-foel,
Radnorshire*, 1792 (Ashmolean, Oxford; W 29), (fig. 35).
That drawing has as its centre-piece a rather battered,
ordinary wooden fence.

Netley Abbey was an important Cistercian foundation
before it was dissolved by Henry VIII in 1536. It then
became a private house until abandoned by its owners
at the beginning of the eighteenth century. By the time
Turner made his drawing, the abbey had long been
in ruins and its picturesque beauty had inspired
a generation of writers and artists. William Sotheby
(1757-1833) wrote a poem inspired by the ruins:
*Ode, Netley Abbey, Midnight*, while Richard Warner
(1763-1853) set his pot-boiler *Netley Abbey: a gothic
story* there.                                          AH

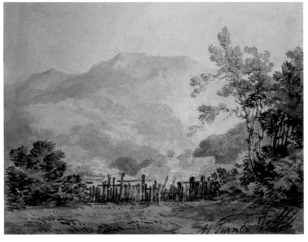

Fig. 35: J.M.W. Turner, *Craig-y-foel, Radnorshire*
WA1913.9, © Ashmolean Museum

**1.** Waagen, G.F, *Treasures of Art in
Great Britain being an account of
the chief collections of paintings and
drawings, sculpture etc.* London,
1854, pp.383-5

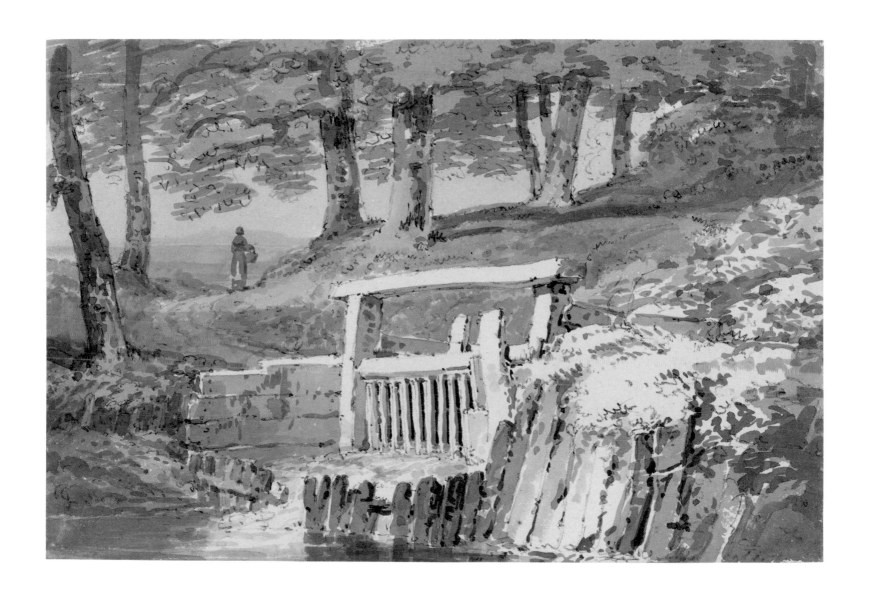

# Harlech Castle, Wales, from the South, c.1796-98

Graphite and wash with white highlights on paper, 26.3 x 36.8cm
INSCRIBED in graphite on verso: 607 Jany 47
PROVENANCE:
William Smith Gift, 1872
NGI.2284

Harlech Castle is a thirteenth-century fortress, located on a spur of rock above the town of Harlech in North Wales. It formed part of an 'iron ring' of castles built by King Edward I along the coast of Snowdonia. These fortifications were intended to prevent the region becoming a focal point of insurrection and resistance. Ironically, in 1404 Harlech was taken by the Welsh rebel leader Owain Glyn Dwr.[1] Although seen from a great distance in Turner's drawing the castle dominates the landscape.

Turner first visited Wales in 1792 and made four further tours of the country before 1799. In the 1770s, Paul Sandby brought this relatively unknown part of Britain to public attention through his series of aquatint prints of Welsh beauty spots. The exact date of this watercolour is unknown, although it was drawn from a similar vantage point as a sketch in the 'Hereford Court' sketchbook (TB XXX VII, 42a), (fig. 36). This was possibly one of the sketchbooks Turner showed Farington when the diarist visited him at the artist's house at Hand-Court, Maiden Lane in October 1798. Farington wrote: 'He shewed me two Books filled with studies from nature – several of them tinted on the Spot, which He found, He said, were the most valuable to him'. Farington goes on to list the locations contained in the sketchbook, including sketches made 'by the River to Harlech'. Turner invited Farington to choose one of the sketches, which he promised to work up or, as he said to 'make a drawing or a picture of it' as a present for the older man.[2]

This drawing, with its subtle washes and 'dot and dash' outlines, is close in style to the 'Monro School' drawings. It once formed part of the collection of William Smith (1808-1876), a London print-seller and notable collector of English watercolours. Unlike the Vaughan Bequest watercolours, this early work is quite faded. The left edge (which was protected by a mount) shows traces of a blue wash which has disappeared from the rest of the sheet. An inscription on the verso: '607 Jany 47' probably indicates the year (1847) Smith acquired the sheet. Also clearly visible on the verso are a number of fingerprints in watercolour, likely to be Turner's. In the 1870s, Smith gave over 80 watercolours by British artists to the Science and Art Museum (now the V&A) and over 100 sheets to the National Gallery of Ireland.

AH

1. Harlech Castle was declared a UNESCO World Heritage site in 1986.
2. Farington, vol.3, p.1074

Fig. 36: J.M.W. Turner, *Harlech from the South, with the Estuary of Traeth Bach in the Distance*. D01295. Photo © Tate

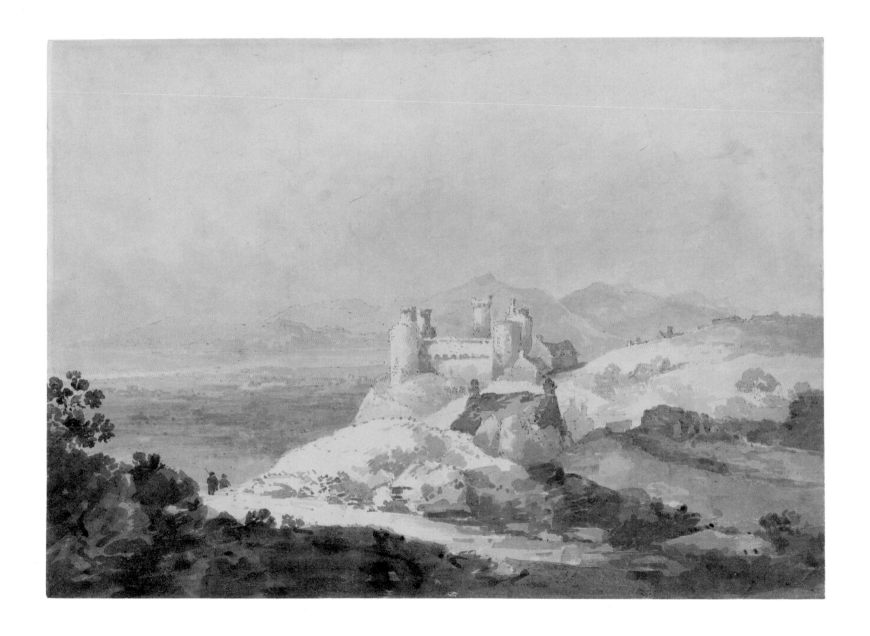

# The Fall of the River Velino, near Terni, after John Robert Cozens 1794/97

Graphite with blue and grey
washes on cream wove paper,
24 x 37.3cm
PROVENANCE: Henry Vaughan
Bequest, 1900
NGI.2405

This early drawing is one of the 'Monro School' sketches produced by Turner and other young artists in the mid 1790s. Dr Monro was the principal physician at Bethlem Royal Hospital where he treated the artist John Robert Cozens (1752-97). It is thought that in 1794, when Cozens was admitted to the hospital, Monro borrowed the older artist's Italian sketchbooks for the young men who attended his 'Academy' to copy.

Cozens travelled through Italy with his patron William Beckford in 1782 and 1783, making hundreds of landscape sketches with a limited palette of greys and pale blues. After Cozens's death in 1797, the six volumes of drawings were returned to Beckford.[1] Although the first page of volume VI records a waterfall Cozens saw on his journey northwards from Rome to Florence, inscribed 'Velino – near Terni Septr. 1783' (Whitworth, D.1975.9.12.19), a specific precedent for Turner's drawing has not been identified. Turner's drawing, although toned with monochrome washes like Cozens's earlier sheet, is landscape format. Cozens's 1783 drawing of Terni is on a vertical format sheet with inscribed colour notes.

Despite the muted colouring and stylised dot and dash type lines used to delineate the waterfall, and the fact that Turner had never been in Italy, he manages to capture the drama of this famous natural feature, showing the rushing water foaming as it hits the rocks below. The tiny figures in the foreground, created using abbreviated calligraphic lines, raise their arms in awe at the magnificent sight before them. Although the provenance of most of Henry Vaughan's Turner watercolours is unknown, it is possible that he bought his 'Monro School' sketches at the posthumous sale of Monro's art collection at Christie's in 1833, since he had inherited his father's fortune in 1828.    AH

1. In the 1970s the Cozens sketchbooks were acquired by the Whitworth Art Gallery, Manchester.

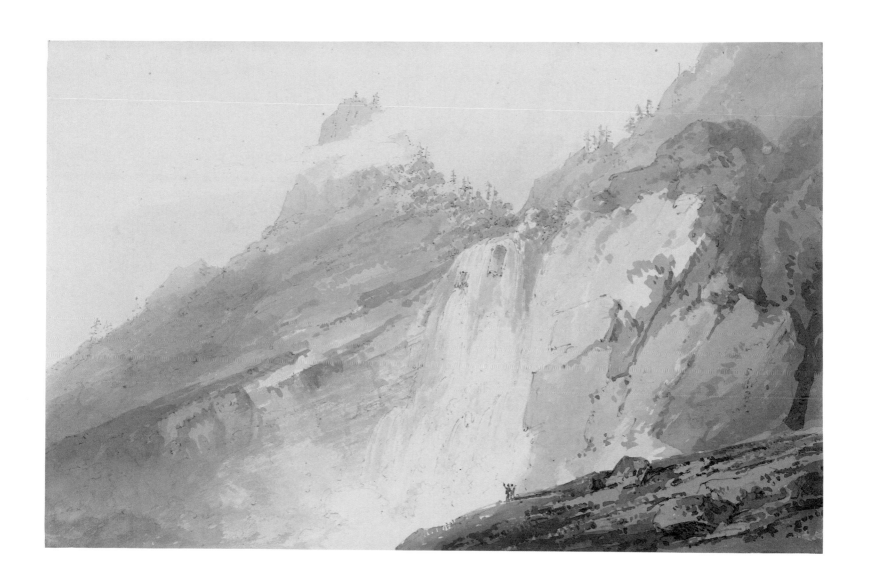

# A River in the Campagna, near Rome, 1794-97

Watercolour and graphite
on off-white wove paper,
15.5 x 25.8cm
PROVENANCE: Henry Vaughan
Bequest, 1900
NGI.2403

In the original listing, which accompanied the Vaughan Bequest watercolours when they arrived at the National Gallery of Ireland in 1900, this sheet was identified simply as: 'Campagna watercolour £60'.[1] In 1902, the Gallery's Director Walter Armstrong (1849-1918) catalogued it as: 'Rome: The Campagna c.1794, 'The Tiber and Mt Soracte".[2] Monte Soratte (Soracte is an archaic spelling) is the only notable mountain ridge in the Tiber valley. As Turner did not visit Rome until 1819 it is most likely a drawing inspired by Cozens's Italian tour of 1782-83. Volume V of the Italian sketches contains drawings of a river flowing through a plain in the countryside outside Rome some of which are inscribed 'near Mola di Gaeta'. A drawing on page 20, dated 8 December 1782, *The mount of the Garigliano* is similar to Turner's composition.

Turner's quiet watercolour features delicate under-drawing with subtle washes of green, brown and ochre which form an integral part of the image. The countryside appears parched and dry despite the presence of the river. This sheet is similar stylistically to the drawings of Thomas Hearne (1744-1817), a topographical artist whose work Dr Monro collected. A watercolour by Turner with similar colouring and treatment of the foliage *Lago Maggiore, Italy* sold at Sotheby's in 2011 (fig. 37). That sheet was based on a drawing by Cozens dated 10 October 1783.[3]

AH

Fig. 37: J.M.W. Turner, *Lago Maggiore, Italy*
**Courtesy of Sotheby's Picture Library**

**1.** This list is in the National Gallery of Ireland's Archive (dossier file NGI.2401). In August 1900 Vaughan's solicitors asked Sotheby's to draw up a valuation list. The titles of the works are probably those used by Vaughan himself.
**2.** Walter Armstong was Director of the National Gallery of Ireland from 1893 to 1914. In 1902 he published a major illustrated book on Turner's work.
**3.** Sotheby's New York, Old Master Drawings Sale, January 26, 2011, lot 650.

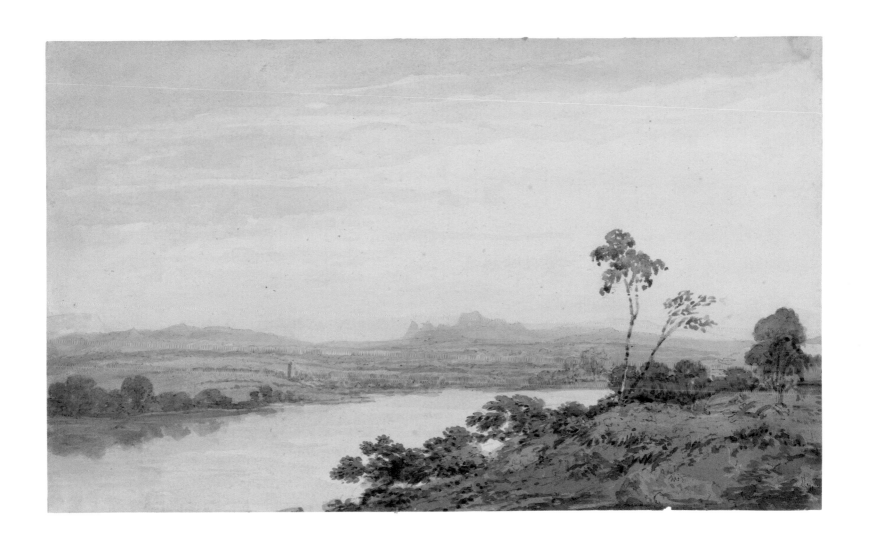

# Beech Trees at Norbury Park, Leatherhead, Surrey, c.1797

Graphite and watercolour
on a sheet lined with laid
paper, 44 x 43.1cm
INSCRIBED (on verso of mount):
Norbury Park. T. 1801.
PROVENANCE: Henry Vaughan
Bequest, 1900
NGI.2409

In 1797, Turner visited Norbury Park, which lies above
the village of Mickleham, near Leatherhead in Surrey.[1]
It was the seat of William Lock (1732-1810), amateur artist,
collector and patron of the arts. The beech woods at
Norbury Park were the chief glory of Lock's hilltop estate.
Lock had developed a taste for old master painting
while on his Grand Tour in the early 1750s. In Rome, he
acquired Claude's *Seaport with the Embarkation of St
Ursula*, 1641, a painting bought in 1824 by the National
Gallery, London (NG30), and amassed an extensive
collection of drawings and watercolours. His home at
Norbury was a meeting place for the artistic and literary
set and notable figures including Henry Fuseli (1741-1825)
and Fanny Burney (1776-1828) visited.[2]

Turner was introduced to the area by Dr Thomas
Monro, a friend and neighbour of William Lock.[3] Turner
and Girtin travelled to Fetcham, near Leatherhead,
to sketch in the neighbourhood, an invitation more
than likely extended to them during the time of their
employment at Monro's 'Academy'. Monro kept some
of their drawings, and in 1823 lent a number of Turner's
early views of Fetcham and Norbury Park to William
Cooke's exhibition.[4] Monro also retained views of nearby
Dorking, Box Hill and Mickleham, which remained in his
collection until his death.[5] These views were sold, along
with most of his collection, at Christie's in June 1833.

In 1797, Turner produced a watercolour of the fern
house at Lock's demesne entitled *Study in September
in the fern house, Mr. Lock's Park, Mickleham, Surrey*
(RA 1798; location unknown; W 239). Wilton grouped the
Dublin watercolour (W 155) together with a number of
deft studies of beech trees, which he identified as being
of Norbury Park or the surrounding neighbourhood,
dated to around 1796 (W 153-9, 161-163).[6] Turner's

continued interest in beech trees was noticed by
Farington. His diary entry for Wednesday 30 October
1799 reads: 'Turner called. Has been in Kent painting
from Beech trees. Very anxious abt. the election.'[7]

This finely executed drawing illustrates the young
artist's confidence in depicting nature within the
conventions of the period. The foliage is rendered with an
almost feathery lightness of touch, reminiscent of Thomas
Hearne's manner. Turner has emphasised the immense
scale of the trees by including two tiny figures, visible
in the distance just to the right of the main tree. The
Indianapolis Museum of Art holds a less detailed study
of the same subject, executed in graphite and grey wash,
and dated 1795-97 (fig. 38). The Yale Center for British
Art has a similarly dramatic drawing entitled *A Great
Tree*, c.1796 (B1977.14.5379; W 157). The Yale watercolour,
which is slightly darker in colour than the Dublin drawing,
comprises a single giant beech tree with two figures
seated at its base. Leeds Museums and Galleries has
another fine depiction of beech trees entitled *Norbury
Park, Surrey*, ? c.1796, in blue and grey wash.    NMN

**1.** Norbury Park surrounds a small
manor house above the village
of Mickleham, between Dorking
and Leatherhead. In 1774 Lock
had the existing house designed
by the architect Thomas Sandby,
and commissioned the Irish artist
George Barrett Senior to paint
decorations in one of the main
reception rooms.
**2.** Joll, Butlin and Herrmann, 2001,
p.176
**3.** Monro rented Fetcham Cottage
near Leatherhead between 1795 and
1805. From 1807 until his death he
resided in a 'country house' at Merry
Hill near Bushey, Hertfordshire.
**4.** Finberg, 1961, p.484, nos.278, 285
**5.** Krause, 1997, p.86
**6.** Wilton, 1979, pp.316-317
**7.** Farington, vol. IV, p.1292. The
'election' referred to by Farington
was Turner's election as an
associate of the Royal Academy.

Fig. 38: J.M.W. Turner, *Beech
Trees*, 1795-97. Indianapolis
Museum of Art, Public
Domain

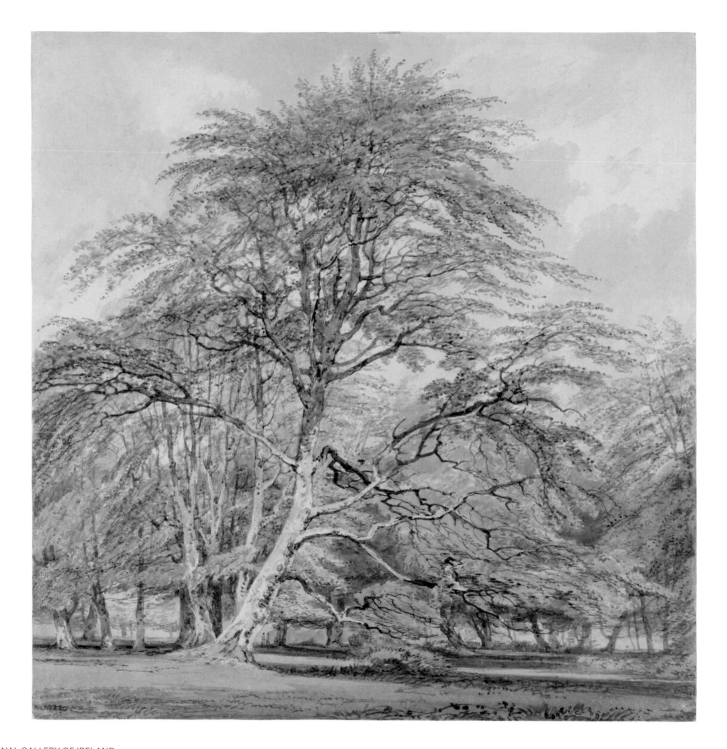

## Edinburgh from below Arthur's Seat, 1801

Watercolour, graphite and
gouache on off-white wove
paper, 25.7 x 41.1cm
WATERMARK: 1794/
J WHATMAN
PROVENANCE: Henry Vaughan
Bequest, 1900
NGI.2410

Turner made his first foray into Scotland in the summer
of 1801. Farington notes in his diary entry for 19 June
that Turner called to tell him that he intended to go to
Scotland the following day on a tour of three months.
Turner returned the following day to get directions to
'particular picturesque places' in Scotland. When he
arrived he 'complained of imbecility' and as a result
Farington advised the young artist to postpone the
journey for a day or two.[1] Turner probably took the mail
coach from London to Edinburgh, a journey that would
have taken three to four days had he not made stops
for sketching. He visited Glasgow, Loch Tay, Blair Atholl
and Stirling, making sketches as he went.

The watercolours related to this tour, particularly
sheets like this which are from the 'Smaller Fonthill'
sketchbook (TB XL VIII), show Turner breaking away
from the traditional, precise mode of topographical
drawing in favour of a freer, looser, more individual use
of watercolour. It is in these works, which include the
National Galleries of Scotland's views of Durham and
the Falls of Clyde, that the beginnings of his life-long
interest in depicting expressively the effects of weather
on the landscape can be seen. There is a real sense
of atmosphere, of 'being there' in this dark image of
Scotland's capital city (W 320). Turner has captured a
heavy summer rain shower rolling in over the city but it
is clear from the bright line of light on the horizon that
a fine spell will follow. The cattle graze calmly in the
foreground unconcerned by the inclement weather.
A print from the *Liber Studiorum* series 'Peat Bog',
published in 1808, shows how he continued to work
enthusiastically to capture the effect of rain on the
landscape (fig. 39).

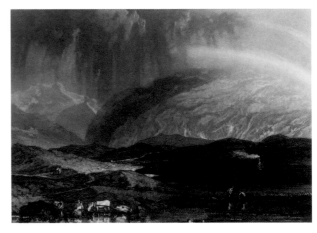

Fig. 39: George Clint after J.M.W. Turner, *Peat Bog, Scotland*, 1812.
NGI.20002

Most of the sheets in the 'Smaller Fonthill' sketchbook
are roughly drawn in pencil with occasional use of colour
washes. The sheets mentioned above, which were all
part of Henry Vaughan's collection, are exceptional as
they are more colourful and more carefully worked up.
It is likely that they left Turner's studio at an early date.[2]
This watercolour has had many titles since it appeared
in the original bequest listing of 1900 as: *Edinburgh
from near the Calton Hill.* In 1902, Armstrong revised the
title describing it as: *Edinburgh from Duddingston* while
more recently (2006) Christopher Baker referred it
to as *Edinburgh from Salisbury Crags.*[3]

AH

**1.** Farington, vol.IV, pp.1563-1564
**2.** Wilton, 1982, p.13
**3.** It has been decided to keep the
title used by Barbara Dawson in her
1988 catalogue which is also used
on the Turner Worldwide website.

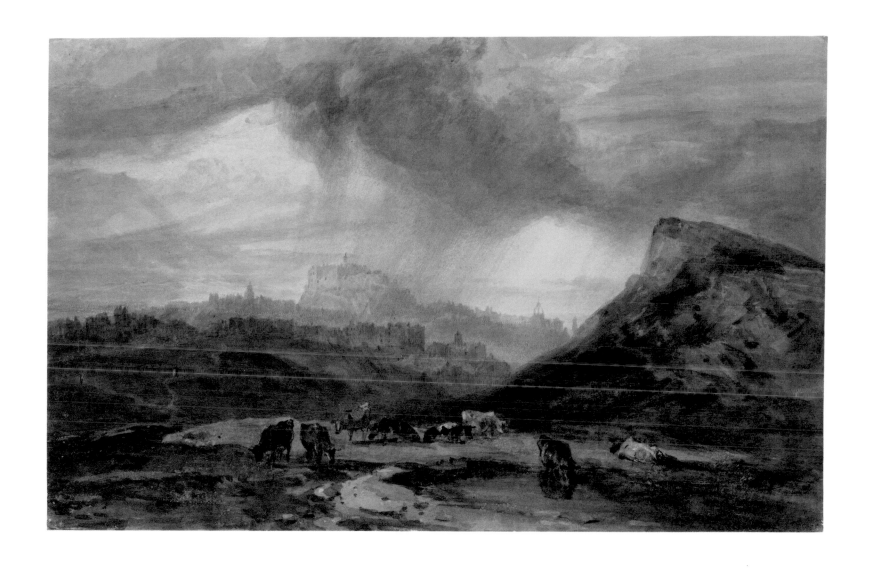

# The Great Fall of the Reichenbach, Switzerland, 1802

Watercolour and graphite over grey wash with scraping out on off-white wove paper; grey wash (on verso), 47.3 x 31.2cm
PROVENANCE: Henry Vaughan Bequest, 1900
NGI.2431

This dramatic watercolour relates to Turner's first visit to mainland Europe in 1802. He took advantage of the temporary peace between France and Britain to cross the channel at Dover and spent some three months travelling through France and Switzerland. He filled nine sketchbooks of varying sizes with pencil and wash sketches. Of these nine sketchbooks, Turner brought four with him from England and purchased a further two in Paris and three in Switzerland.[1] Turner was familiar with John Robert Cozens's drawings of the Reichenbach but the drama and majesty of the actual landscape did not fail to impress the young artist when he finally saw the famous waterfall himself. On his return from Switzerland Turner remarked: 'fragments and precipices were very romantic and strikingly grand [...] The Country as a whole surpasses Wales and Scotland too.'[2]

The National Gallery of Ireland's large, vertical format sheet (W 361) depicts the great two-hundred-foot Reichenbach waterfall in all its glory.[3] The low viewpoint and tiny figures on the outcrop to the centre left of the composition enhance and exaggerate the scale. This natural feature attracted tourists in their droves later in the century, when travel to the Continent became easier.

For his 1802 trip, Turner prepared large sheets of paper by painting on a soft grey wash. This allowed him freedom to create atmospheric images of the landscape he observed, using a limited palette of greys, greens, yellows and browns. Charles Nugent notes that Turner 'prepared this sketchbook especially for the journey [...] and dismembered it soon after his return for mounting in a presentation album for prospective patrons'.[4] The 'St Gotthard and Mont Blanc' sketchbook (TB LXXV) would appear to be the remains of this presentation album, complete with hard cover and brass clasps.

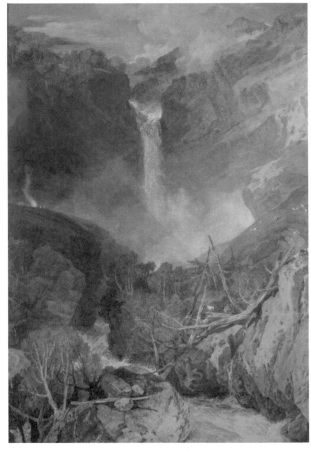

Fig. 40: J.M.W. Turner, *Great Fall of the Reichenbach*
Trustees, Cecil Higgins Art Gallery, Bedford

1. Nugent and Croal, 1996, p.50
2. Farington, vol.V, p.1890
3. The original listing of the Vaughan Bequest watercolours identifies this sheet as 'Handcek Falls, very good watercolour. Early. £300'. The Handeck Falls on the Aar River was a popular tourist spot in the later nineteenth century. It is surprising that it was listed with this title as the back of the mount is clearly inscribed in Henry Vaughan's handwriting 'No. 3 'Falls of Reichenbach' Turner. Henry Vaughan 28 Cumberland Terrace Regents Park'.
4. Nugent and Croal, 1996, p.75

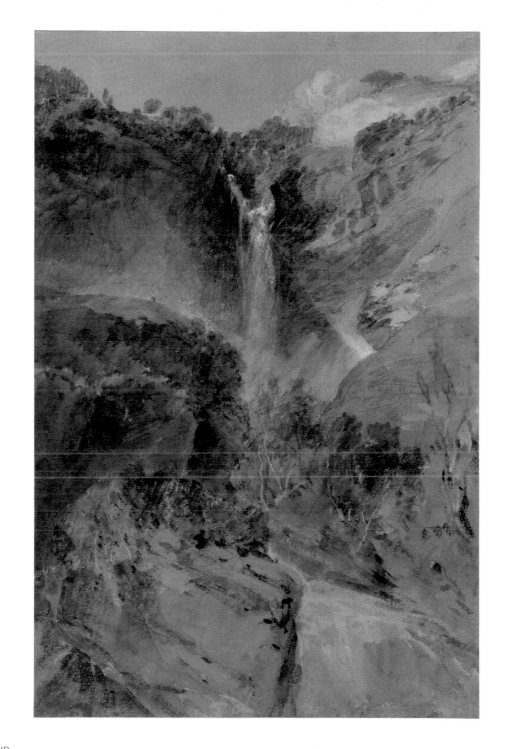

Fig. 41: J.M.W. Turner, *Fall of the Rhine at Schaffhausen*, c.1805-06
Photograph © 2022 Museum of Fine Arts, Boston. Bequest of Alice
Marian Curtis, and Special Picture Fund 13.2723

Opposite: NGI.2431 (detail)
Fig. 42: Detail showing shadowy figures on the bank from
*Fall of the Rhine at Schaffhausen*, c.1805-06

Missing leaves (like this) are now indicated by blank cream sheets. The more finished and colourful sheets were removed from the book at some point and the remaining sheets are generally rough, quickly drawn graphite sketches with occasional touches of white. Other sheets from this book (all of which measure approximately 35.5 x 23.5cm) are in the Courtauld Institute (W 362) and the Yale Center for British Art, New Haven (W 396).

Turner showed drawings from the 1802 tour to the engraver William Daniell (1769-1837), and Farington in November of that year. The latter described them in his diary entry for 22 November as 'slight on the spot, but touched up since many of them with liquid white and black chalk'.[5] This observation is very useful as it gives us an insight into Turner's working methods. He tended to make simple pencil drawings indicating the main features of a view and worked in tone and sometimes colour later, either back at his inn or on his return to his studio in London.

The hundreds of sketches he made on his first visit to the Alps inspired the finished watercolours and oils which he exhibited to great critical acclaim. Turner used the Dublin sheet as the basis for an impressive watercolour with the same title, shown at the Royal Academy in 1804 (Cecil Higgins Art Gallery, Bedford; W 367), (fig. 40). A large oil painting *The Fall of the Rhine at Schaffhausen*, (c.1805-06) was inspired by pencil sketches also made during this 1802 tour. In the huge oil painting (fig. 41), (now in the MFA Boston) the noise and power of the water which thunders over the rocks is palpable. Turner depicted two shadowy figures sitting close to the bank, their backs to the viewer, at a remove from the foreground throng. Perhaps this is how Turner saw himself, attention focused on the waterfall, unfazed by the drama all around. The presence of a young bare-legged boy close to these figures, (fig. 42) who appears to be hurriedly gathering up a portfolio of paper sheets, makes the identification of these anonymous figures as artists more probable. AH

5. Farington, vol.v, p.1936

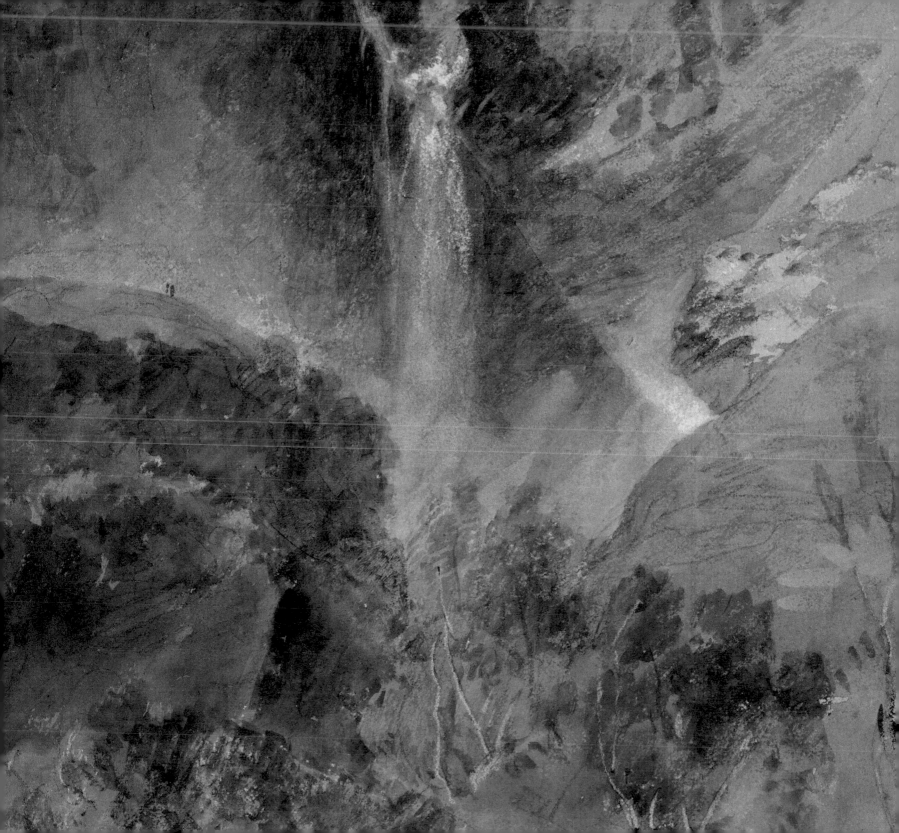

# TURNER'S *LIBER STUDIORUM* PRINT SERIES (1807-19)
## Mer de Glace – Valley of Chamouni – Savoy, 1812

Engraving and mezzotint in
brown ink on wove paper,
29.4 x 42cm; (plate dimensions
21.9 x 29.2cm)
NGI.20007

Turner's *Liber Studiorum* or 'drawing book' was an
ambitious print project begun when he was in his
early thirties. In undertaking this print series, he was
inspired by the seventeenth century painter Claude
Lorrain's *Liber Veritatis*, a book of drawings recording
all his paintings, created to prevent piracy. Turner's
'Liber' comprised a series of engravings after his own
landscape compositions. Turner himself etched the
main image in mezzotint while additional engraving was
added by professional engravers such as Charles Turner
(1774-1857). The significance of the series stems from
the fact that it illustrates Turner's hopes and ambitions
for landscape painting. His aim was to elevate landscape
art to the level of history painting. The print series was
hugely admired by collectors, particularly from the
1860s to the 1920s.

The print shown here, *Mer de Glace – Valley of
Chamouni – Savoy*, was published in May 1812. It was
both etched and engraved by Turner and embodies
the sublime qualities of the Alpine landscape. Given
the simplicity of the design and the lack of a related
finished drawing, it is likely that Turner created this
print by working directly from a rough sketch in his 'St
Gotthard and Mont Blanc' sketchbook (TB LXXV F 23),
made during his first trip to Switzerland in 1802. The
Gallery's 'Reichenbach' watercolour (NGI.2431), which
once formed part of that sketchbook, relates indirectly
to this print.

Turner's original plan was to produce 100 prints in
twenty sets of five. The landscapes were grouped into
six different categories: Architectural, Pastoral, Elevated
or Epic Pastoral, Historical, Mountainous and Marine.
Unfortunately for Turner the print market was at a
low ebb when he began publishing his 'Liber' plates.

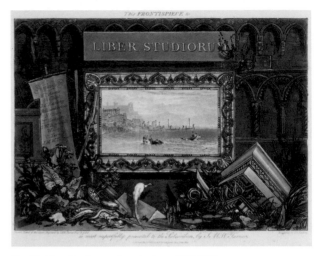

Fig. 43: Liber Studiorum Frontispiece, NGI.11958

In addition, the price he charged was high in comparison
to similar contemporary publications.[1] Public interest
was not as good as expected and when publication
ceased in 1819, the year Turner left England for Italy,
only 71 plates had been published. The decorative
frontispiece, engraved by J.C. Easling was published
in May 1812 (fig. 43).

The National Gallery of Ireland's complete set of
Turner's *Liber Studiorum* print series is made up of good
impressions from the collection of Irish born Stopford
Augustus Brooke (1832-1916), who gave the prints to
the Gallery in 1903.                                              AH

**1.** Forrester, 1996, p.20

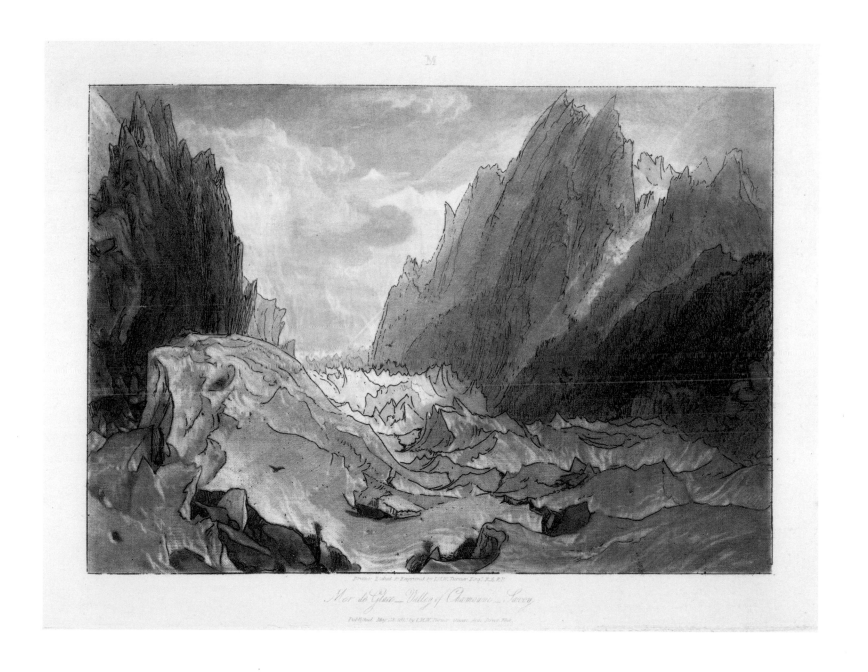

M

*Mer de Glace — Valley of Chamouni — Savoy.*

# The Grand Canal from below the Rialto Bridge, Venice, c.1820

Watercolour, graphite and
gouache with white highlights
on off-white wove paper,
28.4 x 40.6cm
WATERMARK: J WHATMAN/ 1818
/ TURKEY MILL
PROVENANCE: Roland L'Estrange
Bryce (d.1953), transferred from
the Office of Public Works, 1972
NGI.7512

1. Krause, 1997, p.140
2. For a wider discussion of Turner's
travels in Italy see: Cecilia Powell,
*Turner in the South: Rome, Naples,
Florence*, 1987
3. The Accademia Bridge was not
constructed until 1854.
4. Dr Joyce Townsend viewed the
watercolour on 13 June 2012.
5. By the mid 1840s, Turner's
gallery at Queen Anne Street was
neglected. It was in a dilapidated
state, as were some of the pictures,
many of which were unfinished.

Turner was familiar with the subject of Venice and the Rialto Bridge prior to his first visit to the city. In 1818, he was commissioned by James Hakewill (1778-1843), who had toured Italy in 1816 and 1817, to produce watercolours for engravings based on the architect's topographical drawings made during his trip. Hakewill's commission was to cover the whole of Italy. Eighteen of Turner's watercolours, including one of Venice, were engraved and published in Hakewill's *Picturesque Tour of Italy* (1819-20). This collaboration may have persuaded Turner to undertake his first visit to Italy in the summer of 1819. Hakewill provided Turner with helpful tips and advice and recommended that he stay at the Hotel Leon Bianco, on the Grand Canal.[1]

In artistic terms, Italy was the most significant place Turner visited during his life. He had visited the country briefly in 1802, but it was not until 1819 that he made a proper tour. On Turner's outward journey to Rome he stopped off in Venice, visiting Florence on his return journey. He based himself in Rome for three months, from October to December of 1819, and during that time made an excursion to Naples. His absence from home, totalling a full six months from August 1819 to February 1820, included two month-long journeys through Europe.

The bright Italian light ignited a new intensity in Turner's colour palette, expressed through his use of rich golden tones. His first trip to Venice, which lasted about five days, sparked immense creativity.[2] Turner's 'Milan to Venice' sketchbook of 1819 is filled with sketches charting his journey up the Grand Canal from the Lagoon. He drew the Rialto Bridge from a multitude of different angles and viewpoints (TB CLXXV 73-84). In Turner's day this bridge offered the only means of crossing the Grand Canal on foot.[3] He sketched the bridge from a close-up vantage point, evident in the double page view *The Rialto Bridge from the South* in the 'Milan to Venice' sketchbook (TB CLXXV 79 & 78 a), (fig. 44) and from under the bridge looking northwards (TB CLXXV 81 a), (fig. 45).

Probably based on a sketch done in a gondola, the Dublin watercolour shows a rather unusual view taken from below the Rialto Bridge. The compositional device of framing a city scene within the arch of a bridge is reminiscent of Canaletto's (1697-1768) views of Venice. Turner captures the hustle and bustle associated with this commercial centre of trade, as boats jostle for position along the canal. In comparison to Canaletto's calm, idealised views of the city, Turner achieves a more realistic, dynamic sense of movement. The view beyond the bridge takes in the sixteenth-century Palazzo Grimani on the left, its side-elevation cast in shadow. On viewing this watercolour in 2012, Dr Joyce Townsend, Senior Conservation Scientist at Tate Britain believed it to be faded rather than unfinished.[4]

In addition to the drawings already mentioned, an incomplete and badly damaged canvas measuring 177.5 x 335.3cm depicting the Rialto Bridge exists (Tate Britain, N05543; BJ 245).[5] It was titled *A Canal seen under a Bridge* until 1974 when it was identified as a view of

Fig. 44: J.M.W. Turner, *The Rialto Bridge from the South*. M01119. Photo © Tate

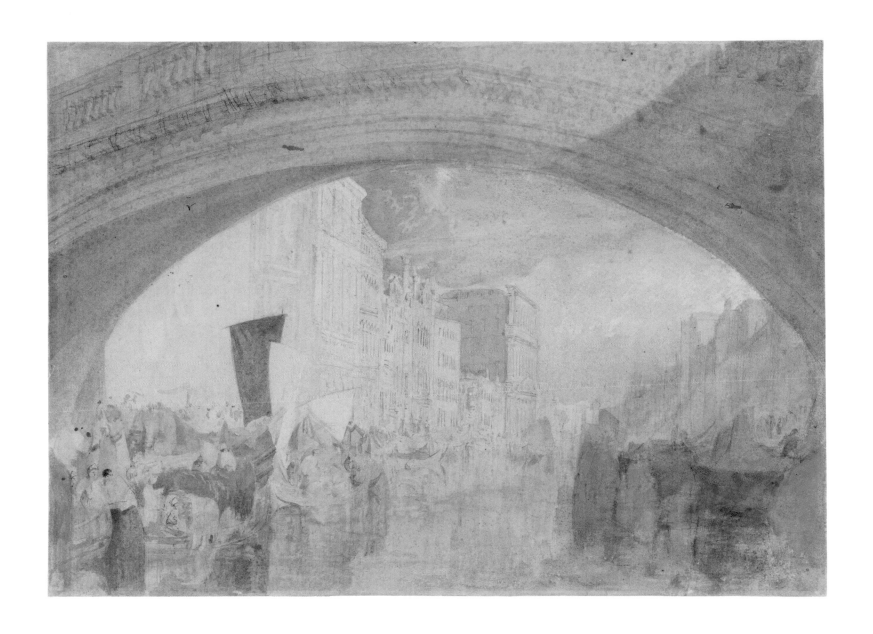

Fig. 45: J.M.W. Turner, *Looking up the Grand Canal, to the North, from under the Rialto Bridge*. D14471. Photo © Tate

Opposite: NGI.7512 (detail)
Fig. 46: J.M.W. Turner, *The Rialto, Venice*, D NG 874
National Galleries of Scotland, Henry Vaughan Bequest 1900

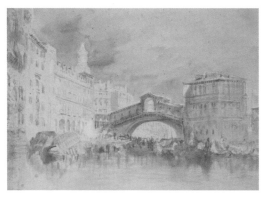

the Grand Canal seen through the arch of the Rialto, looking roughly south. Although of similar composition and orientation to the Dublin work, it would have been uncharacteristic of Turner to produce a large and carefully-painted watercolour in preparation for an oil. The immense scale and format of the unfinished oil equates to the painting *Rome, from the Vatican*, also in Tate (N00503; BJ 228). It has been suggested that the Rialto Bridge painting was conceived as a Venetian pendant to this sweeping view of Rome, taken from the Vatican loggia, exhibited in 1820 following Turner's first visit to Italy.[6]

Another Venetian work which dates to around 1820 is the finished and highly detailed watercolour *Venice, the Rialto* (Indianapolis Museum of Art; W 718), which was among the six sizeable views conceived during Turner's first tour of Italy in 1819 and completed sometime after his return to London on February 1, 1820. These six views were acquired by one of Turner's important patrons, Walter Fawkes. In terms of size the Dublin drawing relates very closely to Fawkes's Italian series, and may have been intended or planned as part of that set. The boats lining the canal in another watercolour

*The Rialto Bridge from the North*, 1840, in the Vaughan bequest of Turner watercolours at the National Galleries of Scotland (D NG 874; W 1369), (fig. 46) are treated in a similarly sketchy fashion to those in the Dublin drawing. Positioned to the left of the Rialto Bridge in the Edinburgh drawing is an arcaded building, the Fondaco dei Tedeschi.[7] The Edinburgh and Dublin views are taken from the north side of the Rialto. However, in contrast the Dublin view is taken from a much closer viewpoint. One can imagine the artist travelling under the bridge and gliding on towards the southern end of the Grand Canal, taking in all the splendid facades as he passed. Ian Warrell has made a connection between the Dublin view of the Rialto and a group of at least nine watercolours of Venice, detailed in *Turner and Venice*.[8] This group of nine studies, similar on stylistic grounds to the Dublin watercolour, seem most likely to relate to Turner's final trip to Venice in 1840. Technically, in all of them, Warrell suggests, there is a building up of colour over a framework of pencil detail. Also, the range of colours deployed is very close throughout this group of sketches, as is the blurring of reflections and the shading used to give buildings substance. **NMN**

6. Joll, Butlin and Herrmann, 2001, p.359
7. It was a former trading house once occupied by German merchants. The five gates allowed merchant ships to be loaded and unloaded easily.
8. Warrell, 2003, p.259

THE WORKS OF J.M.W. TURNER

# A Ship against the Mewstone, at the entrance to Plymouth Sound, c.1814

Watercolour with white highlights and scraping out on cream wove card, 15.6 x 23.7cm
PROVENANCE: Henry Vaughan Bequest, 1900
NGI.2413

In 1811, the engraver and publisher William Bernard Cooke (1775-1858) approached Turner with a proposal to publish a print series entitled *Picturesque Views on the Southern Coast of England*. The series, to be engraved by W.B. Cooke and his brother George, was to function both as a topographical record and as a report on the economic and social condition of the south coast which had suffered badly during the recent hostilities with France. It was an ideal opportunity for Turner to bring his art to a wider public and he undertook the commission with relish. As Ian Warrell points out: 'Turner brought a deft inventiveness and perceptive reportage to his scenes, instilling them with a vigour that contrasted with the sometimes stiff and old-fashioned approach of his peers.'[1]

The series was issued in sixteen parts, three prints in each part accompanied by a letterpress text describing the location, and two related vignettes. Beginning with Whitstable in Kent, the series included forty-nine locations in all, culminating with a view of Watchet on the Bristol Channel. Each sheet, richly coloured and small in scale, measures approximately 15 x 23cm. Since they were destined to be reproduced in black and white by engravers they were, of necessity, incredibly detailed.

This watercolour (NGI.2413; W 454) appeared in part six of the series published in 1815. Turner accurately records the appearance of the waves, their white crests being blown away by the strong wind. The rigging of the ship labouring in the heavy swell, the clouds highlighted by a bright shaft of sunlight, and even the gannet with its characteristic black wing tips in the left foreground are recorded in great detail. The ship is dwarfed by the Mewstone, which notoriously claimed many lives over

the centuries. This dramatic natural feature lies to the eastern end of Plymouth Sound off Wembury Bay. Pieter van der Merwe believes it is unlikely that any ship would have attempted to beat out of Plymouth Sound in such conditions. If the ship shown here had managed to, it is now safe from the Mewstone, but would still be in danger of running aground on the coast, which lies just out of sight to the right. Given its location, it is almost certainly a depiction of a Royal Naval vessel, perhaps a sloop or a small frigate capable of carrying between eighteen and twenty-four guns.[2] During the summer of 1813, Turner spent time travelling along the coast filling sketchbooks with his observations. A number of related studies exist including a spontaneous colour study dated c.1823-26 (fig. 47). In that watercolour, created some ten years later, broad masses of wash in dark blues and greens were used to indicate the turbulent sea, the dark thunderclouds and the massive bulk of the brooding Mewstone (TB CXCVI F; W 773).

AH

Fig. 47: J.M.W. Turner, *The Mewstone*, c.1823-6. D17170. Photo © Tate

1. Warrell, 2008, p.53. Other artists involved in this project included Peter de Wint (1784-1849) and William Alexander (1767-1816) but Turner was responsible for the vast majority of plates produced, probably because the publishers quickly realised the superiority of his designs.
2. E-mail correspondence with Pieter van der Merwe, National Maritime Museum, Greenwich, 6 May 2011.

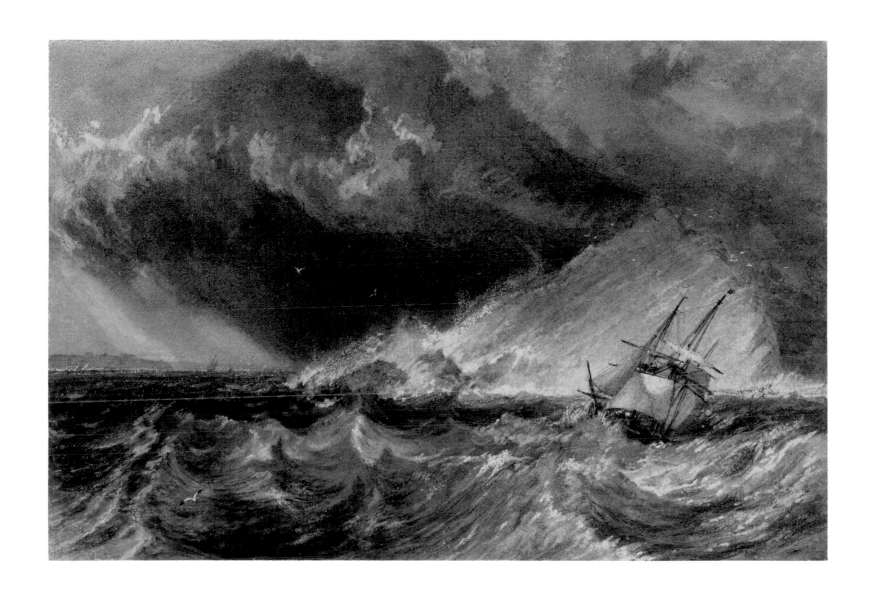

# Clovelly Bay, North Devon, c.1822

Watercolour and graphite with white highlights and scraping out on cream wove paper, 14.6 x 22.5cm
WATERMARK: J WHATMAN/ TURKEY MILLS
PROVENANCE: Henry Vaughan Bequest, 1900
NGI.2414

This jewel-like watercolour (NGI.2414; W 472) was completed around 1822 and like the Mewstone, it was engraved for Cooke's *Picturesque Views on the Southern Coast of England* series, appearing in print form in 1824. Although the picturesque coastal landscape provides a rich backdrop, it is the activities of the men and animals which are central to the composition. Turner's interest in the lives of the people who made their living on this part of the coast is very evident here. He describes in great detail the work of quarrying and burning lime particular to North Devon. To the far left, a man chips away at the cliff-face with a pick-axe. Lumps of limestone are loaded onto the patient donkeys to be brought to the kilns, visible lower down on the beach. Donkeys and ponies were also used to bring the burnt lime up the narrow cliff path for distribution to farmers who used it to neutralise acidic soils. Twelve figures are visible in this detailed image along with seven donkeys and one frisky dog. Unlike his earlier watercolours, where figures were included simply as 'staffage', to add colour or scale to a view, here they are an integral part of the composition. The village of Clovelly can be seen close to the centre of the image clinging to the cliff, its buildings glistening white in the sun. Lundy Island, once the home of a feared pirate family, and now a sanctuary for gannets, puffins and other sea birds, can be made out on the horizon to the right.

Despite its small scale, Turner has used a huge variety of mark-making techniques on this sheet. In the lower left corner yellow pigment is scraped back to indicate grass at the edge of the rock. A variety of ochres and browns is used to record the rough texture of the cliff-face. There is evidence that Turner used his fingertips to add or blend colour, in fact there is a partial fingerprint visible to the right of the brown donkey in the left foreground (fig. 48). In the sky the clouds are rendered using very fine curving brushstrokes of blue, purple and white which gives the effect of pastel. Ruskin sometimes mistakenly described Turner's gouache highlights as 'chalk', presumably because of the fine quality of the lines.[1]

A print after this watercolour was engraved by William Miller (1796-1882), who was employed by the Cooke brothers, when they realised that they would not have time to engrave each design for this series themselves. As always with prints after his work, Turner took time to correct the trial proofs carefully. Turner knew that his skills were highly regarded and he insisted that he receive two complementary prints on high quality paper as well as ten guineas for each of his original designs. Cooke found Turner very difficult to deal with and their relationship broke down irreparably in 1827.　　AH

Fig. 48: Detail from NGI.2414. Shows how Turner used his fingers to create texture on the sheet.

**1.** Townsend, 1999, p.26. On examining this watercolour on 13 June 2012, Dr Joyce Townsend commented that the size on the surface of the paper was uneven. This is particularly noticeable at the top right hand corner of the sheet.

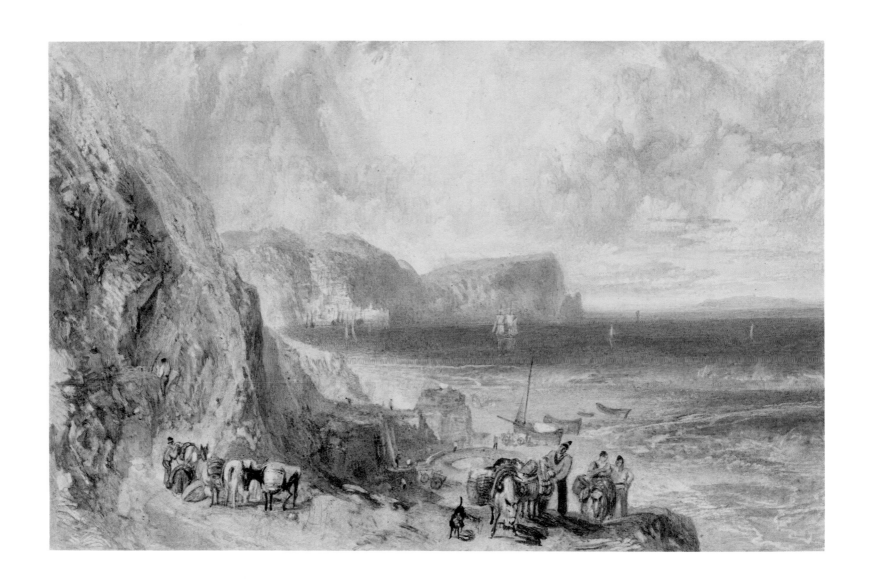

## A Ship off Hastings, c.1820

Watercolour on off-white
wove paper, 20 x 25.9cm
WATERMARK: 1794/ ...HATMAN
PROVENANCE: Henry Vaughan
Bequest, 1900
NGI.2412

In broad washes of pale colour, Turner captures the vaporous atmosphere of haze and mist at sea in this view off Hastings (NGI.2412; W 763). The sheer cliffs and the silhouette of a sailing ship are barely decipherable in the distance. Turner skilfully draws attention to these elements through his use of a slightly darker cobalt blue, which defines the farthest edge of the cliff, as it falls off into the sea, and underscores the ship, whose sails are full with the force of the wind. Pieter van der Merwe notes Turner's 'very successful suggestion of a small merchantman running up-Channel in pretty stiff weather conditions.'[1]

Turner's unconventional methods of painting in watercolour were notorious during his lifetime. In areas of this drawing he has applied the watercolour wet-on-wet, thereby allowing elements to suffuse. In other parts he has vigorously worked the watercolour with the brush to create the impression of choppy waves. Turner allows the paper to show through the thin, translucent washes in some areas. As he worked energetically on batches of watercolour sketches, traces of his fingerprints were often left on his drawings. Here two fingerprints are visible on the left hand edge of the sheet, just at the horizon line and slightly lower down in the area of the sea.

Turner viewed works such as these as preparatory exercises, and never envisaged them as objects for public display. A sketch such as this, made up of subtle colour washes, offers the viewer a fascinating glimpse into the artist's working methods. It also gives an insight into his initial creative spark, the point where ideas evolve to be channelled into more finished designs later. This sketch is similar to the 'colour beginnings' Turner created in his studio, conjured up through his imagination or from his vivid memory. Wilton compared the style and subject-matter of this work to the study of *The Mewstone*, c.1823-26, associated with the *Southern Coast* and the *Little Liber* series in the Tate collection (TB CXCVI F; W 773), which also displays Turner's enthusiastic experimentation with the watercolour medium.

NMN

1. Email correspondence, 6 May 2011

# A Shipwreck off Hastings, c.1825

Watercolour and white
highlights with touches of
gum arabic and scraping
out on cream wove paper,
18.9 x 28.5cm
WATERMARK: J WHATMAN /
TURKEY MILL
PROVENANCE: Henry Vaughan
Bequest, 1900
NGI.2411

The size, subject, and extensive use of stippling suggest that this watercolour (NGI.2411; W 511) was intended for the *Ports of England* series of engravings (1825-28), the stippling being a notable feature of the *Ports* watercolours.[1] Atmospheric effects were also a feature of this series, often given as much importance as the location depicted. Although Turner supplied fifteen watercolours for the series this work did not make the final selection. Its exclusion could have been due to, as Ian Warrell notes, the presence of a shipwreck in the foreground, deemed inappropriate to that series, as it highlighted the 'perilous nature of that part of the coast.'[2] The futility of man's strength when pitted against the might of the sea is graphically illustrated, with ill-fated mariners cast adrift from their capsized vessel. In this *tour de force* of marine painting in watercolour, the dark, turbulent sea, propelled by a strong underlying swell, creates surging waves that engulf the hapless crew. The rich colouration and wide tonal range enhances the dramatic impact of the scene.

Related views include *Hastings from the Sea*, 1818 (British Museum; W 504), (fig. 50) which shows the majestic prospect of the town from the sea, created for an unrealised publication called *Views at Hastings and its vicinity*[3] and *Hastings: Fish Market on the Sands, Early Morning*, 1824 (Hastings Museum and Art Gallery; W 510), a vibrant watercolour depicting the picturesque scene of a fish market on the beach, made for the unfinished project *Marine Views*.[4] A plausible suggestion, newly proposed in 2015 by Eric Shanes and Ian Warrell, is that Turner's colour sketch *Shakespeare Cliff*, c.1825 (Fitzwilliam Museum, Cambridge), (fig. 51) is a study for the finished watercolour *A Shipwreck off Hastings*, c.1825 (NGI.2411).[5]

In Turner's day the seaside resort town of Hastings was a thriving fishing port. In the large watercolour *Hastings from the Sea*, 1818, the town is shown nestled between the cliffs, with the ruins of a Norman castle high on the left. The brilliance of the design, like that of the Dublin watercolour, lies in Turner's depiction of the sea itself with its jagged crests and foaming breakers.    NMN

1. Shanes, 1990, p.145
2. Warrell, *'Another "Coast"!' Turner's English Channel, or La Manche*, 2008, pp.55-56
3. *Hastings from the Sea* was eventually engraved in 1851 and published as a single large plate, although Turner did not live to see its completion.
4. Warrell, 'Another Coast', p.55
5. Jane Munro with Anne Lyles, Ian Warrell and Amy Marquis, *Watercolour: Elements of Nature*, Fitzwilliam Museum, Cambridge, 2015, p.52

Fig. 50: J.M.W. Turner, *Hastings from the sea*, 1818
© The Trustees of the British Museum

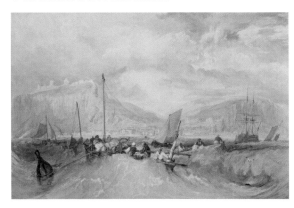

Fig. 51: J.M.W. Turner, *Shakespeare Cliff, Dover*, c.1825
© The Fitzwilliam Museum, Cambridge

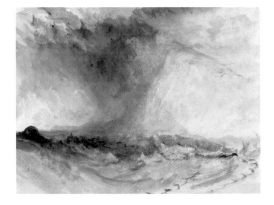

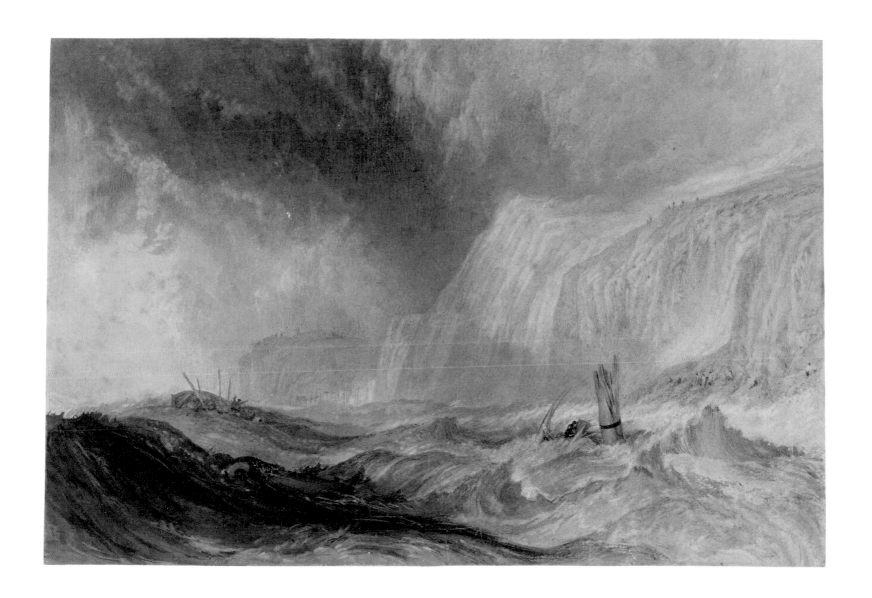

# Fishing Boats on Folkestone Beach, Kent, c.1826-27

SIGNED (lower left) in watercolour: Turner Watercolour, white highlights, graphite and scraping out on cream wove paper, 18.2 x 25.9cm
PROVENANCE: Henry Vaughan Bequest, 1900
NGI.2415

In this view of Folkestone, eleven figures are shown engrossed in their work of gathering fish and cleaning nets. A woman picks up fish from the shore while two men clean and repair a net spread out on the sand to the right. There is a sense of tranquillity, the day's work is nearly finished as the sun sets beyond the old parish church of St Mary and Easnwythe on the cliffs above the town. A man on a horse stands beside the lugger drawn up on the beach. Perhaps he is waiting to take the men or equipment on board to shore. The boat's cod bow net is shown hanging up on the main mast. Turner was keen to show the actuality of the lives of the fishing folk and it is details like this that give these watercolours the appearance of reportage, a sense that Turner actually observed the people at work and noticed happenings particular to the locality.

Unlike Turner's view of Clovelly Bay, this shoreline image (NGI.2415; W 884) did not appear in the 'Southern Coast' print series, nor the later 'Ports of England' series (1826-28). A related pencil drawing (TB CCIII D) with handwritten notes below the image: 'Dover / Folkestone / Lulworth / Saint Mawes / Black Gang' perhaps indicates places along England's south coast that he intended including in a future print series (fig. 52). Similarly finished watercolours are in the Yale Center of British Art: *Folkestone Harbour and Coast to Dover* (B1977.14.4701; W 826) and *St Mawes Cornwall* (B1975.4.964; W 473). The St Mawes sheet is similarly signed with Turner's distinctive Greek 'ε'.

Ian Warrell believes that the Dublin sheet could have been a subject for another proposed print series featuring both English and French coastal villages along the Channel. Turner began thinking about this project following the breakdown in his relations with W.B. Cooke,

who engraved and published the long-running *Southern Coast* print series. During a fraught meeting with Cooke towards the end of 1826 Turner reportedly spluttered 'I will have my terms! Or I will oppose the works by doing another "Coast"!' Turner wasted no time in beginning work on this project. In January 1827 the publishers John and Arthur Arch wrote to William Miller explaining that Turner 'intends publishing a work of twelve Numbers to be called 'The English Channel or La Manche' to consist of views taken by him on both sides of the Channel in the manner of the Views of Southern Coast'. They suggested that Miller might engrave some of the designs. Turner may have intended to use already completed designs like the Dublin sheet for this project but for reasons unknown it was never realised.[1]

Like other watercolours of this period intended for translation into print, this sheet is notable for its incredibly fine detailing, in particular the vertical lines that indicate the sheen on the wet sand and the colourful cirrus clouds illuminated by the setting sun.[2]     AH

1. For a full explanation of this ill-fated project see: Warrell, 'Another Coast! Turner's English Channel or La Manche', 2008, pp.53-64.
2. Illumination under UV light shows more brushstrokes in the sky, particularly around the sun, indicating that some colours have faded over time. There is a lot of white pigment used in the reflections and for the orb of the sun. The dark orange blob to the lower edge of the composition, in the reflection of the sun, is a later retouching.

Fig. 52: J.M.W. Turner, *Folkestone*. D17761. Photo © Tate

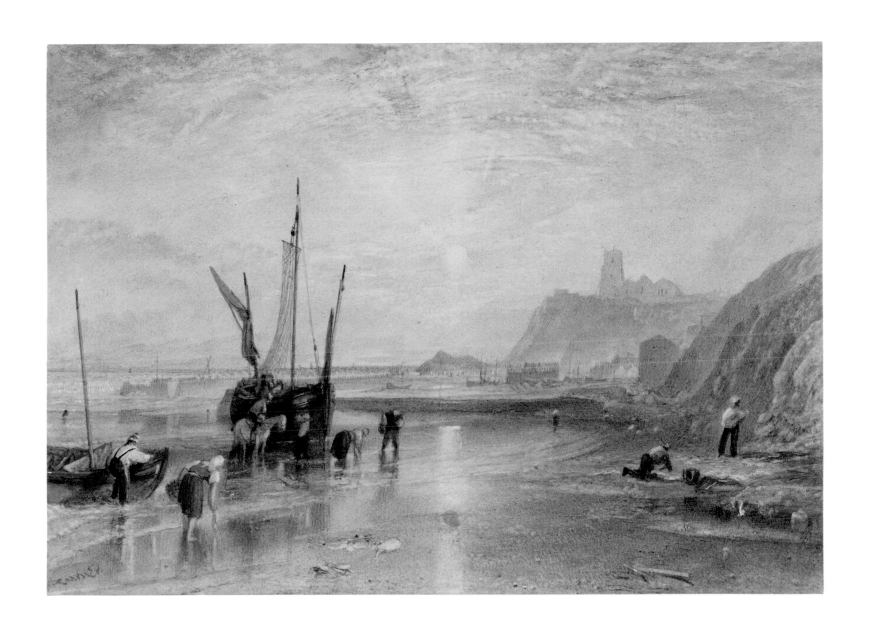

# Shipping, 1827

Graphite on off-white wove paper, 17 x 22.5cm
WATERMARK: J WHATMAN / 1827
INSCRIBED (lower right) in graphite: JMWT
PROVENANCE: Henry Vaughan Bequest, 1900
NGI.2401

This drawing is the only pure graphite drawing in the collection. A confidently drawn image, the pencil is used in a variety of ways to achieve an expressive evocation of a maritime scene. We can imagine the wind blowing, the ships labouring on the rough seas and can sense the anxiety of the people on the pier waiting for the boats to land.

Although in the past, the large three-master sailing ship has been referred to as a 'man-of-war', Pieter van der Merwe has stated that it is probably a small merchantman since it does not appear to be armed.[1] He describes the small boat in the foreground as having the rig of a two masted lugger with an unusually long bowsprit. The rounded leeboard is Dutch in appearance, yet has a square English transom and a rudder typical of a Thames barge. Since it is carrying quite a large number of passengers and some sort of cargo, this craft may have been a passage boat of some sort. In the background from left to right, Turner depicts a fast cutter, which could be a naval or revenue service vessel, a three master at anchor in the distance and a merchant brig at anchor behind the passage boat.

In 1827, Turner received a commission from the architect John Nash (1752-1835) to paint a view of his home, East Cowes Castle, on the Isle of Wight. The artist stayed at Nash's home for six weeks from July to September. The flourishing signature connects this sheet to a group of drawings of shipping subjects made by Turner during his visit. The related drawings are *Man of War* (National Galleries of Scotland, D. NG 852), (fig. 53) and two others in a private collection. A letter attached to the private collection drawings states that they were made for Harriet Petrie (1784-1849), who was at East Cowes Castle when Turner was in residence.[2]

A rough sketch of shipping on a catalogue page, now in the Yale Center for British Art (B 1975.4.1761), is inscribed with the date 30 January 1865. Addressed to Henry Vaughan Esq it reads: 'I send you these hasty scribbles of Shipping I spoke of made by Turner forty years ago to describe to me the different kinds of shipping, / I am dear Sir, yours Faithy. / Thos. Lupton'. The 'scribbles' referred to were sketches related to Turner's 'Ports of England' print series published in the 1820s. Thomas Goff Lupton (1791-1873) was the publisher-engraver who collaborated with Turner on this project. Turner, particular as ever, sent Lupton detailed pencil sketches to explain, in a visual way, the complex rigging of the vessels. The original plan was for twelve mezzotint views, but by 1828 only six had been published. In 1856, the complete series was published with a commentary by John Ruskin.

AH

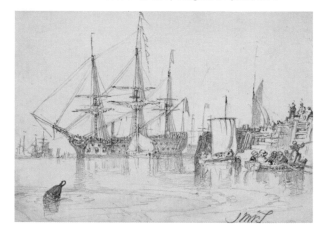

Fig. 53: J.M.W. Turner, *Man of War*, 1827, D NG 852
National Galleries of Scotland, Henry Vaughan Bequest, 1900

1. In the same e-mail 6 May 2011 he provides more detail, noting that, although the ship does not appear to be armed, 'the full sparring and press of canvas hints at naval practice / manning levels. It has a main topgallant sail rigged and a pennant at the main that might be naval.'
2. Baker, 2006, p.44

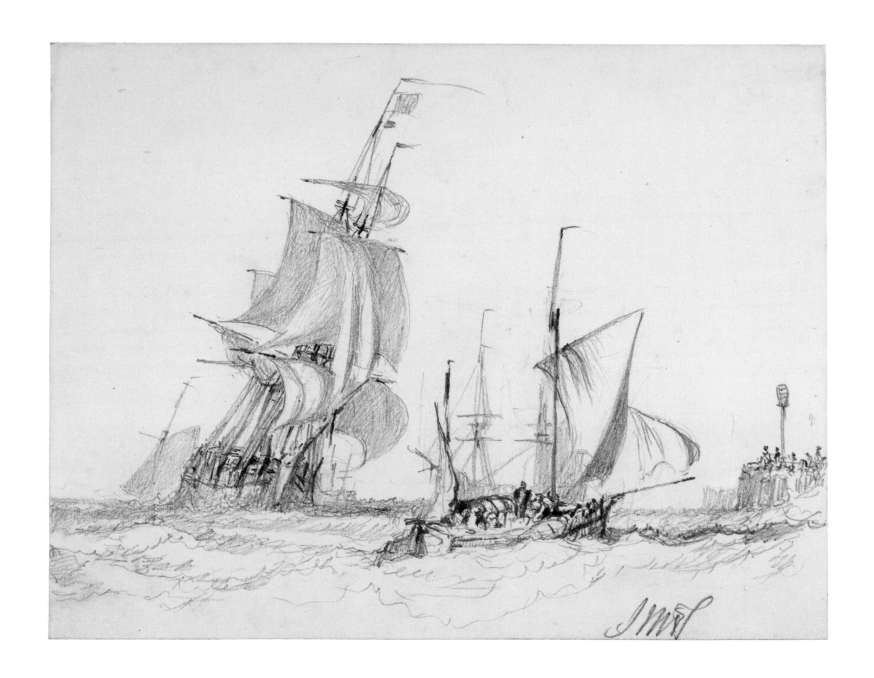

# Sunset over Petworth Park, Sussex, c.1828

Gouache and watercolour on
blue wove paper, 13.9 x 19.3cm
PROVENANCE: Henry Vaughan
Bequest, 1900
NGI.2430

Early in the summer of 1827, Turner visited Petworth House in East Sussex, the country home of George O'Brien Wyndham (1751-1837), third Earl of Egremont. After his seaside sojourn in East Cowes, Turner returned to Petworth, and was probably established there by late October.[1] Turner was invited by Egremont to paint four landscape oils to hang in the magnificent 'Carved Room'. Turner came and went as he pleased and set up a studio in the grand house. One of Egremont's granddaughters, Charlotte King, remembered: 'They were always good friends, though they sometimes spoke their minds very openly to each other …'[2]

By the end of 1827 Turner had produced a large group of brightly coloured drawings on blue paper of the house and grounds. Ian Warrell has pointed out that 'only a handful of Petworth subjects of this kind escaped from Turner's private collection.'[3] Vaughan was a canny collector to have managed to acquire this jewel-like example. These studies were painted in watercolour and gouache on small sheets of blue paper measuring approximately 14 x 19cm. This distinctive paper came from the firm of Bally, Ellen and Steart and was probably made at their De Montalt mills at Comb Down, Bath.[4]

In these studies of Petworth Park, Turner's interest is focused primarily on the sky and the lake. The inclusion of livestock or people is rare. For this view (NGI.2430; W 908), his vantage point is near the lake which lies beyond open parkland in front of the great mansion. The sun sinks behind the deep blue hills, while the sky above is rendered as a glorious *mélange* of reds, yellows and pale blues. A great variety of mark-making is present. Dots of pale yellow gouache over orange wash represent the vibrant sun while a dry brush dragged across the paper is used to create diagonal

dark blue clouds in the right-hand side of the sky. In the foreground, the blue paper is reserved to indicate the still water of the lake with pink washes picking up the reflected sunset. Wet washes of dark watercolour evoke the dark shadows cast by the trees on the shoreline. Some of the trees on the left are glazed with gum arabic to give them extra depth.

It was this principal viewpoint from the house across the expanse of parkland to the lake, that inspired Turner most. The large group of studies of Petworth in the Turner Bequest at Tate includes many versions of this scene. Perhaps closest in terms of composition and colouring is the view illustrated below (TB CCXLIV 18), (fig. 54). Although recently re-titled, it was clearly painted at the same time. Turner must have regarded these studies as successful, as he used the same blue paper and vibrant gouache pigments for many of the studies for the 'Rivers of France' series published in the early 1830s.                                          AH

Fig. 54: J.M.W. Turner, *Twilight: A Lake or River Scene*
D22680. Photo © Tate

**1.** Warrell, Rowell and Blayney
Brown, 2002, p.58
**2.** Ibid, p.17
**3.** Warrell, 1991, p.13
**4.** Bower, 1999, pp.88-98

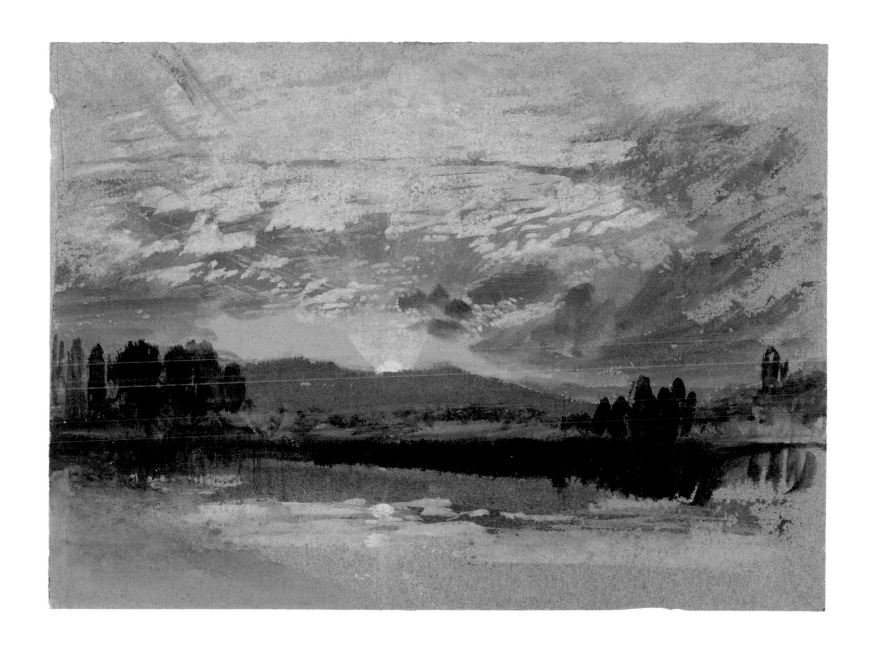

# The Ruined City of Assos, Turkey, 1832-34

Watercolour and white highlights, with details added using a pen dipped in watercolour, on cream wove paper, 14 x 20.5cm
PROVENANCE: Henry Vaughan Bequest, 1900
NGI.2424

Assos, a desolate ruin by Turner's time, was once a thriving seaport called Mysia. Located in northwest Asia Minor (now Turkey), it was here that St Paul joined his companions and sailed on to Mitylene (Acts 20: 13, 14). The ancient city was built on a 700-foot-high conical-shaped rock. Its imposing ruins served as a quarry- the docks at Constantinople were built with great stones taken from its public buildings.

In 1832, Turner received a commission to provide 26 views of biblical scenery to be engraved by the Finden brothers, and published in conjunction with John Murray. Entitled *Landscape Illustrations of the most remarkable places mentioned in the Holy Scriptures* (1835-36), the series included text by the Reverend Thomas Hartwell Horne. Previously the Grand Tour had culminated with a sojourn in Rome; by the end of the eighteenth century the usual itinerary had extended eastwards. Finden's publication sought to satisfy the growing demand for guidebooks of the Holy Land and its antiquities. Despite being an inveterate traveller and being well versed in the Scriptures, having drawn on Biblical subjects throughout his career, Turner never visited the Holy Land. Neither had the other artists employed on this project, including Callcott and Clarkson Stanfield. Their compositions were based on sketches made 'on the spot' by notable travellers like Charles Robert Cockerell and Sir Robert Ker Porter (1777-1842).

Turner based this watercolour *Assos* (NGI.2424; W 1258) on a sketch by the architect and amateur artist Sir Charles Barry (1795-1860), who toured the Middle East between 1817 and 1820. Barry's tour sketches can be found in the Library Drawings and Archives Collection of the Royal Institute of British Architects. Turner admired Barry's drawings and many of his illustrations for *Finden's Bible*, engraved between 1833 and 1836, were based on his work. However, Turner is known to have been somewhat irritated by the literal-mindedness of Barry and the publisher Murray, who complained that Turner placed the sun in impossible positions and put symbolic wolves into some of his designs.[1]

In this watercolour, remnants of the once noble ancient Greek city are illuminated by moonlight. The moon, glimpsed through a doorway, casts its mysterious light on the goats that wander around the fallen columns and classical lintels. According to Wilton, a 'somewhat perfunctory replica' of this subject is in the Blackburn Museum and Art Gallery, Lancashire (W 1262).[2]

Henry Vaughan also owned *Babylon*, 1832-4, another biblical illustration by Turner engraved for *Finden's Bible*, which he bequeathed to the Victoria and Albert Museum (W 1246). The V&A watercolour, showing a rocky landscape outside the ancient city of Babylon was based on a drawing by Sir Robert Ker Porter. **NMN**

**1.** Joll, Butlin and Herrmann, 2001, p.109
**2.** Wilton, 1979, p.450

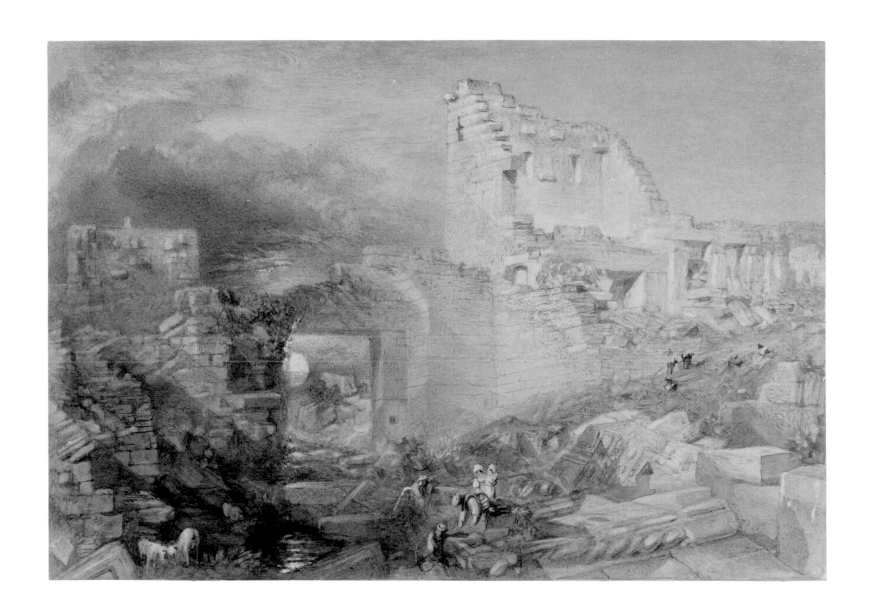

## The Castellated Rhine, c.1832

Watercolour and graphite on paper, 23.5 x 25cm
Traces of a watermark on the lower edge: J WH
PROVENANCE: William Leech Sale, Christie's, London, 21 May 1887, lot 72, bought by Sir Donald Currie; by descent to Major F. D. Mirrielees; Christie's, London, 20 March 1959, lot 58, bought by Sir Alfred and Lady Beit; presented by Clementine, Lady Beit, (Heritage Gift), 2000
NGI.19589

In Turner's day, the Rhine valley was a busy route from the Alps to the North Sea, providing travellers with a range of spectacular sights. The route was frequently used by British travellers, in particular those going to or returning from Switzerland or Italy. Turner explored many stretches of the Rhine on his tours, walking along its banks or travelling by sailing ship or steamboat. He first explored the Rhine in 1817 in the aftermath of the Napoleonic wars. From the wealth of material gathered on his extensive ten day tour of the Rhine between Mainz and Cologne, in the late summer of 1817, he produced an important series of fifty Rhine drawings in watercolour. That autumn, he sold these drawings to Walter Fawkes for the sum of £500.[1] Today these drawings are spread throughout many public and private collections, with the largest single group (seven) located in the British Museum.

Like many other artists, Turner was inspired by the poetry of Lord Byron (1788-1824), who celebrated the scenery and history of the German Rhineland in his epic poem *Childe Harold's Pilgrimage* (canto iii, verses 46-61). In the 1830s, Turner provided numerous minutely detailed watercolour vignettes to illustrate the works of Byron, Scott, Campbell and other poets. This work (NGI.19589; W 1235) was one of seventeen created for a new edition of Byron's writings, published after his death. It is a Romantic interpretation of the evocative lines in Canto X of *Don Juan* (1819-24), which describes the hero's journey through Europe: 'And thence through Berlin, Dresden and the like/Until he reach'd the castellated Rhine'. The watercolour was engraved in 1833 by Edward Francis Finden (1791-1857), and appeared as the title-page vignette to *The Works of Lord Byron*, vol. XVII, 1832-34, published by John Murray.

Turner's extensive knowledge of the region's scenery enabled him to combine architectural and topographical elements from different locations into one composite vista. This highly refined vignette design is, as Cecilia Powell notes, 'not a portrait of any particular place on the river but a distillation of its scenery.'[2] On the left of Turner's watercolour the towers and church spire, enveloped in a hazy mist, derive from the medieval town of Kaub.[3] Turner first saw Kaub, around 40 kilometres south of Coblenz, on his 1817 tour. Intended as a composite image, comprising a medley of ingredients, Turner used artistic license when it came to this vignette or Rhine capriccio. For example, the majestic thirteenth-century castle known as Burg Gutenfels, along with the cliff it is perched on, have been greatly altered and exaggerated. In addition, in the town on the right of this view only the round tower is suggestive of Oberwesel, in reality some miles north along the Rhine and therefore not actually visible from Turner's supposed viewpoint. Glimpsed in the distance is Burg Pfalzgrafenstein, on an island in the centre of the Rhine, just upstream from Kaub. This castle, with its ship-like profile of bastions, was originally built as a tollgate.

A tranquil atmosphere and elegiac mood is evoked through the use of soft blues. The river is busy with sail boats, barges and large log-rafts. These rafts which floated downriver brought goods as well as the timber itself to towns in northern Germany. The huts built onto the rafts provided living accommodation for the crews. Presented in 2000 by Clementine, Lady Beit of Russborough House, this is the only vignette illustration by the artist in the Gallery's collection. **NMN**

**1.** Joll, Butlin and Herrmann, 2001, p.262
**2.** Powell, 1995, p.109
**3.** Le Harivel, Adrian (ed.), *Taking Stock: Acquisitions 2000-2010*, National Gallery of Ireland, 2010, p.132

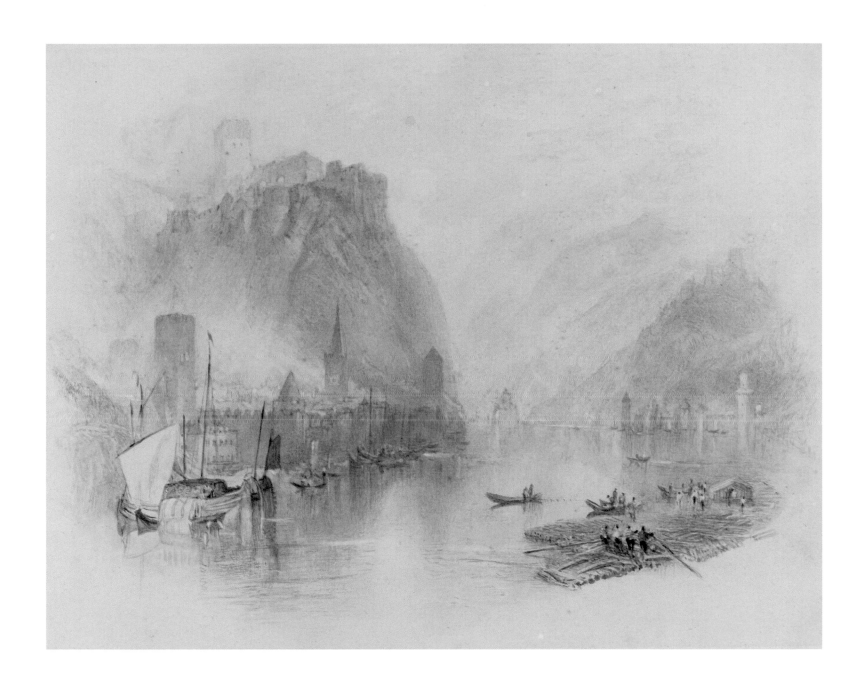

## Below Arvier, looking down the Val d'Aosta towards Mont Emilius, 1836

Watercolour and traces of
graphite on off-white wove
paper, 25.5 x 28.2cm
WATERMARK: B,E, & S, / 1827
PROVENANCE: Henry Vaughan
Bequest, 1900
NGI.2421

In 1836, Turner returned to Switzerland with his patron and friend H.A.J. Munro of Novar (1797-1864). Munro was a wealthy Scottish landowner, amateur artist and art collector. From 1830, he concentrated on collecting the work of J.M.W. Turner and, at its peak, his collection included fifteen oil paintings and some 130 watercolours. Munro's memories provide valuable information about the 1836 tour. In a letter to John Ruskin dated November 1857 Munro summarized their itinerary:

*In 1836 I crossed over to Dover with Turner, then to St Omer, where he sketched with great eagerness [...] All along whenever he could get a few minutes, he had his little sketch book out [...] I don't remember colours coming out till we got into Switzerland.*

Munro goes on to mention Sallanches, Bonneville and Chamonix and notes that they made their way 'onto Courmayer down the Val d'Aosta to Ivria and Turin' where they parted.[1] Turner then made his way back to France via the Mont Cenis pass. What comes across clearly from Munro's lively account is that quick pencil sketches dominated Turner's output for much of the trip. Two sketchbooks are known to definitely relate to this tour, the 'Fort Bard' (TB CCXCIV) and 'Val d'Aosta' (TB CCXCIII) sketchbooks.

This sheet (NGI.2421; W 1441) is relatively large in size, measuring 25.5 x 28.2cm, with two old fold lines visible on the surface. This could indicate that it was once bound into a 'roll' sketchbook. Turner used these sketchbooks, which could be rolled up and carried easily, alongside the smaller pocket-sized hardback books referred to by Munro. The off-white paper is British and is identifiable by a full watermark as being from the papermill of Bally, Ellen and Steart, who also produced the distinctive blue paper favoured by Turner for his colourful gouache studies. This sheet is the only example in the Gallery's collection of the white paper made by this mill.

Henry Vaughan owned seven watercolours from Turner's 1836 tour, three of which he bequeathed to the National Gallery of Ireland and four which went to the National Galleries of Scotland. David Hill has recently re-identified this view which was originally titled 'Tête Noir', a feature in the Villar d'Arene. Turner did not in fact visit this area in 1836. Hill describes this image convincingly as a view of the Val d'Aosta at 'the point at which the road turns the corner below Arvier and the view of Mont Emilus opens beyond. Conditions must have been cloudy on the peak for Turner records only the summit of the Becca di Nona rather than that of Emilius which lies a little to the right'.[2] Hill goes on to point out that Turner took this view in late afternoon, as the sun is picking up the cliff on the left of the composition. His vantage point was most likely on the new road which was constructed around the village of Leverogne to by-pass the narrow main street. The mark-making is exceptionally free and expressive. Turner has used a wide brush to block in the massive shapes of the Alpine landscape in rough washes of ochre, deep blue, burnt umber and black. It would appear that he was working quickly, perhaps perched on a roadside rock high above the valley. **AH**

**1.** Munro's letter is quoted in full in Hill, 2000, p.262
**2.** Hill, 2000, p.283

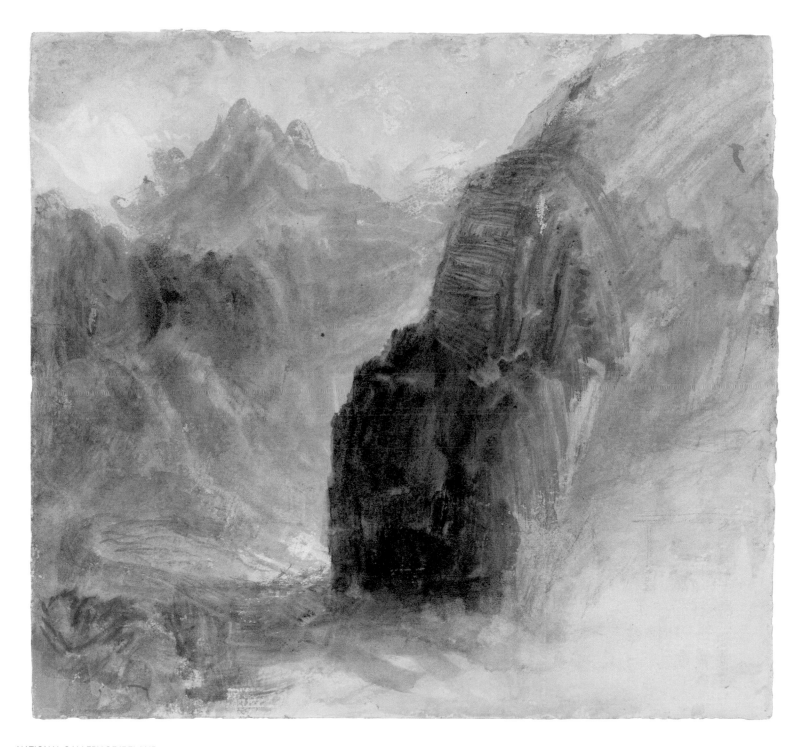

# Châtel Argent above Villeneuve, Val d'Aosta, 1836

Watercolour, gouache and
graphite on off-white wove
paper, 24.2 x 30.4cm
PROVENANCE: Henry Vaughan
Bequest, 1900
NGI.2416

Turner and Munro continued their descent through
the Aosta valley passing the fortified villages of Avise
and Arvier. This sheet (NGI.2416; W 442), one of three
related colour studies, shows the bend in the river as
it meanders down towards the old bridge and town of
Villeneuve in the middle distance. Beyond is the Val de
Rhêmes and the peak of the Grande Rousse mountain.
The focal point is the castle which sits high on the
promontory to the left with the pale church of St Roch
lower down the slope. The road in the foreground,
with heavily laden figures roughly sketched in, is the
road to St Pierre. The tower in the foreground to
the right is the Tour Colin.

Two of the three known watercolour studies of
Châtel Argent were owned by Vaughan, he bequeathed
one sheet to the National Galleries of Scotland (NG
870), while a third is in the collection of the Metropolitan
Museum of Art (40.91.19), (fig. 55). Although these
watercolours relate to pencil drawings in the 'Fort Bard'
sketchbook (tb ccxciv), David Hill argues that they were
probably sketched directly from nature as: 'they are all
from distinct viewpoints, not duplicated exactly by any of
the pencil sketches.'[1] Turner had sketched Châtel Argent
over thirty years before on his first visit to Switzerland in
1802, and a similar view is in his 'Grenoble' sketchbook
(TB LXXIV-68) from that year.

This lower part of the Aosta valley is Italian in
character. Turner creates the impression of a parched
landscape at the end of summer. He uses a great variety
of colours to capture the sun-drenched scene: dusty
pinks and reddish purples along with ochre yellows and
brownish greens. Graphite under-drawing is clearly
visible in the upper part of the composition. On the
verso of the sheet a barely legible inscription, which
appears to read 'Munro' is further proof that this work
dates to 1836.

AH

Fig. 55: J.M.W. Turner, *Châtel Argent and the Val d'Aosta from
the Villeneuve*, 1836. Metropolitan Museum of Art, Public Domain

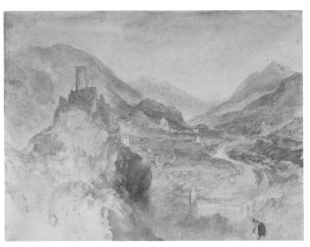

1. Hill, 2000, p.284

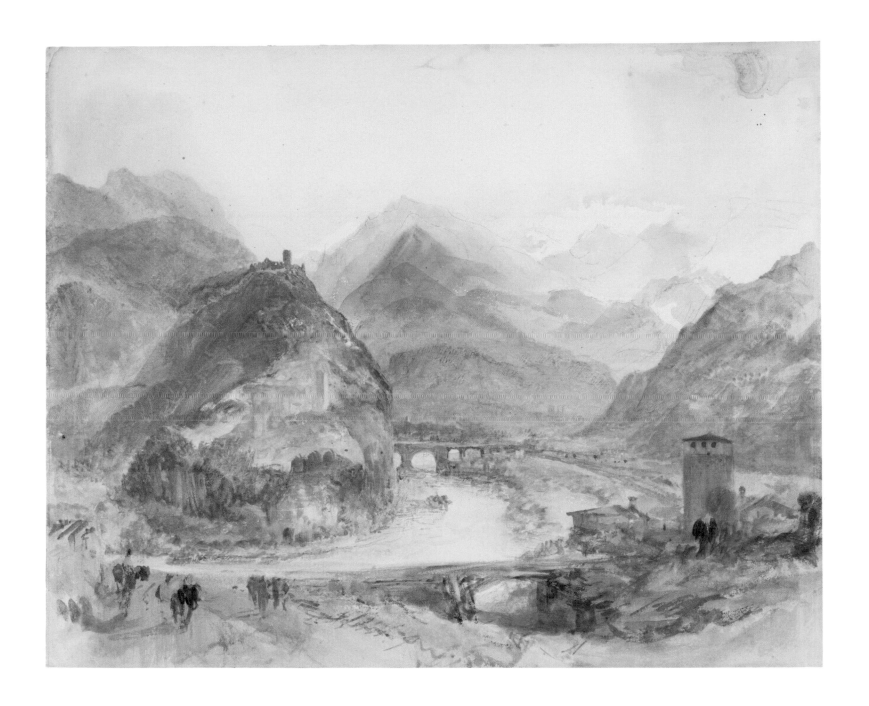

# Montjovet from below St Vincent, looking down the Val d'Aosta towards Berriaz, 1836

Watercolour and gouache with scraping out on off-white wove paper, 24.3 x 30.5cm
PROVENANCE: Henry Vaughan Bequest, 1900
NGI.2419

In Henry Vaughan's original listing this sheet (NGI.2419; W 1443) was identified as 'Stelvio', another Alpine pass far to the east which Turner passed through on his 1842 tour.[1] In 2000, the correct identification of the view was published by David Hill and the watercolour was given the above title.[2] The Alpine pass of Montjovet lies a short distance below the town of Saint Vincent and was in Turner's time a dangerous point for travellers negotiating the Aosta Valley. John Murray's contemporary travel book warns: 'the road ascends steeply on the left of the river, and is cut out of the rock, in some places overhanging the foaming torrent, and where the rock equally overhangs the traveller.'[3]

Although Turner's viewpoint was high above the river, he managed to capture accurately the mists that obscure the valley and town far below. He made a number of pencil sketches recording this location from both above and below. This view, which he decided to work up in colour, evokes the misty, evanescent qualities characteristic of fast flowing Alpine rivers. Turner achieves a great sense of space and distance through overlapping, translucent washes in pastel colours. The technique of scraping out is used to give form and texture to the high sides of the valley but there is little or no delineation of form in actual line. The forms of the valley emerge through sponging, washing in of delicate colours and scraping back of areas of pigment.

A letter from Vaughan's solicitors, dated 14 August, 1900 addressed to Walter Armstrong, Director of the National Gallery of Ireland, referred to a sketch, 'Swiss Landscape' found among Vaughan's effects. This drawing was inscribed 'to go with no. 16'. The solicitors believed that this sketch was related to one of the drawings already bequeathed to Dublin and that,

as such, it also belonged there. Armstrong viewed the sketch in London and, deciding that it was 'of very slight importance', advised the National Gallery of Ireland Board that it 'be not claimed by the National Gallery as its property'.[4] Vaughan's will stated that if his bequest and all its conditions was not accepted the watercolours should be offered instead to the Science and Art Museum (now the V&A).

The delicate watercolour study in blues and yellows titled *A Valley in Switzerland* illustrated below (fig. 56) is in the V&A. The credit line states that it was bequeathed by Mr Henry Vaughan in 1900. I believe this is the watercolour refused by Walter Armstrong. However, comparison with the Alpine views in the Gallery's collection shows that the V&A drawing is closer in terms of general composition to this sheet (NGI.2419) than to (NGI.2416), the 'no. 16' referred to by Vaughan's solicitors. Our drawing may in fact be a reworking of the watercolour view now in the V&A.          AH

Fig. 56: J.M.W. Turner, *A Valley in Switzerland*, c.1842
© Victoria and Albert Museum, London

**1.** In her 1988 catalogue of the Gallery watercolours Barbara Dawson titled it 'An Alpine Pass in the Val d'Aosta'.
**2.** Hill, 2000, p.228
**3.** Ibid, p.289
**4.** Minutes of the Gallery Board Meeting of 29 November 1900

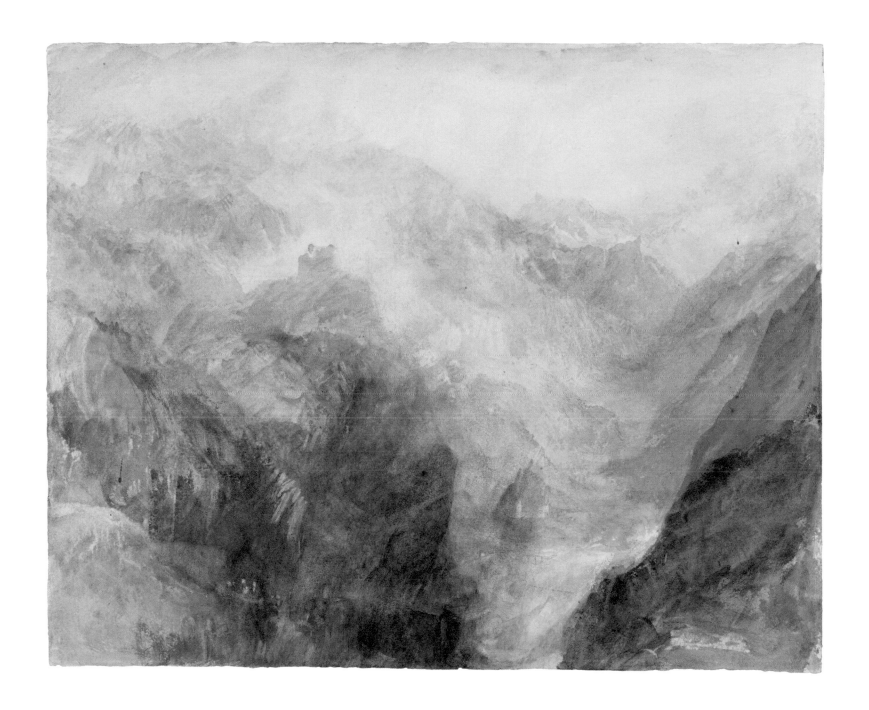

# Le Pont du Château, Luxembourg, 1839

Watercolour, gouache and graphite, with details added using a pen dipped in watercolour, on blue wove paper, 13.9 x 19.2cm
PROVENANCE: Henry Vaughan Bequest, 1900
NGI.2429

On Saturday 3 August 1839 Turner set off for yet another tour of mainland Europe. Bound for Germany, he took a boat to the port of Ostend and went by train to Brussels. Travelling through the newly independent county of Belgium (which had separated formally from the United Provinces of the Netherlands just a few months earlier) he followed the course of the Meuse and Moselle rivers as he had done on his 1824 tour. This later tour lasted about two months and over this time he filled five sketchbooks with quick observational studies in pencil. In addition he produced over 100 richly coloured gouache studies on blue paper.

As Cecilia Powell points out, it was on this tour that Turner made his only known intensive study of Luxembourg. He filled over 30 sketchbook pages with views of the fortified city, the greatest number for any single place on the 1839 tour.[1] Turner's enthusiastic response to the city can be gauged from his sketchbooks. His graphite *aides-memoires* include profiles of fortifications and simplified yet accurate notations of scenes he witnessed. They formed the basis of his bright gouache and watercolour studies on blue paper which, with their rich colouring and high level of detail, were probably worked up later, at an inn or back in his London studio.

The Dublin sheet (NGI.2429; W 1010) which Powell refers to as: 'one of the most brilliant of all his gouaches', relates to sketches in the 'Givet, Mézières, Verdun, Metz, Luxembourg and Trèves' sketchbook (TB CCLXXXVIII). The title of the sketchbook (of continental manufacture with marbled boards) alludes to the breadth of this tour. Two sketches in this book, sheet 61 (verso) and sheet 62 (fig. 57), probably inspired the Dublin gouache. Turner's viewpoint was in the Alzette valley directly below the Pont du Château looking east towards the Rocher du Bock with the fortified towers of the Rham in the distance. Turner has used artistic license here to create an incredibly dramatic composition full of contrasting lights and darks. He exaggerates the depth of the valley and the height of the fortresses above to great effect.

Once again, Vaughan's ability to acquire truly magnificent examples of Turner's work over all periods of his career is obvious in this case. Vaughan's original list describes this sheet as a 'very good watercolour' of Sisteron in Provence, giving it the relatively high value of £200. It was published as a view of Sisteron by Armstrong in 1902, although he queried the correctness of this identification noting that Ruskin had 'doubtfully' stated that it could be a view of Luxembourg. The title of the drawing was not amended until the 1980s.[2] At one time Vaughan owned another similarly dramatic gouache *View of Luxembourg from the South* (private collection).[3]

AH

1. Powell, 1991, p.45
2. Letter in Gallery Archives (dossier file NGI.2429) from Jean-Claude Muller, dated 22 July 1982. Muller points out that it is a view of the Pont du Château, Luxembourg. This title was published in Barbara Dawson's 1988 catalogue.
3. This sheet is reproduced in Powell, 1991, p.175

Fig. 57: J.M.W. Turner, *The Bock, Luxembourg, and St John's Church, from the South-West*. D28276. Photo © Tate

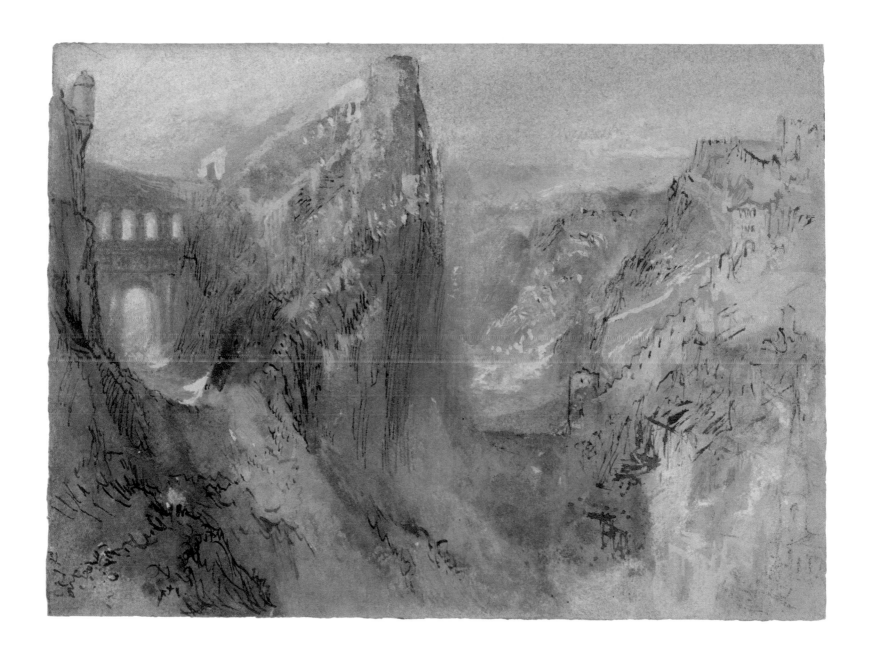

# Bregenz, above the Bodensee, Austria, c.1840

Watercolour, graphite, gouache
and charcoal on blue paper,
19 x 28cm
PROVENANCE: Roland L'Estrange
Bryce (d.1953), transferred from
the Office of Public Works, 1972
NGI.7511

Bregenz is a picturesque town in the western Austrian province of Vorarlberg. It is located on the eastern shore of the Bodensee, which Turner would have known as Lake Constance. Turner passed through the town on his way to Venice in 1840. Turner has made use of artistic license in creating this evocative vista (NGI.7511; W 1351), although he captures the misty blue appearance of the distant Alps accurately. He shows the sun setting over the lake, to the south. In fact, if he had been truthful, the sun would have been out of view to the right of the picture. The hill in the foreground, roughly indicated by black wash and charcoal, does not exist in reality and Turner has emphasised the Martinsturm with its distinctive onion dome to make it more dominant.[1] The ancient town of Bregenz was visited in the seventh century by the Irish missionary St Gall, one of the twelve companions of Columbanus. The Gallus Kirche named after the Irish saint is shown to the far left of the composition.

Turner made a number of quick graphite sketches of the town in the small 'Rotterdam to Venice' sketchbook (TB CCCXX). These sketches may have inspired worked up drawings like the Dublin sheet, which is one of a group of four views of Bregenz on continental blue paper that are similar in terms of technique and size.[2] Until quite recently they had not been identified as views of Bregenz. The Dublin watercolour was known until the 1980s as *Rapperswil*, while the Courtauld's sheet (D.1967.WS.96; w 1350), a worked up image on an identically sized sheet of blue paper was traditionally identified as a view of Locarno (fig. 58). The Dublin watercolour was catalogued as *Rapperswil* due to a handwritten inscription on a label on the back of the frame. Rapperswil is a picturesque town on Lake Zurich which Turner passed through in 1842. In 1982 Dr Oscar Sandner identified this sheet correctly as a view of Bregenz.[3]

It is possible that this watercolour was painted 'on the spot' as there is a spontaneous quality to the mark-making. The paint is loosely handled with only the more important aspects of the composition rendered in any detail. David Hill states that 'Turner takes in quite a wide field of view and takes quite a synthetic view of the space but nonetheless all the elements give every appearance of having been recorded direct from nature.'[4] This sheet was owned by the Bryce family in the twentieth century and formed part of the contents of Bryce House on Garinish Island, County Cork, bequeathed to the State in 1953. In 1972 it was transferred to the National Gallery of Ireland by the Office of Public Works.

AH

Fig. 58: J.M.W. Turner, *View of Bregenz*, 1840
Photo © The Samuel Courtauld Trust, The Courtauld Gallery,
London / Bridgeman Images

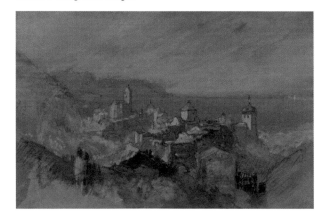

**1.** Information provided by Kurt Grabher, an Austrian familiar with landscape around Bregenz, who viewed the watercolour in 2006.
**2.** Paper expert Peter Bower recently discovered that the flecked blue paper is continental, which makes these watercolours unusual since at this point in his career Turner tended to bring supplies of English made blue paper on his travels.
**3.** National Gallery of Ireland Archive, dossier file NGI.7511. Dr Sandner published this title in his 1983 book, *Bregenz*.
**4.** E-mail correspondence, 25 May, 2012.

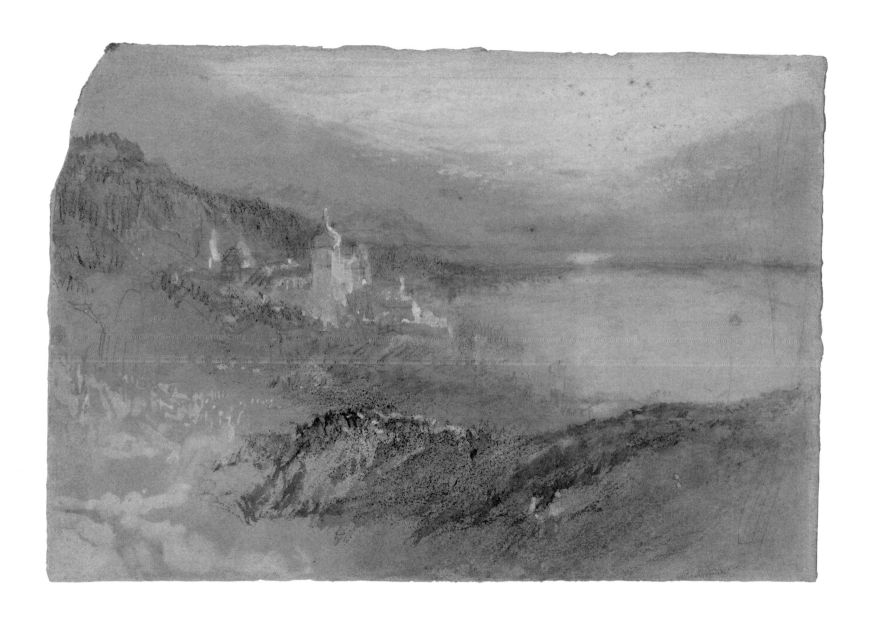

# Storm at the Mouth of the Grand Canal, Venice, c.1840

Watercolour and white
highlights, with details
added using a pen dipped in
watercolour, on off-white wove
paper, 21.8 x 31.9cm
PROVENANCE: Henry Vaughan
Bequest, 1900
NGI.2426

Venice held a special fascination for Turner. In addition to scores of pencil sketches and oil paintings, he produced some 170 watercolours of this magical city, nine of which were owned by Henry Vaughan.[1] This watercolour (NGI.2426; W 1358), one of his more finished Venetian watercolours, once formed part of the so-called 'Storm' sketchbook which Turner used during and after his third and final visit to the city in 1840. During his fourteen-day trip, between 20 August and 3 September,[2] the sixty-five year old artist stayed at the Hotel Europa on the Grand Canal. It has been suggested that the 'Storm' sketchbook was left with Turner's agent Thomas Griffith, who offered the drawings for sale after the artist's death.[3] Nineteen sheets which probably once formed part of this sketchbook have been identified.[4]

This watercolour, which displays Turner's experimental and spontaneous approach, is one in a series that charts the sudden arrival of a late afternoon squall. His application of fluid washes evokes the sense of a city drenched by rain. He obscures all precise topographical detail, preferring to capture dramatic atmospheric effects by merging broad washes of colour. The ominous rain-cloud, a mass of blue and mauve wash, dominates the scene, while numerous canal buildings are delineated with a skein of fine vertical red lines, a typical feature of the artist's late style. Against the dark sky, the Campanile of San Marco stands out a stark white, while to the right San Giorgio Maggiore glows orange.

This watercolour reveals Turner's method of working up his vivid impressions of violent weather once back in the safety of his hotel room. The artist Clarkson Stanfield (1793-1867) observed very stormy weather in October 1830: 'Woe betide the Gondoliers that have not

time to get home before the riot commences! They are knocked about like egg-shells...the inhabitants crowd upon their terraces to look on in silent alarm [...] All Venice is in an uproar.'[5]

As usual, Turner's interest in human incident is clear. Prominently positioned in the foreground is a gondolier, straining to reach shelter. Ian Warrell notes that in several of the 'Storm' sketchbook watercolours: 'Turner deployed to great effect the black silhouette of a gondola, creating a sharp distinction between its inescapable solidity and the limpid washes of the surrounding reflections.'[6] Two equally dynamic watercolours from the 'Storm' sketchbook, depicting the arrival of a thunderstorm on the Lagoon include: *Venice, A Storm*, 1840 (British Museum; W 1354), (fig. 59) and *Venice: looking towards the Dogana and San Giorgio Maggiore, with a Storm Approaching*, 1840 (private collection; W 1355).

NMN

Fig. 59: J.M.W. Turner, *A Storm on the Lagoon, Venice*, c.1840
© The Trustees of the British Museum

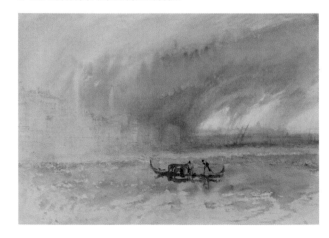

**1.** Six of Vaughan's Venetian watercolours are now in the National Galleries of Scotland and three are in the National Gallery of Ireland.
**2.** See Cecilia Powell's essay 'Approaches to Venice' in Warrell, 2003, pp.30-33 for an in-depth account of the routes taken by Turner on his visits both to and from Venice in 1819, 1833 and 1840.
**3.** Warrell, 2003, p.258
**4.** See Warrell, 2003, p.258, for a detailed listing of the present locations of the 'Storm' sketchbook sheets.
**5.** Van der Merwe, 1979, p.118
**6.** Warrell, 2003, p.168

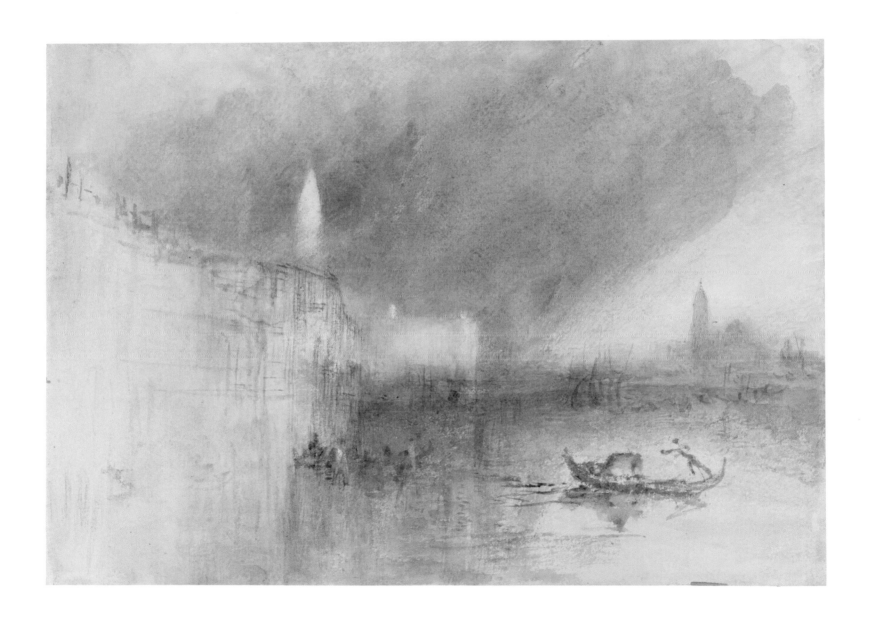

# The Doge's Palace and Piazzetta, Venice, c.1840

Watercolour, white highlights and scraping out, with details added using a pen dipped in watercolour, on off-white wove paper, 24 x 30.3cm
WATERMARK: C ANSELL 1828
PROVENANCE: Henry Vaughan Bequest, 1900
NGI.2423

This highly finished watercolour (NGI.2423; W 1356) belongs to a series of expressive works produced around the time of Turner's Venetian tour of 1840. Turner creates a luminous, hazy atmosphere by intricately weaving together contrasting colours into a harmonious whole. These chromatic combinations reveal his ability to capture the effects of sunlight, in particular the distinctive golden light of late summer, which here is shown enveloping the city. Walter Armstrong described this watercolour in glowing terms: 'It is an exquisite pattern of colour, held together by prismatic truth, by the sense it conveys of a beam of white light laid open and analysed.'[1]

Mirrored in the aquamarine waters, the rosy red façade of the Doge's Palace and the mauve coloured Biblioteca Marciana and Palazzo della Zecca (the mint) appear ephemeral and weightless. Turner imbues the floating city with a sense of mystery and wonder. He shows how one's ability to perceive the buildings in sharp focus is inhibited by the glare of the setting sun that glows intensely behind the top south-west corner of the Doge's Palace. The gondolas, with their distinctive black outlines, give substance to this otherwise evanescent vision. Skilfully using a pen dipped in red watercolour Turner delineates some features more accurately, such as the decorated sails of possibly Venice's local fishing craft, known as *bragozzi*, as well as the canopy of a gondola in the foreground and some figures. Even the lozenge-shaped pattern across the upper level of the Doge's Palace is hinted at by way of these scratchy pen lines.

Another equally finished watercolour of the Doge's Palace, taken from the opposite direction is *The Piazzetta, Venice*, 1840, with its brilliant crack of lightning, which illuminates the sky and part of the Basilica di San Marco. This dramatic watercolour, which originally came from the 'Storm' sketchbook, now forms part of the Vaughan Bequest at the National Galleries of Scotland (W 1352), (fig. 60).          NMN

Fig. 60: J.M.W. Turner, *The Piazzetta, Venice*, 1840, D NG 871
National Galleries of Scotland, Henry Vaughan Bequest, 1900

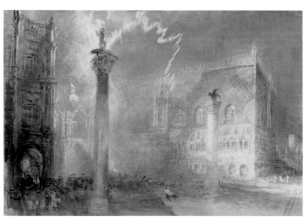

1. Armstrong 1902, p.139

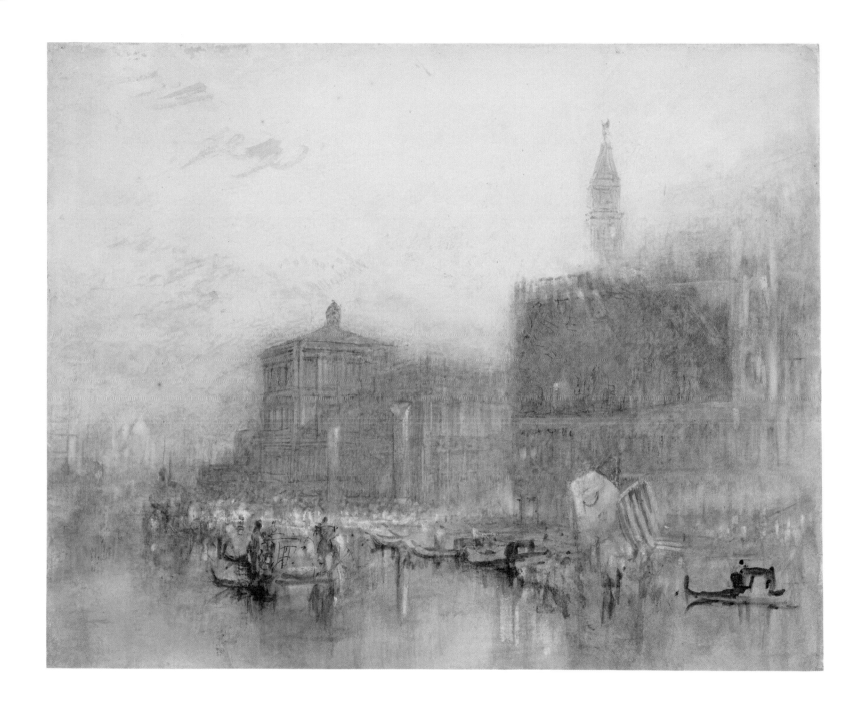

# San Pietro di Castello at Sunrise (formerly identified as San Giorgio Maggiore), c.1840

Watercolour and graphite
on off-white wove paper,
22.5 x 29cm
PROVENANCE: Henry Vaughan
Bequest, 1900
NGI.2417

This watercolour was newly identified and re-titled by Ian Warrell in October 2012.[1] The church of San Pietro di Castello stands on a small island to the east of the city. The watercolour was clearly painted during, or shortly after, Turner's final stay in Venice at the end of August 1840. This was his longest stay in the city and his most productive: he filled at least two roll sketchbooks with watercolour studies, as well as working on many other loose sheets of paper.[2] The dimensions of this sheet are very similar to those of the pages of the roll sketchbooks (22 x 32cm), although the width may have been trimmed.[3]

The subject of the image has been a matter of some uncertainty, with most scholars eventually linking it with the other views Turner made of Palladio's island church of San Giorgio Maggiore.[4] As this landmark dominates the Bacino di San Marco, directly opposite

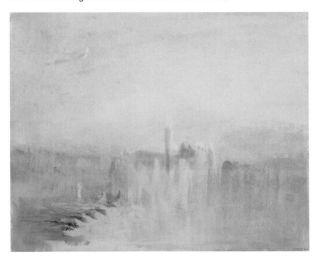

Fig. 61: J.M.W. Turner, *Venice: San Giorgio Maggiore at Sunset, from the Riva degli Schiavoni.* D32161. Photo © Tate

the Doge's Palace and the Piazzetta, it would seem to be a logical conclusion. However, the details of the architecture are not altogether consistent with the actual building, especially the gap between the church and its campanile. Unlike San Giorgio Maggiore, the church of San Pietro di Castello stands far apart from its fifteenth-century belltower.

A more convincing identification of the island in question can be made by considering this colour study alongside Turner's other Venetian watercolours and pencil sketches made in 1840. Many explore the eastern end of Venice, dominated by the dockyards of the Arsenale, while some watercolours in the Turner Bequest show the view back to the centre of the city from the long quayside.[5] In his pencil notes in the 'Venice and Botzen' sketchbook, Turner also ventured into the narrow canals to see the city's original cathedral San Pietro di Castello on the island of Olivolo (TB CCCXIV 26, 27 verso, 45, 46 verso, 47). It appears to have been late in the day when Turner made these pencil sketches, as they are not very precise or detailed. This would help to explain the vagueness in the way he later developed this watercolour study of the church. Here, Turner makes use of the open waters he remembered around the island to recreate the dazzling effect of sunrise. As in some of his other works, the effect depicted has, in the past, been mistaken for a sunset.

The church in the Dublin watercolour is barely recognisable as it has been simplified and reduced down to its most rudimentary forms. Solid form appears liquefied by intense light. A watercolour that displays a similarly fluid treatment is *Venice: San Giorgio Maggiore at Sunset, from the Riva degli Schiavoni,* 1840 (TB CCCXVI 24), (fig. 61).

NMN

1. The Gallery is grateful to Ian Warrell for bringing this new information to our attention.
2. See Lindsay Stainton, *Turner's Venice*, 1985; and Ian Warrell, *Turner and Venice*, 2003.
3. The 1834 Whatman watermark visible on other related pages is not present on this sheet.
4. The original listing of the National Gallery of Ireland Vaughan Bequest watercolours of 1900 identified this sheet as: 'Venice – San Giorgio – water colour sketch £20.'
5. Warrell, 2003, pp.230-1, figs. 249-251

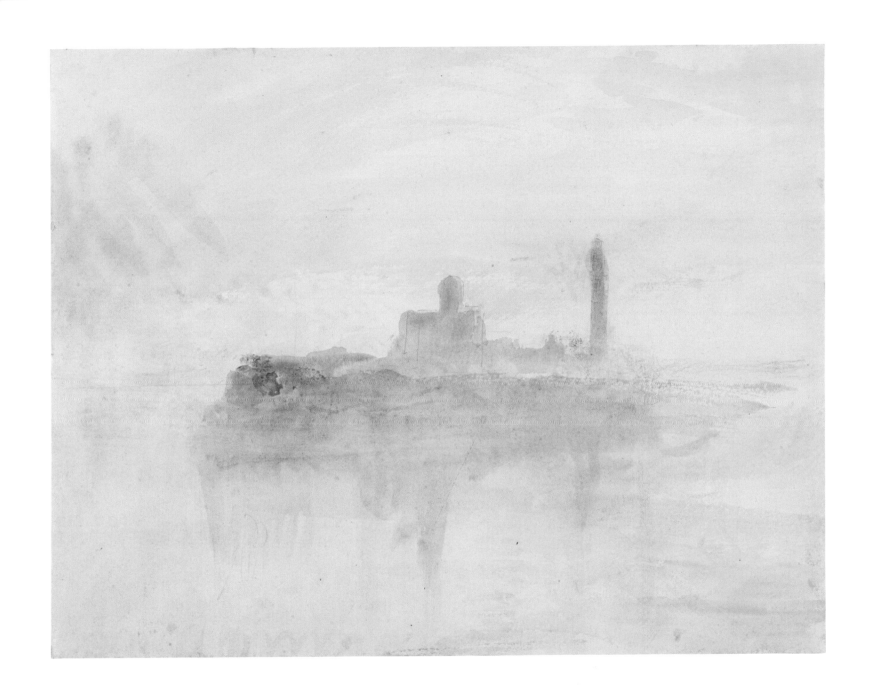

# Passau, Germany, at the Confluence of the Rivers Inn and Danube, 1840

Watercolour and graphite, with details added using a pen dipped in watercolour, on off-white wove paper, 24 x 30.3cm
INSCRIBED on verso: Ratisbon - Passau
PROVENANCE: Henry Vaughan Bequest, 1900
NGI.2418

Passau, in the southeast of Germany at the border with Austria, is known as the 'Three Rivers City', due to its position at the confluence of the rivers Danube, Inn and Ilz. Parts of the old town were rebuilt in the seventeenth century by Italian Baroque masters after a devastating fire. The impressive cathedral of St. Stephan with its high octagonal onion-domed tower is visible in the centre of Turner's panoramic view. To the right, high above the town is the majestic Oberhaus fortress, guarding the confluence of the Danube and the Ilz. Turner made three tours through Germany during the 1830s. He passed through the country again in 1840 when he made his only known visit to Passau.[1] He travelled with small hard-cover sketchbooks, larger soft-bound 'roll' sketchbooks and a good supply of loose sheets of paper. The dimensions of this drawing correspond to those of many of the drawings associated with his visit to Venice in 1840.[2]

On his return from Venice in 1840, Turner took a steamship across the Gulf of Trieste, which spared him the inconvenience of crossing the Alps by road. He continued north to Vienna and then up the Danube past Passau to Regensburg (then known as Ratisbon). This part of Turner's itinerary may be traced through his pencil sketches in the 'Trieste, Graz and Danube'

sketchbook (TB CCXCIX) and the 'Venice; Passau to Würzburg' sketchbook (TB CCCX). The inscription in Turner's handwriting on the back of the sheet (published here for the first time) may indicate the towns he wished to visit on his itinerary (fig. 62).

In the Dublin watercolour (NGI.2418; W 1317), the artist's delicate palette and emotive response to the landscape echoes the effects he achieved in his late Venetian works. A hazy blue atmosphere, created by the shimmering mists rising from the two rivers and the steam of the ferries that journeyed between Passau and Kinz suffuses the entire scene. This magical vista, bathed in a luminous, translucent light, exudes a dreamlike charm. Some features dissolve while others emerge from the rising mists. Turner used a pen dipped in red-brown watercolour to define elements like the castellated buildings to the right and the figures and steamboats to the left more precisely. This is a typical feature of his late style.

Fig. 62: NGI.2418. Inscription on the verso of the sheet: 'Ratisbon-Passau'.

**1.** See Powell, 1995, pp.68-70, 157-64, for detailed information on Turner's visit to Passau.
**2.** See Warrell, 2003, p.259, for information on the papers used for the Venetian watercolours.

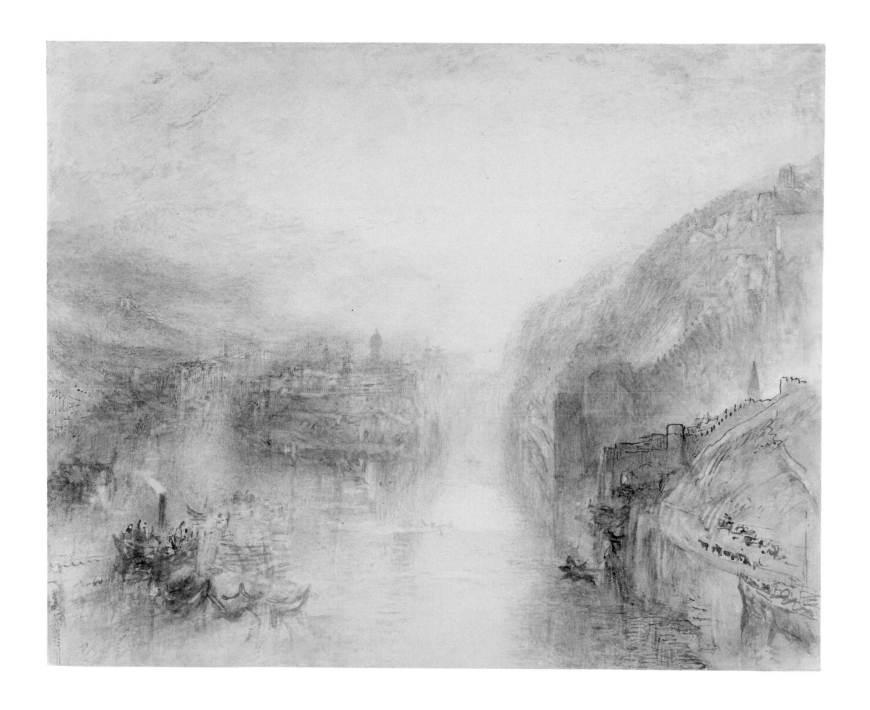

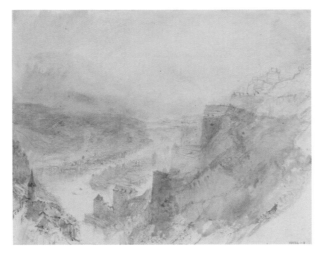

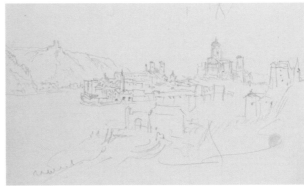

There is a small group of equally atmospheric studies of Passau dated to 1840 in the Turner Bequest at Tate Britain. These expressive studies, some on small loose sheets of grey paper, some on white paper from the 'Passau and Burg Hals' sketchbook (TB CCCXL), (fig. 63) reveal how Turner drew this city from a multitude of different perspectives and viewpoints, endlessly evoking its unique and intriguing qualities. In pencil sketches such as *Passau: The Confluence of the Ilzstadt*, 1840, (fig. 64) from the 'Venice; Passau to Würzburg' sketchbook (TB CCCX), one can see how Turner jotted down accurate topographical information on the city and its surroundings 'on the spot'. In contrast to what Turner would have observed at ground level, the Dublin watercolour presents an imaginary bird's eye view of the city. Between 1840 and 1845, Turner favoured evocative or ethereal views like this, where atmosphere takes precedence over precise detailing. **NMN**

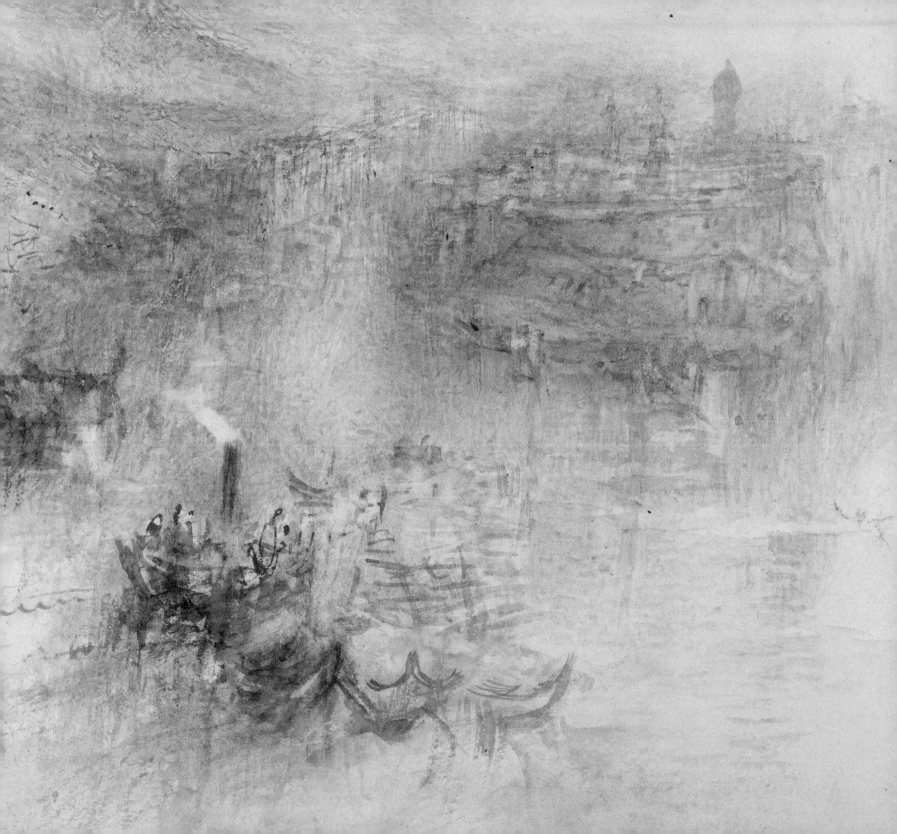

# Ostend Harbour, c.1840

Watercolour with scraping
out on ivory wove paper,
25 x 36.6cm
PROVENANCE: Henry Vaughan
Bequest, 1900
NGI.2425

Until recently, this watercolour was known as *Great Yarmouth Harbour, Norfolk*, c.1840 (NGI.2425; W 1408). Wilton grouped it, on stylistic grounds, with five other views (W 1405-1410), traditionally known as Yarmouth subjects.[1] Ian Warrell has proposed that this richly coloured view depicts the coast at Ostend.[2] In 2007, a related watercolour, known as *Yarmouth Roads*, c.1840 (Lady Lever Art Gallery, National Museums Liverpool; W 1409), was also identified by Warrell as an Ostend view.[3] He suggested that the above watercolour, newly titled, *A Steamer off Ostend, with the Rising Moon*, c.1840, could possibly have been the germ of the composition for Turner's visionary late oil painting *Snow Storm – Steam Boat off a Harbour's Mouth Making Signals in Shallow Water, and Going by the Lead* (exhibited RA 1842).[4] Warrell also identified another of Wilton's Yarmouth subjects (*?Yarmouth, Norfolk, ?c.1840*; W 1405), showing seagulls circling above fish caught in a net on the shore, as a view of Ostend (Ashmolean Museum, Oxford).[5] This brings to three the number of watercolours now securely identified as being views of Ostend.

On the final leg of Turner's return journey home from Venice in 1840 he followed a familiar route, travelling down the Rhine to Cologne and on to Ostend.[6] When one examines Turner's 'Würzburg, Rhine and Ostend' sketchbook, 1840 (TB CCCIII) it becomes clear that the location of the Dublin watercolour is indeed Ostend. In a number of sketches the placement of the windmill behind the lighthouse is similar to that shown in the Dublin watercolour (TB CCCIII 6 a & 19). In numerous sketches Turner roughly denotes the windmill itself with an X, while in others he details the upper part of the lighthouse more precisely (TB CCCIII 4 a). The first page

of the sketchbook also relates to the Dublin watercolour as it shows sketches of sunset (TB CCCIII 1). On another page, Ostend's harbour walls and fortifications are shown in addition to its curving coastline (TB CCCIII 18). To the left of this same sheet is a sketchy shape, possibly a figure, similar to the lone figure in the Tate watercolour (fig. 65).

During the 1840s, Turner produced many vividly-coloured watercolour studies of beaches and skies using loose, fluid washes. Most appear to have been made for the artist's own satisfaction rather than as preparatory studies for finished pictures. The spectacular sunset in the Dublin watercolour enhances the overall mood of reflection. Turner is more concerned with presenting an impression of the rich colours and effects of sunset rather than an accurate topographical record.

NMN

**1.** Owing to their similar size Wilton thought it likely that these leaves came from the same sketchbook. Also, due to the technical features they shared with some of the artist's Venetian colour studies he conjectured a date of c.1840.
**2.** Email correspondence, 29 June 2012
**3.** Warrell, 2007, p.192, fig.38
**4.** Ibid
**5.** Warrell, 2007, p.198
**6.** Warrell, 2003, p.33

Fig. 65: J.M.W. Turner, *Ostend: Harbour*
D30492. Photo © Tate

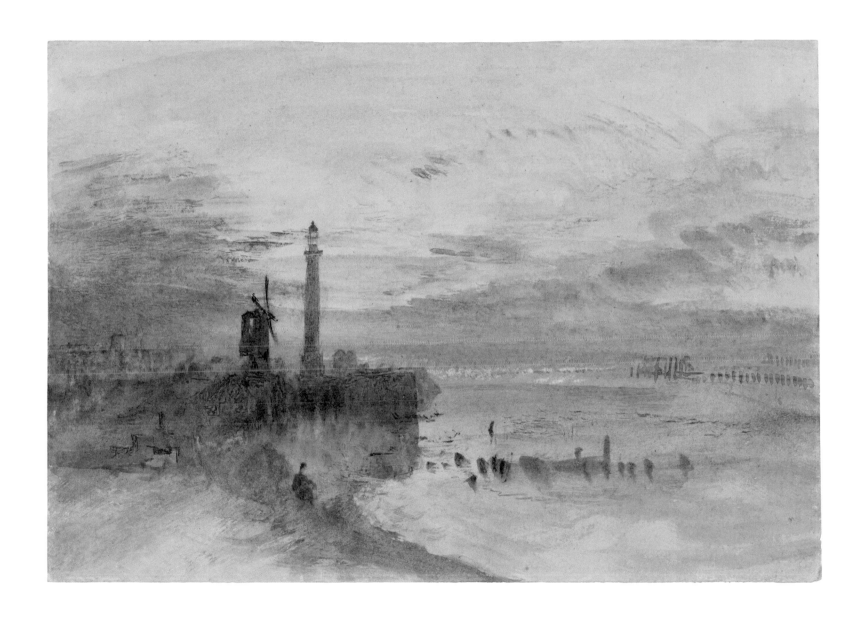

# Lake Lucerne from Flüelen, 1841

Watercolour and graphite with white highlights on ivory wove paper, 23 x 29.1cm
WATERMARK: J WHATMAN/ TURKEY MILL/ 1840
PROVENANCE: Henry Vaughan Bequest, 1900
NGI.2427

Turner made Switzerland the focus of his last major excursions between 1841 and 1844. He was first inspired by Lake Lucerne in 1802, and made it his base on several occasions during his late tours. Turner revered the dramatic scenery, which served as a powerful stimulus for his imagination. His deep interest is evident in the many rapidly sketched memoranda found in his sketchbooks. This view (W 1476) is taken from near the village of Flüelen at the southern end of the lake, which was a significant point on the route to Italy via the St Gotthard Pass. Turner had painted the large watercolour, *Lake of Lucerne, from the landing place at Flüelen, looking towards Bauen and Tell's Chapel, Switzerland*, (RA 1815) for his patron and friend Walter Fawkes (private collection; W 378).[1] In the foreground of that detailed watercolour, a group of people, including women and children, some laden down with baskets, are shown disembarking from rowing boats, while in the middle-ground boats sail towards the shore.

A coloured sketch on a loose sheet from the same viewpoint as the Dublin drawing, looking north down Lake Lucerne is in the Turner Bequest at Tate (TB CCCLXIV 344), (fig. 66).[2] A view of the lake looking in the opposite direction entitled *Lake Lucerne: the Bay of Uri, from Brunnen*, c.1841-42 (TB CCCLXIV 342) is also part of the Turner Bequest at Tate (fig. 67). That watercolour, showing boatmen and traders ferrying goods across the lake, exudes something of a similar mood as the Dublin watercolour while echoing its composition in reverse.[3]

Turner worked up some of the Swiss watercolour sketches in his 'roll' sketchbooks into a series of sample studies. These gave a sense of the composition without any elaborate or specific detail. Through his agent Thomas Griffith (fl.1831-1869) he showed these sketches to a select group of potential patrons, who commissioned him to produce larger, finished watercolours from their chosen samples. The 26 finished watercolours made from these studies were sold in three sets between 1842 and 1845.[4] Over half of these 26 finished watercolours showed Lucerne, testament to the deep impression the place made on Turner.[5]

The Dublin watercolour bears a strong resemblance to *Flüelen: Morning (Looking towards the Lake of Lucerne): Sample Study*, c.1844-45 (TB CCCLXIV 282), which led to the finished watercolour *Flüelen: Morning (looking towards the lake)*, 1845 (Yale Center for British Art, New Haven; W 1541), (fig. 68). H.A.J. Munro of Novar, one of Turner's principal patrons, was the first owner of the Yale watercolour, but he later exchanged it for a Swiss subject owned by Ruskin. When Ruskin himself visited Flüelen in 1852 he confirmed the accuracy of

Fig. 66: J.M.W. Turner, *The Lake of Lucerne from Flüelen* D36204. Photo © Tate

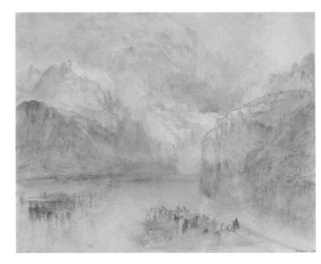

1. Wilton, 1979, p.99
2. Warrell, 1995, p.80
3. Cecilia Powell suggested the link between these two views of Lake Lucerne, e-mail correspondence 4 September 2012.
4. See Warrell, 1995, pp.149-155 for the definitive modern account and detailed listing of the origins of the late Swiss watercolours.
5. Turner produced a further two sets of finished watercolours between the years 1847-51, including two dating to 1847-48 and ten dating to c.1845-51.

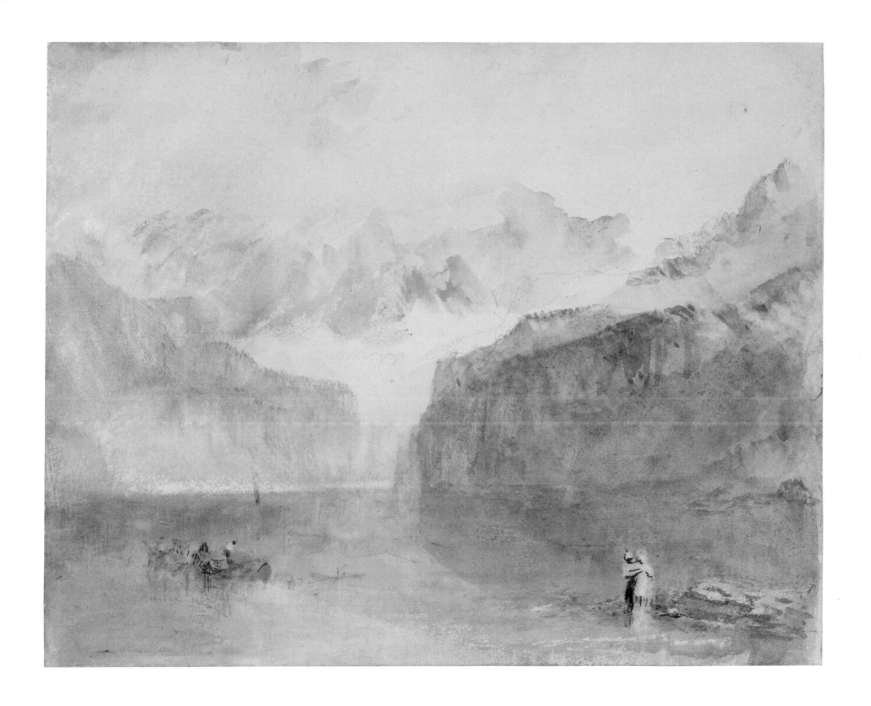

Fig. 67: J.M.W. Turner, *Lake Lucerne: The Bay of Uri, from Brunnen*, c.1841-42. D36202. Photo © Tate

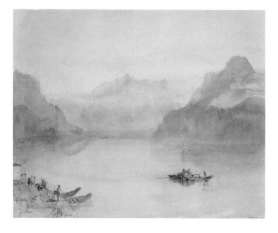

Opposite: NGI.2427 (detail)
Fig. 68: J.M.W. Turner, *Flüelen: Morning (looking towards the lake)*, 1845
Yale Center for British Art, Paul Mellon Collection, B1977.14.4715, Public Domain

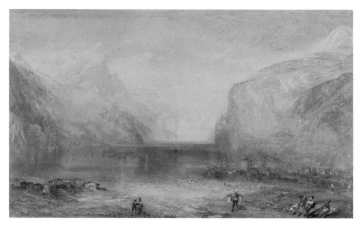

the individual features shown in the view now in Yale. However in his diary he noted, 'there is no point from which he could have got his view. He supposes himself in the air.'[6] Ruskin also assumed that Turner made studies from the window of his inn.[7] In Turner's depictions of the village of Flüelen itself he tended to focus on its most prominent buildings: the Baroque church of Saints George and Nikolaus and the medieval keep known as Schlösschen Rudenz. In contrast to the Dublin view, the Alpine peaks in the finished watercolour at Yale are set further back. Overall the Dublin view is less expansive, as the village of Flüelen (to the right) is not visible, its proximity merely suggested by a building at the water's edge. Two other watercolours depicting Flüelen from Lake Lucerne, dating to c.1841 and 1845 respectively, are in the Fitzwilliam Museum, Cambridge (W 1483) and The Cleveland Museum of Art (CMA, 1954.129; W 1549). An atmospheric night-time scene *On Lake Lucerne looking towards Flüelen*, ?1841 that once belonged to Henry Vaughan, now forms part of the Courtauld's collection of Turner watercolours (D.2007.DS.47; W 1479).

Turner's concern in these late Swiss watercolours is to register subtle gradations of light, by layering translucent washes with minute weaves of hatched and stippled colour. In the Dublin sheet only a faint under-drawing can be seen in the area of the mountains. Tinted mists descend from the mountainsides down to the glacial waters, evoking an overall sense of tranquillity and calm. Using a red-brown pigment, possibly applied with a very fine brush in this instance rather than a pen, the artist picks out the craft on the lake and the figures on the shore, which adds definition to this otherwise ghostly mirage. A couple of fingerprints are visible at the lower left hand corner of this drawing in the turquoise waters, which testifies to the fact that Turner handled his watercolours while they were still wet.                    NMN

**6.** (*Works*, XIII, p.460, n.2) cited in Warrell, 1995, p.79
**7.** Warrell, 1995, p.80

# Sketch: Lake Lucerne from Flüelen, 1841

Watercolour and graphite
on cream wove paper,
21.3 x 28.2cm
WATERMARK: J WHATMAN/
TURKEY MILL/ 1840
PROVENANCE: Henry Vaughan
Bequest, 1900
NGI.2428

This slight sketch[1], measuring 21.3 x 28.2cm (NGI.2428; W 1477), was taken from a similar viewpoint as the more developed sketch *Lake Lucerne from Flüelen* (NGI.2427; W 1476). However, Ian Warrell notes that the view 'appears to have been taken from a raised position, since it includes a wide expanse of foreshore [...] where traders and boatmen are seen at work.'[2] Turner chose to leave the entire foreground area free of watercolour. He used abbreviated pencil marks to sketch in the jetty that projects out into the lake on the left, as well as the boats, figures and animals that mingle along the water's edge. For Turner, human incident was always an integral aspect of his overall design. He employed translucent washes in yellow and pink to block in the masses of the mountains that sweep down to the lake. A subtle turquoise wash indicates the calm waters, while a faint blue (smalt) stain, dabbed on in places, reveals a cloudy sky. Turner's skill is in using the swiftest wash of the palest tint to convey the evanescent atmosphere.

A connection could be made between this brief sketch and the more detailed colour study *Lake Lucerne from Flüelen ('The First Steamer on the Lake of Lucerne')*, 1841, (fig. 69) bequeathed by Henry Vaughan to University College London in 1900 (UCL EDC 2176; W 1482). Although the Alpine peaks are obscured by clouds and swirling mists in that watercolour, the overall vantage point is similar to that of the Dublin sketch. Both works depict locals busily disembarking from boats, some carrying heavy loads. The jetty, merely hinted at in the Dublin sketch, becomes a prominent feature in the UCL watercolour.

In the more developed watercolour a steamboat is clearly discernable on the lake. Seen by Turner as a symbol of positive change in an industrial age, the steamboat churns out smoke that merges with the diaphanous sweeps of cloud and mist. The vertical dash of pigment, left of centre in the other Flüelen sketch (NGI.2427), could indicate either a sailing boat or steamboat. The two Dublin works (NGI.2427 and NGI.2428), and the watercolour now housed in UCL are all sketches or independent studies, showing varying degrees of finish. Between them they illustrate the range of Turner's sketching practices, from rudimentary record-keeping to a fully resolved composition. Despite the evident connections between the UCL and Dublin studies, Vaughan chose to break up this group of watercolours and bequeath them to separate public institutions. Following the example of Ruskin, he spread his collection between institutions so that many could study and enjoy the works. In 1861, Ruskin gifted 25 Turner watercolours to the Fitzwilliam Museum, Cambridge, and earlier that year gave a group of 48 watercolours and drawings to the University of Oxford, where he had studied from 1837-41.    NMN

Fig. 69: J.M.W. Turner, *Lake Lucerne from Flüelen (The First Steamer on the Lake of Lucerne)*, 1841. Photo © UCL Art Museum, University College London / Bridgeman Images

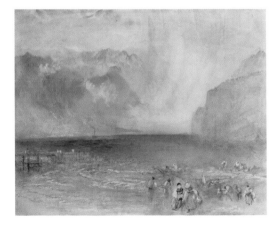

**1.** Ian Warrell has noted that the dimensions of this sheet suggest that it has been trimmed (both height and width) at some point. Email correspondence, 7 September 2012.
**2.** Warrell, 1995, p.80

# A Shower over Water, traditionally called Lake Lucerne, 1841-45

WATERMARK: TURKEY MILLS/
J WHATMAN/ 1818
Watercolour on ivory wove
paper, 22.5 x 28.9cm
PROVENANCE: Henry Vaughan
Bequest, 1900
NGI.2422

Turner continuously studied the changing tempers of the elements. In this sketch, he has reduced the sea and sky to their simplest representation (NGI.2422; W 1475). Using a few broad horizontal washes of colour dragged with a brush, he captures a raincloud as it sweeps across an expanse of water. Turner often exploited the fact that translucent washes allowed the brightness of the paper to enhance the colours. Here, he has left the white paper exposed in the foreground to represent the surface of the calm water, while directly under the mass of cloud he has applied dark brown pigment in jagged lines to indicate the crests of choppy waves. Informal studies like this were intended for private reference, an essential aspect of Turner's working process. They also provided the stimulus for creating more detailed and complete work.

The inherent characteristics particular to watercolour enabled Turner to capture meteorological effects with a sense of immediacy. Colour studies were as much a product of his vivid imagination and recollections as of direct observation. Turner was particularly interested in the dynamic movement and changeability of clouds, which he evoked through gestural mark-making and spontaneous chance effects in watercolour. In many storm and raincloud studies he applied washes of different strengths to conjure up the effects of agitated weather at sea. In the experimental study *Storm Clouds, Looking Out to Sea*, 1845 (T B CCCLVII 11), (fig. 70) Turner manipulated the watercolour with his fingers to evoke the veils of cascading rain.[1]

Fig. 70: J.M.W. Turner, *Storm Clouds, Looking Out to Sea*, 1845
D35397. Photo © Tate

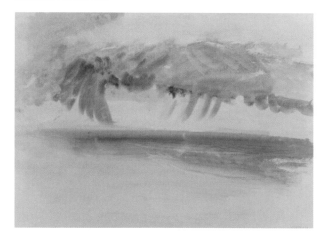

1. For a detailed examination of how that work was painted see: Moorby and Warrell, 2010, p.54-57.
2. Moorby and Warrell, 2010, p.46
3. Email correspondence, 7 September 2012.

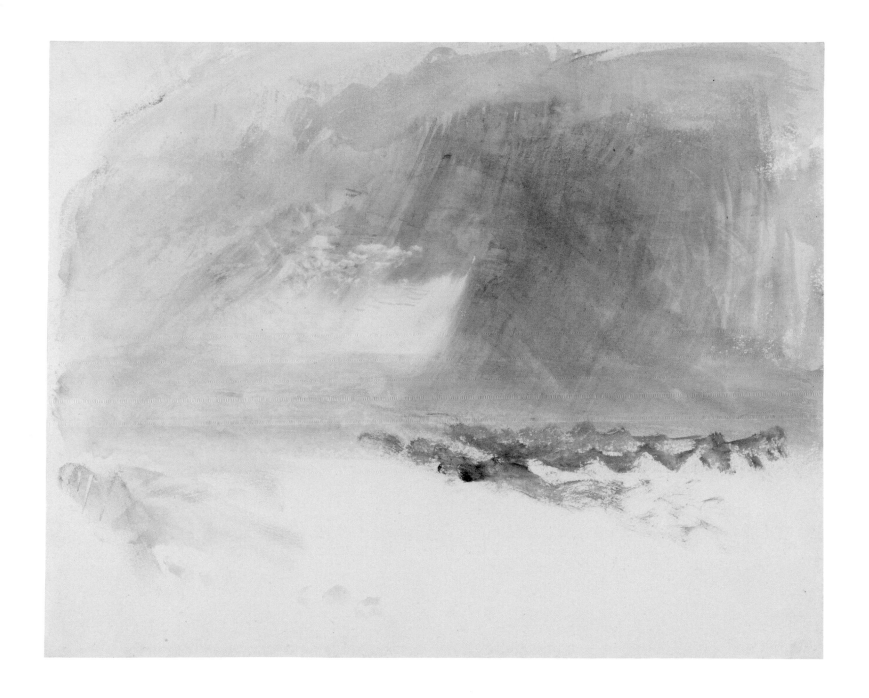

Fig. 71: J.M.W. Turner, *Grey Clouds over the Sea*
D36288. Photo © Tate

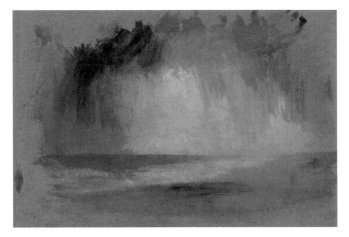

Opposite: NGI.2422 (detail)
Fig. 72: J.M.W. Turner, *Storm Cloud over a River*, 1845
© The Fitzwilliam Museum, Cambridge

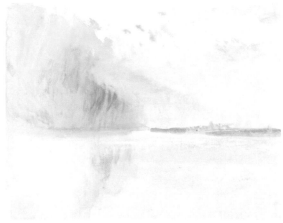

Turner mastered the innovative 'wet-in-wet' technique, which involves the application of colour using a wet brush on a water-soaked paper, so that the paint softens and blurs, in addition to the dry brush technique, which involves making marks using a wet brush on a dry paper in order to achieve crisp-edged marks.[2] Sometimes Turner drenched the paper with watercolour but then lifted colour off in places to create fleeting atmospheric effects. Numerous studies in Tate Britain are similar in subject and treatment to the Dublin watercolour: *The Storm Clouds*, c.1820-30 (TB CCLXIII 71); *Grey Clouds over the Sea*, c.1835-40 (TB CCCLXIV 420), (fig. 71); *A Storm over the Rigi*, c.1844 (TB CCCLXIV 179); *Rain Clouds*, c.1845 (TB CCCLXV 19) and *A Shower over the Sea*, 1845 (TB CCCLVII 14).

Ian Warrell has questioned the traditional identification of this watercolour as a Lake Lucerne subject. He believes that it could be 'the sort of study Turner made at Margate or on the Channel coast in the 1840s'.[3] In later life Turner was repeatedly drawn back to Margate on the Kent Coast, where he endlessly contemplated the expansive skies and vast stretches of coastline.[4] The fact that this sheet is watermarked 1818, substantially earlier than the 1840 watermark visible on the two Dublin views of Lake Lucerne from Flüelen (NGI.2427 and NGI.2428), contributes further evidence to the possibility that this may not indeed be a Lucerne subject. Warrell has suggested a link between the Dublin drawing and the watercolour *Storm Cloud over a River*, 1845 (Fitzwilliam Museum, Cambridge PD. 115-1950; W 1427), (fig. 72) which, as he notes, 'seems to be on the same paper, and which recreates a passing storm in paint with the same fluency.'[5]   NMN

**4.** As a young man in the early 1790s, and again in the early 1830s, Turner was a regular visitor to the seaside town of Margate, on the eastern tip of the county of Kent, about seventy miles downriver from London.
**5.** Email correspondence, 7 September 2012.

# Bellinzona, Switzerland, with the Fortresses of Uri, Schwyz and Unterwalden, 1842

WATERMARK: J WHATMAN/
T M LL (watermark cropped)
INSCRIBED (on verso):
Bellinzona / No. 5; verso,
lower right ?408
Watercolour, graphite, gouache
and white highlights with
scraping out on off-white wove
paper, 22.7 x 28.5cm
PROVENANCE: Henry Vaughan
Bequest, 1900
NGI.2420

Bellinzona lies east of the Ticino River, at the foot of the Alps. The town, strategically positioned at the entrance to the Alpine passes of St Gotthard and San Bernardino, acts as a gateway to Italy for travellers coming from northern Europe. The fortifications that dominate the town are among the most impressive examples of medieval defensive architecture in the Alps.[1] The fortress in the foreground, Burg Uri (also known as Castelgrande), is the largest and oldest of these thirteenth-century castles, perched on a rocky peak overlooking the river valley. A series of ramparts connects it to Schwyz (Castello Montebello), higher up. The castle with the highest elevation, Unterwalden (Sasso Corbaro), is located on an isolated promontory south-east of the other two. At the time of Turner's visit to Bellinzona, all three castles were ruinous, although Burg Uri still operated as an arsenal and prison.[2]

Fig. 73: J.M.W. Turner, *Bellinzona, No.11, Switzerland*, c.1842/43
Photo © Manchester Art Gallery / Bridgeman Images

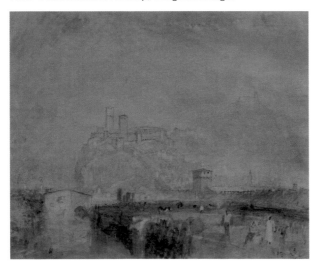

Turner returned to Switzerland in the summer of 1842. From Lucerne he travelled to Küssnacht, Arth and Goldau, and journeyed south through the St Gotthard Pass to Bellinzona and the Italian lakes.[3] Returning to London that autumn, he presented his dealer Thomas Griffith with a collection of Swiss and Italian sketches, which were to be shown to a small group of prospective patrons. In great anticipation, Ruskin wrote in his diary for 16 January 1843: 'Turner is going to do ten more drawings and I am in a fever till I see the subjects.'[4] In the end Turner produced six finished Swiss watercolours in 1843, commissioned by either Ruskin or Munro of Novar, one of which is entitled *Bellinzona from the Road to Locarno* (City of Aberdeen Art Gallery and Museums Collections; W 1539).

Many of Turner's late sketches are inscribed in pencil on the verso with a number, title and, where appropriate, the name of the person who commissioned a finished watercolour from the sketch.[5] Four sketches of Bellinzona produced in 1842-43 are inscribed with the following on the verso: *Bellinzona / No. 10* (Indianapolis Museum of Art, 72.209, W 1457); *Bellinzona / No. 11* (Manchester City Art Galleries, 1917.100; W 1489), (fig. 73); *Bellinzona /No. 12 / 13 x 0 14/ Mr Munro* (Tate Britain, TB CCCXXXII 25), (fig. 74); and the present drawing *Bellinzona / No. 5* (NGI.2420; W 1491). Using Ruskin's recollections, Ian Warrell listed the Dublin drawing as one of the sketches produced by Turner in 1842-43, entitled *Bellinzona from the West*.[6] The recently discovered inscription on the verso of the Dublin drawing provides further proof that this is indeed one of the 'sample' colour sketches that was proposed to potential clients.

**1.** Bellinzona's three medieval castles and fortifications, among the best preserved in Switzerland, were designated a World Heritage Site by UNESCO in 2000.
**2.** Warrell, 1995, p.88
**3.** See Warrell, 1995, pp.10-20, for an in-depth account of Turner's Swiss tours.
**4.** Warrell, 1995, p.151
**5.** See Warrell, 1995, pp.149-155, for the definitive modern account, and detailed listing, of the origins of the Swiss series.
**6.** Warrell, 1995, p.151

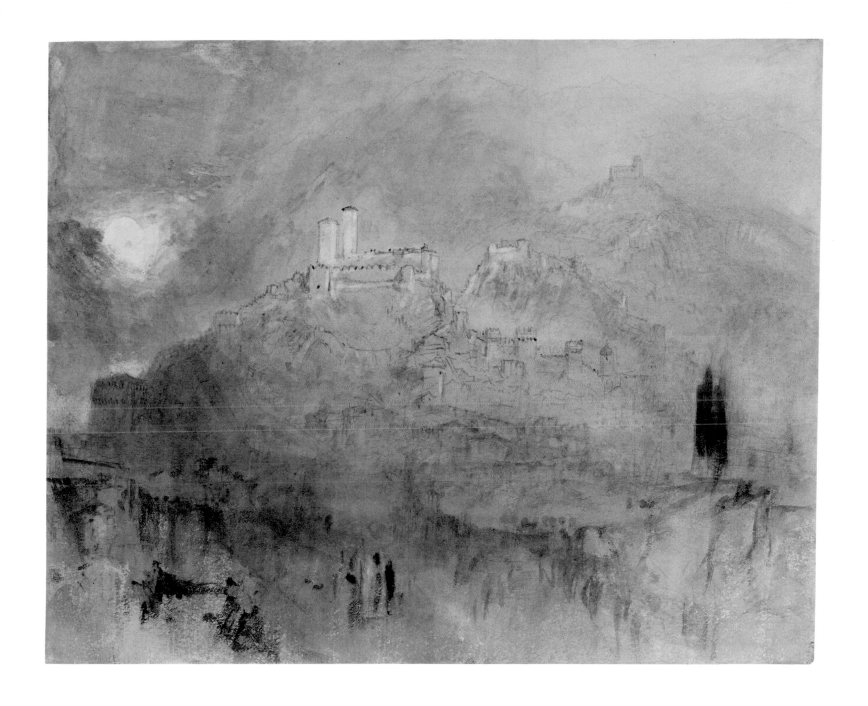

Fig. 74: J.M.W. Turner, *Bellinzona from the Road to Locarno:*
*Sample Study.* D33495. Photo © Tate

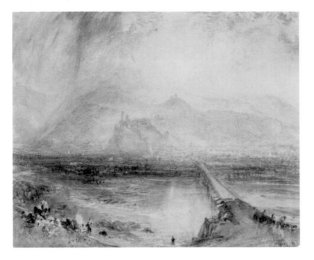

Opposite: NGI.2420 (detail)
Fig. 75: J.M.W. Turner, *Bellinzona.* D33627. Photo © Tate

Turner travelled again to Switzerland in the summer of 1843, revisiting the St Gotthard Pass and Bellinzona. The picturesque beauty of the lakeside town made a strong impression on him, evident in the numerous sketches and colour studies he made of it from different orientations and viewpoints. These can be found in the 'Bellinzona' (TB CCCXXXVI) and 'Fribourg, Lausanne and Geneva' (TB CCCXXXII) sketchbooks at Tate Britain; as well as in the group of works catalogued as 'Bellinzona, Sion, &c.' (TB CCCXXXVII), (fig. 75).

Turner revelled in depicting a subject at different times of the day, charting the transient effects of changing light and weather upon a specific motif. His interest here is in capturing changing light effects over the landscape, reflected in the dusky pink hills, the stark white towers, and the valley consumed by darkness. To conjure the impression of moonlight, Turner often reserved areas of white paper or lifted off pigment in certain places. He has left an area of paper free of colour to indicate the moon, working around it with cobalt blue washes of differing depth to enhance its luminescence.

This late watercolour displays a range of experimental techniques. In the lower parts of the composition, dark washes have been dragged across the sheet with a dry brush to obscure precise details. In other areas scraping out is visible, achieved perhaps with the end of a brush. This technique is used to create highlights, most evident in the two towers of Burg Uri. The castles and fortified walls are delineated in graphite, with a sequence of dark brown dots applied to emphasise the battlements. To the right, Turner has used strokes of dark blue and purple to denote tall cypress trees. Such trees reoccur in the Indianapolis view of Bellinzona and in *Bellinzona from the South-East,* ?1843, in the Turner Bequest at Tate (TB CCCXXXVI 15). **NMN**

# Wellmich and Burg Maus on the Rhine, 1844

Graphite, watercolour and
gouache with scratching-out
on off-white wove paper,
18.3 x 24.3cm
PROVENANCE: Miss Annie
Callwell Bequest, 1904
NGI.3776

In the summer of 1817, Turner made an extensive trip through Northern Europe, travelling along the Rhine through the Low Countries and Germany. In mid-August he stopped at Coblenz, where he made many sketches of the great fortress of Ehrenbreitstein. From there he walked upstream sketching the numerous picturesque villages and castles that line the dramatic banks of the great river. He overnighted in St Goar, and spent much time sketching the nearby castles and villages including Wellmich on the opposite bank.

Turner returned to this area many times over the following decades including his last tours of 1841 and 1844, when he was in his late sixties. Despite his age he was still very active. He wrote to Walter Fawkes's son Hawkesworth in December 1844 detailing the tour he made that summer:

> ... the rigours of winter begin to tell upon me, rough and cold [...] I went however to Lucerne and Switzerland [...] The rains came early so I could not cross the Alps, twice I tried was sent back with a wet jacket and worn out boots and after getting them heel-tapped I marched up some of the small valleys of the Rhine and found them more interesting than I expected.[1]

This drawing (NGI.3776; W 1343), which has been dated to his 1844 trip, depicts the village of Wellmich, as seen from near St Goar, with its pale buildings and gothic church tower at the centre of the composition.

High above on the hill to the right stands the ruined fortress (officially called Burg Thurnberg) completed by the Archbishop of Trier in the fourteenth century. This castle was referred to as 'Burg Maus' by the aggressive owners of the nearby fortress of Neukatzenelnbogen, nicknamed 'Katz' castle. For centuries the castles have been known as 'Cat' and 'Mouse'. Despite its dangerous feline neighbour, Burg Maus stood firm until 1806 when Napoleon's forces destroyed it as part of their systematic destruction of the fortresses along the Rhine.[2]

Dating this sheet is difficult. Turner's use of delicate pencil lines to delineate landscape features combined with light washes of colour give the sheet atmosphere and a sense of the time of day. Stylistically it is similar to the collection of colour studies of locations along the Rhine (all of similar size and format) which Wilton grouped together with a possible date of 1844.[3] In particular the following drawings: *On the Rhine*, 18.4 x 24.1cm (V&A 103; W 1328) *On the Rhine: Looking over St Goar to Katz from Rheinfels*, 18.1 x 23.7cm (Ashmolean Museum; W 1329) and *On the Rhine: the Katz*, 18.3 x 24.1cm (MFA Boston 06.124; W 1332), seem to correlate with the Dublin drawing, being similar in terms of size, media and technique. However, the bright yellow washes used by Turner to indicate the cliffs bathed in sunlight are similar to the washes commonly found in his colour studies of the west facing fortress of Ehrenbreitstein which date to 1841. Further research is needed to clarify the date of the Dublin drawing.[4]

**1.** Gage, 1980, p.203
**2.** Powell, 1991, p.99
**3.** Wilton, 1979, pp.459-462
**4.** Powell, 1991, pp.94-95, 184-187

Fig. 77: J.M.W. Turner, *Bacharach*, c.1841-45
© The Fitzwilliam Museum, Cambridge

On the verso of the sheet is a pencil sketch of the town of Bacharach (fig. 76), situated upstream of Wellmich on the opposite bank. In Turner's day Bacharach was renowned for the picturesque beauty of its medieval half-timbered houses surrounded by castellated defensive walls and gate towers. Here, Turner uses abbreviated pencil lines to record the distinctive profiles of the houses and churches and the fortifications on the surrounding hills.

A finished watercolour view of Bacharach (of similar dimensions, 18.4 x 24.1cm) is in the Fitzwilliam Museum (581: Cormack 49; W 1324), (fig. 77).

The Dublin drawing arrived in 1904 as part of a bequest of 37 works on paper from a Dublin lady, Miss Annie Callwell. This drawing, no.33 on her list, was noted simply as 'Sketch by Turner'.[5]    AH

Opposite Fig. 76: *Bacharach*, verso of Wellmich sheet, NGI.3776

**5.** The Callwell Bequest included works by nineteenth century British and Irish artists including Petrie, Burton, Cox, T.M. Richardson and Copley Fielding.

# Turner's Watercolour Materials
## RANSON DAVEY

Fig. 78: San Pietro di Castello, NGI.2417

## APPENDIX 1: PIGMENTS

### 'Papers tinted with pink and blue and yellow'

This rare description of Turner's working methods in watercolour dates to the summer of 1816, when he was staying at Farnley Hall in Yorkshire. Walter Fawkes's daughters remembered seeing 'cords spread across the room as in that of a washer woman, and papers tinted with pink and blue and yellow hanging on them to dry.'[1] This vivid memory of the distinctive brightness of Turner's colour washes also evokes the dampness of the process and his method of working on multiple sheets of paper (fig. 78).

Turner's early training as a topographical artist meant that, as a young artist in the 1790s, he created images using washes of blue and grey over pencil outlines. By the age of ten he was making money by hand-colouring engravings while his first watercolour was exhibited at the Royal Academy when he was fifteen.[2] He would have been familiar with the traditional watercolour palette of brown earth pigments, indigo and Prussian blues and transparent organic yellows like Indian yellow and gamboge, which were

useful for mixing greens. Green pigments are generally absent from the Gallery's Vaughan Bequest works. The watercolour of beech trees (NGI.2409) does feature some mixed greens but the later Dublin watercolours show very little evidence of a pure green (or indeed any green) although synthetic green pigments were available from around 1814 and are found in his work from the 1830s.

Turner's palette changed dramatically as his technique and personal style evolved and matured (fig. 95). Following his first trip to the Continent in 1802, he moved towards a higher-keyed palette based on opposing primaries and enthusiastically tried out and adopted the brighter new colours which were becoming available (fig. 79). These included cobalt blue, available by 1807 and noted on his watercolours from 1810[3], the vivid opaque range of yellows based on chrome, available from 1814 and a range of pink, red, scarlet and brown madders, introduced by George Field (1777-1854), the colour-maker.[4] Turner also moved towards an increasing use of opaque pigments on coloured papers.

Fig. 79: Gradated washes of watercolour pigments that have been identified in the National Gallery of Ireland works. Historical pigments from collection of R. Davey.

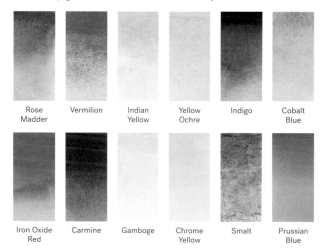

| Rose Madder | Vermilion | Indian Yellow | Yellow Ochre | Indigo | Cobalt Blue |

| Iron Oxide Red | Carmine | Gamboge | Chrome Yellow | Smalt | Prussian Blue |

1. Wilton, 1979, p.104
2. Wilton, 2006, p.14
3. Townsend, 1999, p.41
4. Ibid, p.47

## Turner's watercolour pigments

A lot is known about Turner's materials thanks to the pigments and media found in his studio following his death. Now preserved in Tate Britain as part of the Turner Bequest, they include bottles and jars of pigments, bladders of paint, various gum media and 'hard' watercolour blocks, introduced by Reeves in the eighteenth century. A major analysis of these items and the watercolours themselves by Dr Joyce Townsend, Senior Conservation Scientist at Tate, has yielded valuable information about Turner's practice and use of pigments and has confirmed dates for the introduction of new pigments. Dr Townsend has established that Turner was often the first among his peers to use new pigments.[5]

## Technical analysis of Turner watercolours at the Gallery

In 2011, a major project was undertaken to analyse the media and supports used in the Turner watercolours at the Gallery. This was the first time such in-depth research had been undertaken. The analysis of the watercolours was done through examination by stereo binocular microscope, Infrared reflectography (IR), ultraviolet fluorescence (UVF), and X-ray fluorescence (XRF), (fig. 80). Polarising light microscopy (PLM) was used to confirm results where sampling sites allowed, for example on the wash on the verso of the Reichenbach sheet (NGI.2431). These methods of analysis proved most effective with inorganic pigments and revealed some thin toning washes that had escaped notice before. Overall, the project provided valuable new information about the pigments and Turner's working methods. A database has been compiled which will aid further research into the Dublin watercolours.

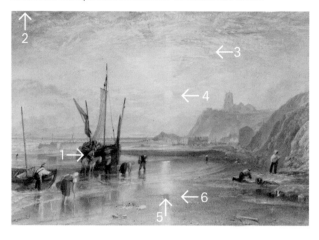

Fig. 80: Illustration of Folkestone (NGI.2415) showing the areas of the sheet where samples were taken. XRF results shown below.

| XRF Results | Strong peak | Medium peak | Weak peak | Inference |
|---|---|---|---|---|
| 1. Boat Red | Fe, Hg | | S?, Mn | Vermilion (HgS) and umber (Fe, Mn) |
| 2. Blue sky edge | | Fe | Ca, Cu, Ni, Hg | A cobalt blue, likely smalt (Co, Ni) Prussian blue (Fe), vermilion (Hg) |
| 3. Yellow cloud | Fe, Hg | | Ca, Cr?, Ni, Cu | Vermilion (Hg), yellow ochre (Fe), chrome yellow? |
| 4. Yellow near sun | Fe | Ca | Ti, Cu | Yellow ochre-natural (Fe, Ti), Chalk (Ca) |
| 5. Round yellow area (retouching?) | | Fe, Ca | Cr?, Mn, Ni, Cu, Hg | An umber (Fe, Mn) chrome yellow (Cr)? |
| 6. Yellow beach close to centre | Fe | Fe | | Ochre (Fe), chalk (Ca) vermilion (Hg) stippling |

Non destructive XRF analysis was undertaken on 15 of the National Gallery of Ireland watercolours using a Bruker AXS TRACERturboSD (portable XRF) by Trinity College Library Dublin: S. Bioletti, A. Smith and Dr. R. Goodhue.

**5.** Townsend, J, 'The materials of J.M.W. Turner: pigments' in *Studies in Conservation*, vol.3, no.4, 1993, p.82

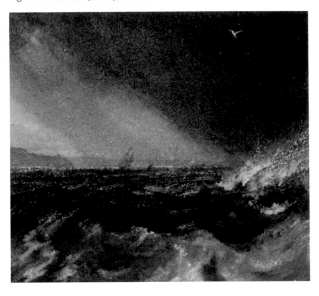

## Blue pigments

'There is Mr. Turner, the great sea painter.'
This is how fellow artist, C.R. Leslie, described Turner
to his young son in 1832, having spotted his friend in the
park at Petworth. Blue pigments are clearly essential
to a landscape and marine artist and the blues most
widely used by artists throughout this period were indigo
and Prussian blue. Both pigments, which Turner used
throughout his career, had good working properties in
watercolour and combined well with other colours to
create greens, purples and neutral-tint greys.

## Prussian blue

This colour was identified on early watercolours including
the detailed image of the West Gate Canterbury of 1793
(NGI.2408) and late works like the ethereal view of Venice,
c.1840 (NGI.2423). The importance of Prussian blue to Turner
is reflected in the fact that it is the sole blue pigment present
in his smaller travelling palette. The dramatic image of the
Mewstone, which dates to c.1814 (NGI.2413), has Prussian
blue in the dark, threatening storm cloud. Turner has used a

more transparent, cobalt-based pigment, smalt, to lay in the
choppy waves. The brushstrokes of opaque red vermilion
in the troughs of the waves, which capture the unsettled
surface to the water (fig. 81), are an unusual feature. The
water is calmer in the view of Lake Lucerne (NGI.2427),
where a small bead of thick Prussian blue, at the lower
edge, has been worked into thin washes to indicate surface
reflections. The tinting strength of the pigment shows
even in the thinnest washes, which are laid on top of a thin
preparatory wash of yellow ochre and then a wash of blue
smalt. Extensive working with the fingers is evident from the
clear fingerprints on the left edge of the image (fig. 82).

## Indigo

Turner also relied heavily on the organic blue pigment
indigo, despite growing concerns about its light-fastness.
He combined indigo and grey washes in the 'Monro school'
works of the 1790s and continued to use it throughout his
career. Its instability can be seen in the non-Vaughan view
of the Rialto Bridge, c.1820 (fig. 83). The appearance of the
strip of paper on the left edge, protected from exposure to

Fig. 83: Rialto Bridge (detail), NGI.7512

Fig. 84: Clovelly Bay, NGI.2414

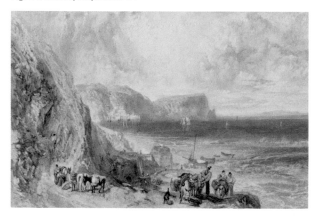

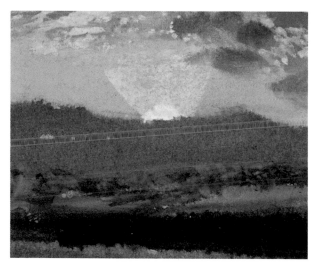

Fig. 85: Sunset over Petworth Park (detail), NGI.2430

light by a window mount, gives an indication of the original depth of colour of this watercolour. Given its predominant golden tones today, it is surprising to realise how much indigo blue was present on the sheet originally.

## Cobalt and smalt

Cobalt blue was discovered by a French chemist Thénard in 1802. By 1807 it was available as a pigment, used in both watercolours and oils, although it does not appear in Turner's watercolours until 1810. Its brilliancy, stability, transparency and evenness of colouring made it a useful addition to the watercolourist's palette for seas and skies. These attributes can be seen in the sparkling view of Clovelly Bay, c.1822, where its brightness contributes a sense of warmth to the image (fig. 84). In the later watercolour of the sun setting over Petworth Park, c.1828, cobalt blue has been mixed with a brown umber pigment (containing manganese) and used as a wash to depict the hills silhouetted by the sinking sun (fig. 85). Painted on blue paper, the bright glow of the sunset was achieved with a relatively opaque yellow ochre pigment.

The new cobalt blue was seen as more stable than the other cobalt-based blue, smalt, therefore it supplanted the older pigment in colourmen's lists and in general popularity. Despite this, in the examination of the Vaughan Bequest watercolours at the Gallery, smalt was found to have been used on seven works which date to between 1814 and 1841, while surprisingly, cobalt blue was only found on four works dating to between 1822 and 1840. So far the two pigments have not been identified on the same work.

## Smalt

Smalt is problematic in terms of its use as a watercolour pigment due to its nature as a blue glass. When it is finely ground, the colour becomes paler, and it is decolourized (fades) in polluted atmospheres. In the two related studies of Lake Lucerne (NGI.2427 and NGI.2428) which date to 1841, the skies contain smalt. An enlarged detail of the former (fig. 86), shows the gritty nature of the pigment and the strong colour. George Field included painted-out samples of blue pigments for testing in his 'Practical Journal' of 1809. He describes the sample of 'French Smalts' as: 'the most beautiful powder blue I ever saw'.[6] Since Turner used smalt so regularly he must have been unconcerned about the known risks of fading or perhaps he simply enjoyed the challenge of making it work in watercolour.

## Yellow pigments

Turner is famous for his pictures of Romantic sunrises and sunsets, bathed in a yellow glow. These pictures owed much to his admiration of Claude Lorrain. Yellow was clearly Turner's favourite colour for the depiction of light and atmosphere in his pictures. His creative use of yellow was not always understood by his contemporaries however. The caricature by Richard Doyle which appeared in a satirical journal *The Almanac of the Month* in 1846 (fig. 87), illustrates how critics made fun of his techniques despite John Ruskin's championing of the elderly artist's unconventional methods in *Modern Painters* (1843).

Fig. 86: Lake Lucerne (detail), NGI.2427

Fig. 87: Richard Doyle, *J.M.W. Turner painting one of his pictures*, 1846
© National Portrait Gallery, London

**6.** Harley, R. *Artists' Pigments, c.1600-1835*, New York, 1970, colour plate 3

## Gamboge and Indian yellow

Both of these organic yellows, which are transparent, were used routinely by Turner in his watercolours. Gamboge is the resin extract of an Asian tree (*Garcinia*) and is the only watercolour pigment which does not need a gum binder. It combines well with Prussian blue to make greens and with burnt sienna to create an orange. It was sometimes also used as a glaze. Indian yellow also had an exotic Asian origin, being derived from the urine of cows fed solely on mango leaves, a practice that was banned at the end of the nineteenth century. Indian yellow is a beautiful pure yellow, the brighter of the two although it has poor lightfastness. It has a very distinctive bright fluorescence in ultraviolet light.

## Yellow ochre

Toning washes of yellow ochre were found over part or whole sheets on both white (NGI.2427) and blue paper (NGI.2430). The fact that metallic impurities like titanium were detected alongside the pigment's main component, iron, suggests that Turner was using a natural ochre rather than a synthetic one.

## Chrome yellow

This colour was introduced as a pigment in 1814 following the isolation of chrome by Vauquelin, a French chemist, in 1797. The brightness of the pigment with its lemon-yellow colour attracted Turner immediately and he used it extensively (fig. 88). Darker shades of chrome yellow extending to a chrome orange were introduced later and all became an important part of his palette.

Fig. 88: Luxembourg (detail), NGI.2429

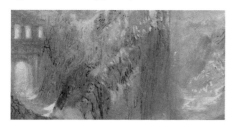

Fig. 89: Fluorescence of rose madder
Above: detail of NGI.2429 viewed under normal light
Below: same detail viewed under UV light

## Pink and red pigments
## Madder lakes

A large range of shades of madder were found in Turner's studio pigments from rose-pink through reds to brown. These are dyes extracted from the madder root (*Rubia tinctorum*) precipitated onto a substrate. Typically the dyes were fixed onto an alumina base to create the pigment, although sometimes iron and copper salts were used as substrates to vary the colour from brown-red to blue-red. The distinctive bright fluorescence of rose madder in ultraviolet light (a salmon-pink colour) has been shown to be specific to the pigment being fixed on a substrate containing alumina (fig. 89).[7]

**7.** Townsend, J, 'The materials of J.M.W. Turner: pigments' in *Studies in Conservation*, vol.38, no.4, 1993, p.241

### Iron oxide reds

These stable earth pigments are very much the workhorses of the watercolourist's palette. Turner used both natural iron oxides, like Indian red and Venetian red (named for their place of origin) and synthetic iron oxides, the manufactured 'Mars' colour range which gave brighter red and orange shades. They can be differentiated (when viewed under a microscope) by the evenness and fineness of the particle size of the synthetic pigment.

### Vermilion

A rich red pigment, mercuric sulphide, is found throughout most of Turner's later, more finished watercolours. It was applied in many ways: in small touches of stippling, as an extended outline using a brush or pen, or in washes of rich colour. Two different uses are illustrated. Vermilion appears as a thin line drawn with a pen for details and to provide a contrast to the blue-green washes of the water (fig. 90). Turner also uses it in a broader wash with a thick application of paint in the late view of *San Pietro di Castello* (NGI.2417).

### Chemical alteration of vermilion

Analysis of the red area in the same Venetian sketch (NGI.2417) confirmed the presence of a lead pigment (fig. 91). Peaks for mercury (Hg) and sulphur (S) were also found. This could indicate that red lead was mixed with the vermilion, as there was no lead white pigment visible. However, it is more likely that a wash of chrome yellow, a lead chromate, is near or underneath the vermilion. These two pigments are, in theory, chemically incompatible as the lead component can react with the sulphide in the vermilion to form a black-lead sulphide. The dark area of colour, which seems not to have been intentional on the artist's part, may represent this chemical darkening of the pigment.

Fig. 90: Doge's Palace (detail), NGI.2423

Fig. 92: Bellinzona (detail), NGI.2420

Fig. 93: Reichenbach (detail), NGI.2420

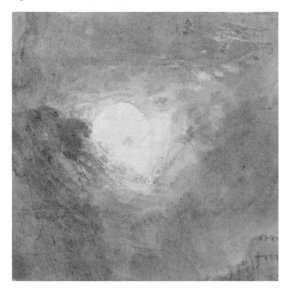

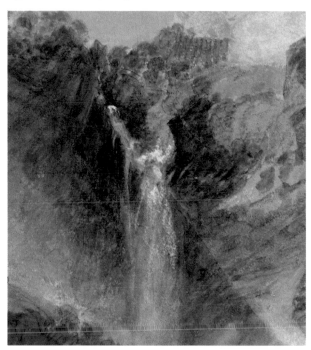

## White pigments and white paper

Turner was a master at using the natural brightness of paper for his white highlights. He either reserved an area of paper or lifted off pigment with a wet brush. A slight tide-line which can be seen around the top of the moon in this watercolour indicates both methods may have been used in this depiction of moonlight (fig. 92). Another method he used was to lay a coloured wash over the paper and then selectively remove it by washing, sponging, scraping or rubbing, to expose the natural colour of the paper beneath. For the study of the Reichenbach waterfall of 1802, Turner first laid down a warm grey wash, created with Prussian blue and a red pigment, over both sides of the sheet to give a mid-tone. He then scraped out the highlights of the cascading water with a sharp object, perhaps a scraper or an engraving tool (fig. 93). The view of Bregenz, c.1840, painted on blue paper, shows the full range of subtle effects Turner could achieve with white pigments. These are used for the clouds, the water and its reflections, foreground details and to indicate light striking the buildings of the town (fig. 94).

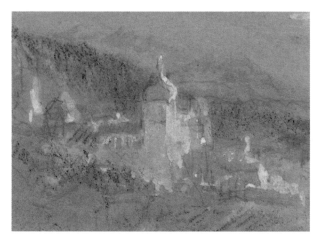

Fig. 94: Bregenz (detail), NGI.2420

### Lead white

Throughout his career, for white bodycolour highlights, Turner's preferred pigment was the opaque pigment lead white. This is visible in the smoke curling up the tower in the early watercolour of the West Gate in Canterbury (NGI.2408).

### Chalk white

Later in his career, when he was working on blue papers, Turner used the more transparent chalk white pigment to achieve translucent, atmospheric effects. Chalk white is used for the mist rising up from the valley in the view of Luxembourg which dates to 1839 (NGI.2429).

### Chinese white

Winsor and Newton introduced their new zinc oxide pigment Chinese white in 1834.[8] This had advantages over lead white in that it was non-toxic and did not darken when combined with sulphur-containing pigments or when exposed to a polluted environment. However Turner did not take to Chinese white and it was not found on any works in the Dublin collection, in line with research into the Turner Bequest watercolours carried out at Tate. Dr Joyce Townsend notes that Turner tried out an earlier version of zinc oxide in a sketchbook once, but it never appeared again.[9]

Fig. 95: Ceramic watercolour palette used by Turner
Tate, lent by the Ashmolean Museum, 1987. Photo © Tate

**8.** Harley, R. *Artists' Pigments, c.1600-1835*, New York, 1970, p.179
**9.** Townsend, 1999, p.45

## APPENDIX 2: PAPERS

Turner lived a long life through turbulent times of great political and industrial change, which affected the papermaking industry in Britain. He saw the introduction of mechanical papermaking machines, in particular the Fourdrinier machine and Dickinson's Paper Mould machine. He witnessed the development of new ways of preparing paper pulp based on chemical bleaching using chlorine. In the final decade of his life wood pulp became a major source of fibre for papermaking. As with pigments, Turner followed new developments in papermaking closely and experimented with a wide range of paper types, weights, colours and surfaces. However, by the 1820s he was wealthy enough to buy large supplies of his favourite papers. These tended to be the more expensive papers with the trusted 'Whatman' watermark.

### The papers of the Vaughan Bequest watercolours

Most are handmade rag papers, well sized with gelatine and hardened with alum (fig. 96). All of the National Gallery of Ireland works except the large early watercolour of beech trees from 1793 (NGI.2409) are on wove paper. Wove paper is formed on a papermaking mould with a woven brass cover, a development pioneered by James Whatman I (1702-59) at Turkey Mill in the 1750s (fig. 97). These papers would have been produced for a range of different uses including writing and printing as well as drawing.

### Turner and Turkey Mill

Of the fourteen watercolours with fully recognizable watermarks (see appendix 3) there are sheets from four different paper mills recorded. An astonishing eleven sheets were made at one mill, the aforementioned Turkey Mill, near Maidstone in Kent, while it was operating under three different management teams. When Paul Sandby painted his view of Turkey Mill in 1794, it was the largest papermill in Britain, famed for the quality of its product (fig. 98). The smooth surface of its wove paper clearly attracted Turner and other artists of his generation. The quality of its gelatine

Fig. 96: Hand-made papers viewed in transmitted light
Above: wove paper; below: laid paper

Fig. 97: Screen surface of a twentieth century papermaking mould, c.1987. Collection: Paper Conservation Department, National Gallery of Australia

Fig. 98: Paul Sandby (1731-1809), *A View of Vinters at Boxley, Kent, with Mr. Whatman's Turkey Paper Mills*, 1794. Yale Center for British Art, Paul Mellon Fund, B2002.29, Public Domain

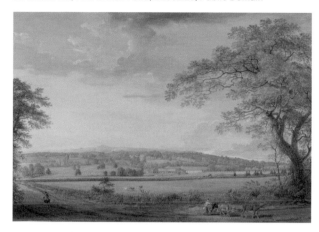

sizing was especially critical for Turner as he developed increasingly vigorous wet techniques of paint application, manipulation and removal, including scrubbing, sponging, rubbing and scraping.

### Turner's use of paper

To make the best use of the large sheets of paper he purchased in bulk, he would halve the sheet, then quarter it and so on. This was done for a number of reasons: for economy, to develop series of works in the same format, and for the creation of sketchbooks, an important part of his creative process. Research into Turner's papers by Peter Bower has enabled the reconstruction of some original full-size sheets. It has also provided information about the size of single small sheets and aided the identification of related works in the Turner Bequest.

**Detail from Sandby's watercolour above of Turkey Paper Mills**

## APPENDIX 3: WATERMARKS ON TURNER'S PAPERS IN THE NATIONAL GALLERY OF IRELAND

Full or partial watermarks are visible in 18 of the 36 Turner watercolours in the collection. The sizes of the sheets and the heights of the letters in the watermarks and countermarks are given in centimetres. Where possible, the side of the sheet used by the artist is noted, whether 'Felt' or 'Wire' (see glossary). The papers of two of the National Gallery of Ireland's collection of *Liber Studiorum* prints were also examined.

### Vaughan Bequest watercolours

———
NGI.2401 *Shipping*, 1827
Off-white, thick wove paper, 17 x 22.4cm (Felt)
Watermark: J WHATMAN / 1827 Size: J,W 2cm;
HATMAN 1.5cm
Papermaker: W Balston, Springfield Mill, Maidstone, Kent

William Balston was apprenticed to James Whatman II at Turkey Mill. In 1794 he joined with the Hollingworth Brothers to take over the business from Whatman.[1] However, Balston left the partnership in 1805 and built his own mill, Springfield Mill in Maidstone, the following year.[2]

———
NGI.2402 *Sluice-gate near Netley Abbey*, 1794-7
Off-white wove paper, 13.7 x 20.6cm (Felt)
Watermark: WHATMAN
Size: W 2cm; HATMAN 1.3cm
Papermaker: James Whatman II, Turkey Mill, Maidstone, Kent

———
NGI.2403 *A River in the Campagna*, 1794-7
Off-white wove paper, 15.5 x 25.8cm (Wire)

———
NGI.2404 *Old Dover Harbour*, 1794-7
Off-white wove paper, 23.2 x 34.4cm (Felt)

———
NGI.2405 *Falls of Velino, near Terni*, 1794-7
Cream wove paper, 24 x 37.4cm (Felt)

———
NGI.2406 *Shakespeare's Cliff, Dover*, 1794-7
Off-white wove paper, 20.6 x 27cm (Wire)

———
NGI.2407 *Waterfront of Old Dover Harbour*, 1794-7
Off-white wove paper, 22.6 x 28.4cm (Wire)
Watermark: J WHATMAN
Size: J 2cm; W 1.8cm; HATMAN 1cm
Papermaker: James Whatman II, Turkey Mill, Kent

James Whatman II succeeded to the paper business of his famous father on the latter's death in 1759. After coming of age, he ran the mill until 1794, when he sold it to the partnership of William Balston and the Hollingworth brothers.[3]

———
NGI.2408 *West Gate, Canterbury*, c.1793
Off-white wove paper, 28 x 20.3cm (Wire)
A small strip of paper, 1cm in width and thinner than the main sheet has been added to the bottom of the sheet. This is unusual in Turner's practice, as he rarely needed to extend or cut down a sheet's format, unlike his contemporary John Constable.[4]

**1.** Balston, Thomas, *William Balston Papermaker, 1759-1849*, London, 1954
**2.** Whatman International plc, which continues to operate from Springfield Mill. was taken over by the US company GE Healthcare in 2008.
**3.** Balston, Thomas, *James Whatman, Father and Son*, London, 1957
**4.** Noted by Dr Joyce Townsend during a workshop 'Technical Analysis of the Watercolour Materials of J.M.W. Turner' held at the National Gallery of Ireland, 13 July 2012.

NGI.2409 *Beech Trees at Norbury Park*, c.1797
Off-white laid paper, 44.1 x 43.3cm
Laid line interval: 22 per 2.4cm (1inch); Chain line interval:
2.5-2.7cm (Wire)
Countermark: J WHATMAN Size: J 2.4cm; W 2.15cm;
HATMAN 1.5cm
Papermaker: James Whatman II, Turkey Mill, Maidstone,
Kent

There are traces of a watermark (Strasburg Lily type) on
the edge of this sheet. It was previously laid down on a grey
laminate board.

NGI.2410 *Edinburgh from below Arthur's Seat*, 1801
Off-white wove paper, 25.8 x 41.1cm (Felt)
Watermark: 1794 / J WHATMAN Size: 1794 1.4cm; J 2.2cm;
W 2cm; HATMAN 1.2cm
Papermaker: W Balston and T & J Hollingworth, Turkey Mill,
Maidstone

The inclusion of the date in this watermark was a response
to an Act of Parliament in 1794, concerning excise duty on
paper, but earlier dates can also sometimes be found in
papers which date back to the late seventeenth century. It
is important to note that a paper mould with this date could
have been in use for up to four or five years after 1794, so
too strict an interpretation should not be put on this date.

NGI.2411 *A Shipwreck off Hastings*, c.1825
Cream wove paper, 19 x 28.5cm (Wire)
Watermark: J WHATMAN / TURKEY MILL Size: J,W 1.8cm;
HATMAN 1.5cm; T,M 1.5cm; URKEY\ILL 1.1cm
Papermaker: T & J Hollingworth, Turkey Mill, Maidstone, Kent

NGI.2412 *A Ship off Hastings*, c.1820
Off-white wove paper 20.2 x 26cm (Wire)
Watermark: 794 / HATMAN
Size: 794, HATMAN 1cm
Papermaker: W Balston and T & J Hollingworth, Turkey Mill,
Maidstone, Kent

NGI.2413 *A Ship against the Mewstone*, c.1814
Cream wove (laminate), 15.6 x 23.7cm

NGI.2414 *Clovelly Bay*, c.1822
Off-white wove paper, 14.7 x 22.6 cm (Wire)
Watermark: J WHATMAN / TURKEY MILLS
Size: J,W 1.8cm; HATMAN, T,M 1.5cm; URKEY ILL 1.1cm
Papermaker: T & J Hollingworth, Turkey Mill, Maidstone, Kent

NGI.2415 *Fishing boats on Folkestone beach*, c.1826-27
Thin cream wove paper, with some shives apparent,
18 x 26cm (Felt)

NGI.2416 *Châtel Argent, Val d'Aosta*, 1836
Off-white wove paper, 24 x 30.4cm (Felt)

NGI.2417 *San Pietro di Castello, Venice*, c.1840
Off-white wove paper, 22.5 x 27cm (Wire)

NGI.2418 *Passau, Germany*, 1840
Off-white wove paper, lined, 24.1 x 30.4cm

NGI.2419 *Montjovet from below St.Vincent*, 1836
Off-white wove paper, 24.2 x 30.5cm (Felt)

———
NGI.2420 *Bellinzona, Switzerland*, 1842
Off-white wove paper, 22.8 x 28.5cm (Felt) Sheet is lined
with wove paper
Watermark: J WHATMAN / T MILL (second line trimmed)
Size: J,W 2.8cm; HATMAN 2.2cm
Papermaker: T & J Hollingworth, Turkey Mill, Maidstone, Kent

———
NGI.2421 *Below Arvier, Val d'Aosta*,1836
Off-white wove paper, 25.6 x 28.3cm (Felt)
Watermark: B,E,& S,/ 1827 Size: B E S 2cm; &, 1827 1.8cm
Papermaker: Bally, Ellen & Steart, De Montalt Mill, Bath,
Somerset

George Steart made a range of white and coloured papers
at this mill. Turner used his sand, buff, olive and grey
colours as well as the white sheets. It was Steart's blue
papers, with their dense structure and rich colour, which
were a particular favourite with Turner. He exploited this
paper to great effect for the brightly coloured groups of
watercolours of Petworth Park (NGI.2430) Luxembourg
(NGI.2429) and the rivers of France series in the 1820s
and 1830s.

NGI.2422 *A Shower over water*, 1841-45
Off-white wove paper, 22.5 x 28.9cm (Wire)
Watermark: TURKEY MILLS / J WHATMAN / 1818
Size: J,W 2; HATMAN,1818 1.5cm; T,M 1.8cm; URKEY ILLS
1.5cm
Papermaker: T & J Hollingworth, Turkey Mill, Maidstone, Kent

An interesting variant watermark to the usual singular
'Turkey Mill'. When James Whatman sold Turkey Mill to W.
Balston and the Hollingworth brothers in 1794, two other
mills were included. This could indicate a manufacture at
one of these subsidiary mills.[5]

———
NGI.2423 *Doge's Palace and Piazzetta, Venice*, c.1840
Off-white wove paper, 24 x 30.3cm (Felt)
Watermark: C ANSELL / 1828 Size: C,A 1.5cm; NSELL 1828
1.3cm
Papermaker: Muggeridge, The Paper Mill, Carshalton,
Surrey

This mark is found in watercolours Turner produced on his
Continental tours as well as in England.

**5.** Peter Bower notes the usage
of 'Mills' instead of 'Mill' in this
watermark. The title of Paul
Sandby's 1794 watercolour refers
to the mills in the plural also: *A
View of Vinters at Boxley, Kent, with
Mr. Whatman's Turkey Paper Mills*.
(Private communication, September
2012). Note that the same variant
watermark is present on NGI.2414

NGI.2424 *Assos*, 1832-34
Cream wove paper, 14 x 20.5cm, lined with an off-white wove sheet, which is slightly skinned, particularly at the edges.

NGI.2425 *Ostend Harbour*, c.1840
Off-white wove paper, 24.5 x 36cm, lined with a sheet of white wove mould-made paper, with a 'T H SAUNDERS' watermark.

NGI.2426 *Storm on the Grand Canal, Venice*, c.1840
Off-white wove paper, 21.8 x 31.9cm (Wire)

NGI.2427 *Lake Lucerne from Fluelen*, 1841
Off-white wove paper, 23 x 29.2cm (Wire)
Watermark: J WHATMAN / TURKEY MILL / 1840 Size: J,W 1.8cm; HATMAN, T,M, 1840, 1.5cm ; URKEY ILL 1cm
Papermaker: T & J Hollingworth, Turkey Mill, Maidstone, Kent

NGI.2428 *Sketch: Lake Lucerne from Fluelen*, 1841
Off-white wove paper, 21.4 x 28.2cm (Wire)
Watermark: J WHATMAN / TURKEY MILL / 1840
Size: J,W 1.8cm; HATMAN; T,M 1840 1.5cm; URKEY ILL 1cm
Papermaker: T & J Hollingworth, Turkey Mill, Maidstone, Kent

NGI.2429 *Le Pont du Chateau*, Luxembourg, 1839
Blue wove paper, 14 x 19.1cm, sheet has torn edges.
Paper made from both blue-dyed and white rags.

NGI.2430 *Sunset over Petworth Park*, c.1828
Blue wove paper, 13.9 x 19.3cm (Wire)
Paper made from both blue-dyed and white rags.

NGI.2431 *Reichenbach Fall*, 1802
Off-white wove paper, 47.3 x 31.2cm, prepared with a grey wash on both sides of the sheet.
Previously mounted onto a large laminate board of off-white wove paper, 63.6 x 47.2cm with a gold line decoration.
Verso of laminate board inscribed: J M W Turner. RA. Reichenbach (probably Henry Vaughan's handwriting).
Watermark on verso of laminate board: J WHATMAN/1859

## Non Vaughan Bequest watercolours

NGI.2284 *Harlech Castle, Wales*, 1796-8
Thick wove paper (laminate?), 26.3 x 36.8cm

NGI.3776 *Wellmich and Burg Maus on the Rhine*, 1844
Off-white wove paper, 18.3 x 24.3cm
Trace of a watermark on the lower edge.
The sheet shows extensive patchy discolouration.

NGI.7511 *Bregenz, Austria*, c.1840
Blue wove paper 19.2 x 28cm, sheet irregular with torn edges, missing top left corner.

NGI.7512 *Rialto Bridge, Venice*, c.1820
Off-white wove paper, 28.3 x 40.7cm (Wire)
Watermark: J WHATMAN / 1818 / TURKEY MILL
Size: J,W 2.4cm; HATMAN 1.7cm; 1818 1cm; T 2.2cm; URKEY MILL 2cm
Papermaker: T & J Hollingworth, Turkey Mill, Maidstone, Kent

NGI.19589 *The Castellated Rhine*, c.1832
Thick sheet of off-white wove paper, 23.5 x 25cm
Traces of a watermark on the lower edge: J WH
The sheet is quite discoloured through exposure to light.

## Liber Studiorum prints

NGI.11958 Frontispiece, 1812
White wove paper, irregularly trimmed (Wire)
Sheet size: 29.5 x 43.5cm; Platemark size: 21 x 29.2cm
Watermark: J WHATMAN / 1810
Size: J 2.7cm; W2.2cm; HATMAN 1.9cm; 1810 2.2cm
Papermaker: W Balston, Springfield Mill, Maidstone, Kent

NGI.20007 *Mer de Glace*, 1812
White wove paper, irregularly trimmed (Felt)
Sheet size: 29.4 x 42cm; Platemark size: 21.9 x 29.2cm
Watermark: J WHATMAN / 1810 Size: J 2.7cm; W 2.2 cm;
HATMAN 1.9cm; 1810 2.2cm
Papermaker: W Balston, Springfield Mill, Maidstone, Kent

Thanks to Susie Bioletti, Peter Bower and Dr Joyce
Townsend, for guidance and proofing of the text. Thanks
to my colleagues in the Conservation Department at the
National Gallery of Ireland, especially Ewelina Bykuc for
assistance in the technical examination and photographic
documentation of the works over a long period of time,
Roy Hewson for the technical photography including
false colour infrared, Niamh McGuinne for her input into
infrared reflectography and ultraviolet fluorescence. Finally,
thanks to Mariateresa Pullano for assistance in recording
the watermarks and to Rose Peel, Piers Townshend and
Jane Colbourne for their encouragement and for sharing
information.

## Glossary

Felt = The top side of the sheet of paper as it lies on the
mould. It is couched down onto the papermaker's felts,
thus the watercolour is executed on the smooth front
side of the sheet. The countermark/watermark read the
right way round when held against the light. However it is
important to note that both sides of the sheet are pressed
between felts after couching.

Wire = The side of the sheet formed next to the wove
screen (or the chain and laid wires) of the papermaking
mould. This imparts more texture, especially in the case
of laid paper, and is considered the verso of the sheet.
The countermark/watermark reads backwards from
this side, when held to the light.

Shives = small clumps of unprocessed fibres included
in the furnish (paper pulp).

# Acknowledgements

During the research process, many people advised and provided valuable information and assistance for this publication. Cecilia Powell and Ian Warrell, both experts on Turner who have published many books on the artist, have been particularly helpful, answering queries, clarifying information and alerting us to valuable new research. Sincere thanks also to: Christopher Baker, National Galleries Scotland; Susie Bioletti, Trinity College Dublin; Peter Bower; Julia Beaumont-Jones, Tate; Julius Bryant, V&A; Craig Hartley and Elenor Ling, Fitzwilliam Museum; David Hill, University of Leeds; Cormac Lowth, National Maritime Museum of Ireland; L.K. Moore; Jacquie Moore, Office of Public Works (OPW); David Morris, Whitworth Gallery; Joanna Selborne, Courtauld Institute; Peter Sizer; Dr Joyce Townsend, Tate; Pieter van der Merwe, National Maritime Museum; Stephen Wildman, Lancaster University.

Grateful thanks to Ranson Davey, former Conservation Department colleague, for the valuable research undertaken on the media and supports of the Gallery's watercolours and for compiling the appendices. Sincere thanks too to past and present staff and former colleagues, who have assisted in ways too many to mention: Ewelina Bykuc, Paper Conservation; Leah Benson, Archive; Małgorzata Dynak, Intern; Lydia Furlong, Gallery Shop; Valerie Keogh, Press Office; Adrian Le Harivel and all our Curatorial colleagues; Niamh McGuinne, Conservation; Donal Maguire, CSIA; Marie McFeely, Sean Mooney, Brendan Maher, Niamh O'Brien and Louise Morgan, Publications and Images; Andrew Moore and all the Library staff; Orla O'Brien, Development; Mary O'Riordan, Print Room Volunteer; Chris O'Toole, Photography; Sean Rainbird, Director.

Every January the Turner watercolours are displayed in the Print Gallery. Thanks to all our colleagues in the various departments who ensure that the exhibition and related events are a continued success: Art Handling, Buildings and Maintenance, OPW (lighting and carpentry), Education, Exhibitions, Publications and Images, Registrar's Office, Press Office and Visitor Services.

Finally, thanks to Roy Hewson, Senior Photographer for the superb photographs which show Turner's watercolours to best advantage and to Jason Ellams for the elegant design of this book.

**ANNE HODGE** and **NIAMH MAC NALLY**

# Select Bibliography

**ARMSTRONG 1902**
Walter Armstrong, *Turner*, London, 1902

**BAKER 2006**
Christopher Baker, *J.M.W. Turner: The Vaughan Bequest*, National Galleries of Scotland, Edinburgh, 2006

**BOWER 1990**
Peter Bower, *Turner's Papers: A Study of the Manufacture, Selection and Use of his Drawing Papers 1787-1800*, exhibition catalogue, Tate Gallery, London, 1990

**BOWER 1999**
Peter Bower, *Turner's Later Papers*: A *Study of the Manufacture, Selection and Use of his Drawing Papers 1820-1851*, exhibition catalogue, Tate Gallery, London, 1999

**CORMACK 1975**
Malcolm Cormack, *J.M.W. Turner, RA, 1775-1851: A Catalogue of Drawings and Watercolours in The Fitzwilliam Museum Cambridge*, Cambridge, 1975

**DAWSON 1988**
Barbara Dawson, *Turner in the National Gallery of Ireland*, Dublin, 1988

**FAIRBANKS HARRIS and WILCOX 2006**
T. Fairbanks Harris and S. Wilcox, *Papermaking and the Art of Watercolour in Eighteenth Century Britain*, Yale, 2006

**FARINGTON**
K. Garlick, A. Macintyre, K. Cave, E. Newby (eds.), *The Diary of Joseph Farington*, 17 vols, New Haven and London, 1978-98

**FINBERG 1909**
A.J. Finberg, *A Complete inventory of the Drawings of the Turner Bequest*, 2 vols, London, 1909

**FINBERG 1961**
A.J. Finberg, *The Life of J.M.W. Turner, R.A.*, 2nd edn, London, 1961

**FORRESTER 1996**
Gillian Forrester, *Turner's 'Drawing Book': The Liber Studiorum*, exhibition catalogue, Tate Gallery, London, 1996

**GAGE 1980**
John Gage (ed.), *The Collected Correspondence of J.M.W. Turner*, Oxford, 1980

**HAMILTON 2009**
James Hamilton, *Turner and Italy*, exhibition catalogue, National Galleries of Scotland, Edinburgh, 2009

**HILL 2000**
David Hill, *Joseph Mallord William Turner: Le Mont-Blanc et la Vallée d'Aoste*, exhibition catalogue, Aosta, 2000

**JOLL, BUTLIN and HERRMANN 2001**
Evelyn Joll, Martin Butlin and Luke Herrmann (eds.), *The Oxford Companion to J.M.W. Turner*, Oxford, 2001

**KRAUSE 1997**
Martin Krause, *Turner in Indianapolis – The Pantzer Collection of Drawings and Watercolors by J.M.W. Turner*, Indianapolis Museum of Art, Indianapolis, 1997

**MOORBY and WARRELL 2010**
Nicola Moorby and Ian Warrell (eds.), *How to Paint like Turner*, Tate Gallery, London, 2010

**NUGENT and CROAL 1996**
Charles Nugent and Melva Croal, *Turner Watercolors from Manchester*, Manchester, 1996

**POWELL 1991**
Cecilia Powell, *Turner's Rivers of Europe: the Rhine, Meuse and Moselle*, exhibition catalogue, Tate Gallery, London, 1991

**POWELL 1995**
Cecilia Powell, *Turner in Germany*, exhibition catalogue, Tate Gallery, London, Städtische Kunsthalle Mannheim and Hamburger Kunsthalle, 1995

**ROWELL, WARRELL and BLAYNEY BROWN 2002**
C. Rowell, I. Warrell and D. Blayney Brown, *Turner at Petworth*, exhibition catalogue, Petworth House, West Sussex, 2002

**RUSKIN**
E.T. Cook and Alexander Wedderburn, A. (eds.), *The Works of John Ruskin*, 39 vols, London, 1903-1912

**RUSSELL and WILTON 1976**
John Russell and Andrew Wilton, *Turner in Switzerland*, Zurich, 1976

**SELBORNE 2008**
Joanna Selborne, *Paths to Fame: Turner Watercolours from the Courtauld Gallery*, exhibition catalogue, Wordsworth Trust and Courtauld Gallery, 2000

**SHANES 1990**
Eric Shanes, *Turner's England 1810-38*, London, 1990

**STAINTON 1985**
Lindsay Stainton, *Turner's Venice*, London, 1985

**TOWNSEND 1999**
Joyce Townsend, *Turner's Painting Techniques*, Tate Gallery, London, 1999

**VAN DER MERWE 1979**
Pieter van der Merwe, *The Spectacular Career of Clarkson Stanfield 1793-1867*, exhibition catalogue, Tyne and Wear County Museums, Newcastle, 1979

**WARRELL 1991**
Ian Warrell, *Turner The Fourth Decade: Watercolours 1820-1830*, exhibition catalogue, Tate Gallery, 1991

**WARRELL 1995**
Ian Warrell, *Through Switzerland with Turner: Ruskin's First Selection from the Turner Bequest*, exhibition catalogue, Tate Gallery, London, 1995

**WARRELL 2003**
Ian Warrell *et al*, *Turner and Venice*, exhibition catalogue, Tate Gallery, London etc 2003

**WARRELL 2008**
Ian Warrell, *J.M.W. Turner*, exhibition catalogue, National Gallery of Art, Washington, DC; Dallas Museum of Art; Metropolitan Museum of Art, New York; London, 2008

Ian Warrell, 'Another Coast! Turner's English Channel or La Manche', pp.51-64 in *Coasting : Turner and Bonington on the shores of the Channel*, exhibition catalogue, Nottingham Museums and Galleries, 2008

**WILTON 1979**
Andrew Wilton, *J.M.W. Turner, his Art and Life*, New York, 1979

**WILTON 1982**
Andrew Wilton, *Turner Abroad: France, Italy, Germany, Switzerland*, London, 1982

Andrew Wilton, *Turner in Scotland: The Early Tours*, Aberdeen, 1982

**WILTON 1984**
Andrew Wilton, 'The "Monro School" Question: Some Answers', *Turner Studies*, vol.4, no.2, 1984, pp.8-23

**WILTON 2006**
Andrew Wilton, *Turner in his Time*, London, 2006

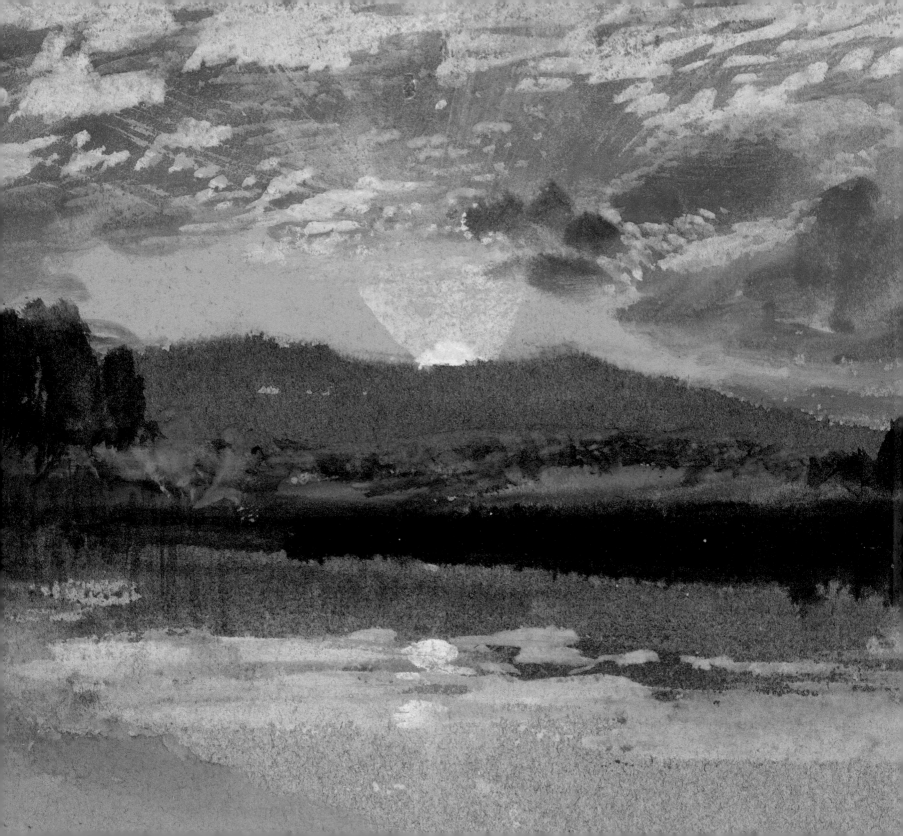